CORRECTIVE LIGHTING, POSING & RETOUCHING

FOR DIGITAL PORTRAIT PHOTOGRAPHERS

3rd Ed.

JEFF SMITH

AMHERST MEDIA, INC. ■ BUFFALO, NY

ABOUT THE AUTHOR

Jeff Smith is a professional photographer and the owner of two very successful studios in central California. His numerous articles have appeared in *Rangefinder, Professional Photographer,* and *Studio Photography and Design* magazines. Jeff has been a featured speaker at the Senior Photographers International Convention, as well as at numerous seminars for professional photographers. He has written numerous books, including *Outdoor and Location Portrait Photography, Posing for Portrait Photography, Professional Digital Portrait Photography,* and *Jeff Smith's Senior Portrait Photography Handbook* (all from Amherst Media®). His common-sense approach to photography and business makes the information he presents both practical and very easy to understand.

Check out Amherst Media's blogs at: http://portrait-photographer.blogspot.com/
http://weddingphotographer-amherstmedia.blogspot.com/

Published by:
Amherst Media, Inc.
P.O. Box 586
Buffalo, N.Y. 14226
Fax: 716-874-4508
www.AmherstMedia.com

Publisher: Craig Alesse
Senior Editor/Production Manager: Michelle Perkins
Assistant Editor: Barbara A. Lynch-Johnt
Editorial Assistance from: Sally Jarzab, John S. Loder

ISBN-13: 978-1-58428-990-6
Library of Congress Control Number: 2009911198
Printed in Korea.
10 9 8 7 6 5 4 3 2 1

TABLE OF CONTENTS

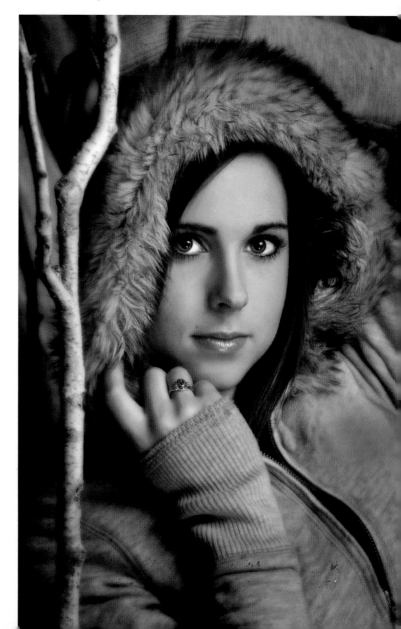

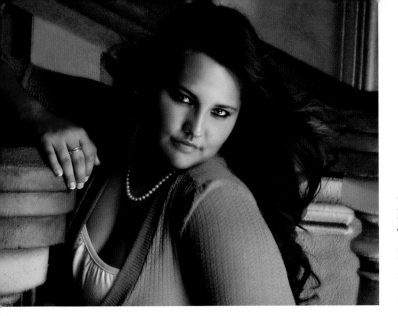

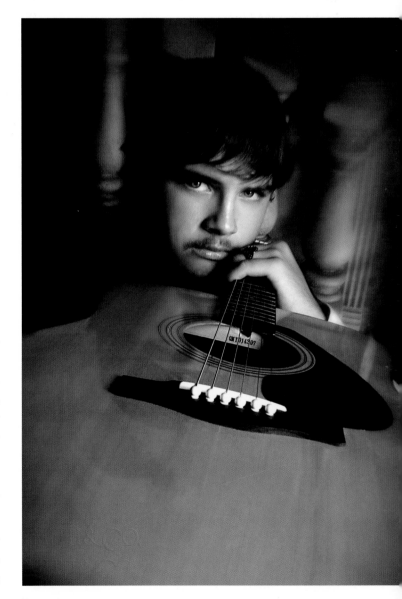

PHOTOGRAPHING REAL PEOPLE

PERFECT CLIENTS ARE RARE

Beauty and photography have always gone hand in hand. Maybe it's our fascination with beauty that brings us to this profession. From the minute a novice photographer picks

Being a true professional means knowing how to make real people look their very best.

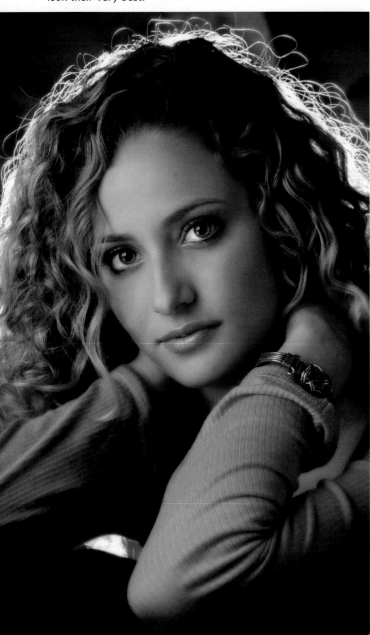

up a camera, the quest for beauty starts—we dream of the day when, as professional photographers, we'll create beautiful portraits of beautiful people. We want to find the perfect face to photograph and bring our vision to life.

After all of our training, we are ready for game day—the day we are no longer students but professionals. We are now ready to create those beautiful images of beautiful people and get paid for it as well! Your first paying client shows up . . . and what does she look like? Chances are she does not look like the people that you photographed while you were learning photography. In all your training, you've probably never seen a photographer or professor work with a person who looks like the human being standing in front of you. I have never once seen a seminar leader, teacher, or professor stroll out to do demonstrations with a model who wasn't perfect. Unfortunately, this means that most of our training has prepared us to photograph only about 5 percent of the buying public—your clients in a photography business.

Why would our education be so limited, only teaching us to create beautiful portraits of beautiful people? First of all, it is easy for the teachers. With a basic understanding of lighting and posing you can take some spectacular images of a perfect model. Second, it is what most of the people learning photography expect. If you went to a seminar and an overweight, unattractive model walked out, most of the people in the audience would feel cheated. Many of those in the audience would make comments like, "After what we paid for this program, this is the best model you could come up with?"

On occasion, I have heard similar comments about my books because I don't hand-select models, then show only the single best image from many sessions with them. In-

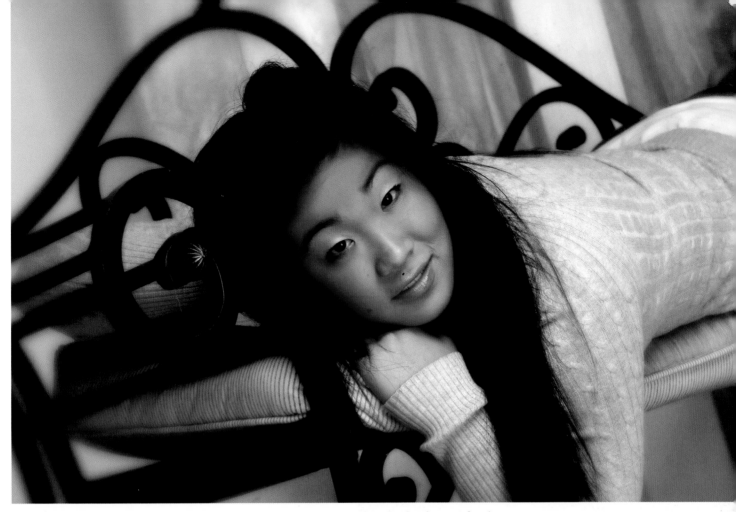

Everyone wants to look beautiful in their portraits—and it's your job to make that happen for them.

stead, I show the clients I work with—because that's the best way to give my readers a true idea of professional photography. To make money in this profession, you must work with all people, not just the beautiful ones. It is one thing to make "Ms. Perfect" look "perfect" in a demonstration but quite another to make Mr. and Mrs. John Q. Public, people who are overweight, balding, and much less photogenic than the instructor's "Ms. Perfect," look good in an actual paying session at your studio.

I hate to be closed-minded. Maybe there actually is a photographer out there somewhere who makes a good living in a portrait studio that only photographs beautiful people. If there is, I would like to shake his or her hand—and then buy the studio. This book, however, is for all the rest of us who have a variety of clients, with a variety of problems, but who would also like to appear beautiful in their portraits.

This book is for the open-minded, educated photographer who wants to make money in this profession by learning how to photograph all of their clients and not just the pretty ones. I work with high-school seniors all day long, every day of the week, and maybe 5 percent of them are attractive enough for their egos to handle looking at a portrait that shows them as they really are—a portrait that only depicts reality. Keep in mind, I'm talking about clients at an age when they have everything going for them. They probably will never again be as thin, with as much hair, and as wrinkle-free as they are at this point in their lives. As we age, the "reality" gets harder and harder to handle, but clients still want portraits that they consider flattering and attractive. Achieving that goal is the subject of this book.

CARING ABOUT YOUR CLIENTS

If you are the average photographer, trained to take salable portraits for about 5 to 7 percent of the buying public (maybe 15 percent if you live in Hollywood, where every waiter/waitress is a would-be actor) you have probably found yourself photographing people that you were never \trained to work with. Often, you may find that you really don't care about the outcome of their sessions because you

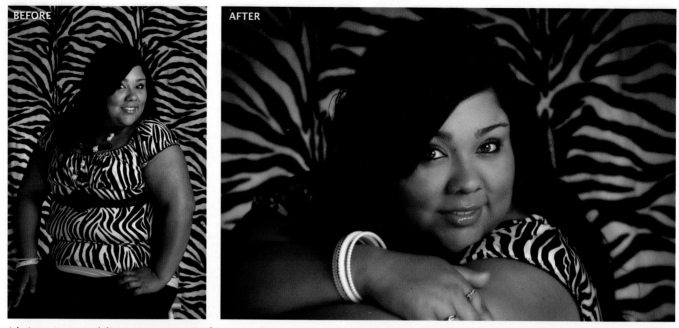

BEFORE AFTER

It's important to deliver great portraits for every client—not just the size-two supermodels.

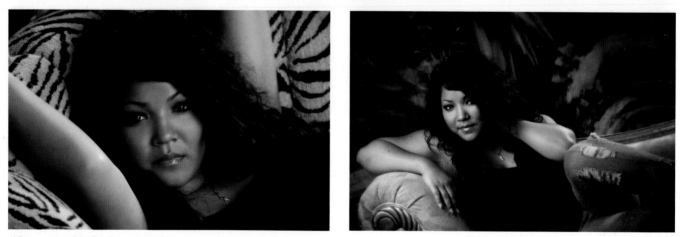

When you take the time to make every subject look their very best, you'll be amazed at the reactions you'll get—from your subjects, from their friends and family, and from your market as a whole.

feel it is hopeless to try to produce an appealing portrait of someone who is so un-photogenic. Ultimately, your un-photogenic clients irritate you; they seem oblivious to the way they really look and then get mad at you because they look the way they do in the portraits you create!

When I say "you," I actually mean "me." These were my thoughts and feelings as I started my career. When a client would see her previews and make comments like, "I look fat in these pictures," I wanted to yell out, "You look fat in person, too—you actually must be fat!" Everything changed for me one day when I came face to face with a senior girl who was very overweight. When I looked into this girl's eyes, she looked sad. For the first time ever, I wondered about how she would feel looking at herself in

the images I created of her. I thought about what her friends would say as they looked at her images and how that would make her feel. For a moment, I felt sad too. This young lady had a beautiful face, but she was so large that no one ever noticed.

At that time I knew nothing about corrective technique so I just looked at the areas of her body and face that showed how heavy she was and I did everything I could to hide them. I worked harder on her session than I had on all the sessions I had taken that week, but I saw that it was working. My shtick of funny, politically incorrect jokes was replaced by an overwhelming desire to make this young lady beautiful so she would like the way she looked and be proud to show the portraits to her friends.

The session ended, but what it taught me never did. I was in the studio when a staff member showed the senior and her mother the images. The mother started to cry—and when she saw me across the room, came over to give me a hug. As she hugged me she said, "I tell my daughter how beautiful she is and these portraits show the beautiful young lady I see." This was almost twenty years ago and it still chokes me up.

This was the moment when I realized how incomplete my training really was. It started me looking for ways to make the average client look beautiful. I did this to force myself to keep trying to enhance my client's appearance and to never forget the feeling I had when I made that mother cry. As I was trying to learn more about correcting problems, I could never find much information on the subject, so most of what I learned was through trial and error and being committed to my clients.

I knew it was working when I started hearing the senior guys say things like, "This guy can make anybody look good—did you see Tiffany's pictures?" One guy asked if I would give him the phone numbers of the girls in the sample books, then one of his buddies spoke up and said, "They look good in these pictures, but they don't look like that when you see them at school!"

In this book, I will explain a great deal about what it takes to correct the flaws that real people have—but without some compassion for your clients, the "how" really doesn't matter; you will find it too hard or time-consuming to adopt these methods as a standard way of photographing. Only when you understand why people make the bad choices they do and why they can be so oblivious to the way they actually look, can you find the compassion to do anything about it.

THE APPROACH

Cameras are designed to record reality—a two-dimensional record of a three-dimensional world. Most photographers start to feel pretty good about themselves when they can, by the proper use of lighting, achieve a portrait that has the appearance of a third dimension. But then what? Reality, with the appearance of a third dimension, is what the department store and mall photographers give their clients. They produce images that are a road map of the human face, showing every inch, every pore, and every line. Who wants to see all that? Even for many professional photog-

raphers, the only way they attempt to make reality easier on their clients' egos is to use diffusion for a softer portrait. To take it to the next level, we will begin by looking at ways to use lighting and posing to correct or conceal problem areas. Then we'll move on to ways to correct any remaining problems using digital technology.

Considering that digital is all the rage, why, you might ask, have I decided to put off talking about Photoshop until later in the book? Well, although enhancements and corrections are easier with digital, they are still expensive—whether in terms of time or money.

If you prepare your clients adequately, control the session effectively, and capture the images properly (using what you will learn in this book), you will be able to go quickly from the camera room to the viewing room. You will have previews that are good enough for the client to

When your images are lit and posed correctly, they'll look great straight out of the camera—meaning you'll spend less time on Photoshop enhancements.

When you clearly inform your clients about how to prepare for their session, you eliminate a lot of the obstacles to creating a great portrait.

actually like how they look without significant Photoshop enhancement. This is important, because it allows you to present your images to clients immediately after the session, which is a major sales booster. You can't possibly retouch away every sign of weight gain and aging on every shot and still show your images right after the session—and you certainly can't expect a client to order an image

BUILD ON THE EXCITEMENT

We show all of our clients their images a few minutes after the session is over. I do this because I like making money from the images I create—and the client's excitement (reading: willingness to buy!) is always the highest after the session ends. National and department store studios use this technique to sell work that most people wouldn't buy after the excitement was over! In my experience, photographers who learn the proper steps to take to show the client their images right after the session will see a 20 to 30 percent increases in the size of their orders.

that makes her appear overweight and old just because you promise you will be Photoshopping her beautiful.

If the previews that come out of your camera aren't 90 percent as good as your final images you have a problem. You might have poor photography skills and be relying on Photoshop to survive. If you are good photographer, you might not be correcting as much as you could in the camera room and letting your computer staff make up for your lazy ways. Or you could be a photographer who overcorrects and over-creates in Photoshop because you think a beautiful portrait isn't enough—it has to be changed or altered in some way to appear as though it has been created in Photoshop. (This is the direction in the education of senior photography right now. Everything has to look Photoshopped, surreal, and not normal to be cool—or that's at least what the educators say. Clients, however, often have a different opinion.)

Digital photographers waste far too many billable photography hours sitting in front of a computer fixing problems that should have been dealt with in the planning or photographing of the session. The "we can fix anything" way of thinking takes the profit out of your business, because whether you do the corrections yourself or pay someone else to do it, it costs you money. I consider myself a businessperson first and a photographer second.

The average photographer has about twenty-five billable hours per week (when you include vacations, sick days, holidays, etc.). This means that you have approximately 1300 billable hours per year. If you create $100 in sales per billable hour, your studio will generate $130,000 for the year. The average photographer, in a retail studio, gets to keep (profit) somewhere between 15 and 30 percent of the gross sales. Fifteen percent of $130,000 isn't going to keep you living at the Ritz—as a matter of fact, it will barely keep you in a cheap apartment.

In our studio, we achieve sales averages of over $500 per hour. I can't do this by spending my time color correcting and retouching images on my computer. While you will need to be knowledgeable about digital retouching in order to set the standards for artwork on your photography and establish time requirements for these corrections, this is not work that the average photographer can afford to do personally. Instead, it can be hired out to a person making $10 an hour. If you intend to live much above the poverty line, this is an important issue.

This book is for those of us who have a variety of clients, with a variety of problems, but who also want to appear beautiful.

The good news is that, other than simple retouching for acne and other blemishes, enhancements and corrections should rarely need to be done if you know what you are doing when you take each portrait. Given the cost of digital work, this means you can significantly improve your efficiency and income just by being careful to identify and eliminate problems before you capture an image. That's exactly where we'll begin in chapter 1.

1. IDENTIFYING PROBLEMS

REALITY AND EGOS

As a photographer, how many times do you have a female client come in with a tight blouse, one that shows every ripple and bulge, and wonder why she's so oblivious to the way she really looks? And it's not just women—middle-age men are the kings of denial. They actually believe their comb-over makes them look like they have a full head of hair or that everyone doesn't know it's really a wig. (And the woman on their arm who is half their age loves them for their classic good looks and not their money, right?)

We all do this. When I look in the mirror, I don't see me, I see the man I was twenty years ago. Then, I have a portrait taken and reality rears its ugly head: the guy in the picture looks a lot like a man in his forties! Reality is not our friend and our minds work hard to prevent our egos from having to face the truth about our appearance.

I have had men with six hairs on their head act amazed that they appeared bald in their portraits. If you want to see denial in action, watch people try on clothing—well, not while *changing* (that's illegal) but the minute they see themselves in a mirror. They pull their shoulders back and suck it in. Then they come to you for a portrait and say you got them at a bad angle—after all, they just bought this outfit and they didn't look fat in it at the store!

Reality is almost never our friend. Your goal is to make all your subjects look as good as they think they look.

This is the world in which we must work; it is your skill and understanding that will take a client from where they are to where they wish they were. Corrective techniques in lighting and posing bridge the gap between the way your clients actually look and the idealized self-image their minds allow them to see.

IMAGINED VS. REAL PROBLEMS

Almost every person has something in their appearance that they would change if they could. There are two general types of problems that you will come across when working with your clients. These are the imagined problems and the real problems.

The "imagined" problems are normally found in very attractive, very photogenic clients. Usually these problems are very slight. Most of the time the person who has these problems is the only one who can actually see them with-

RIGHT—Although women are more prone to imagined appearance problems, guys are also becoming increasingly image-conscious. **BELOW**—*If the client expresses concern about any aspect of their appearance, it needs to be softened in the final portrait—even if it doesn't seem like a problem to you.*

out a lot of careful searching. These problems are the hardest to correct because most photographers never take the time to speak with their clients about such issues before

Hiding the chin area eliminates a concern many clients express.

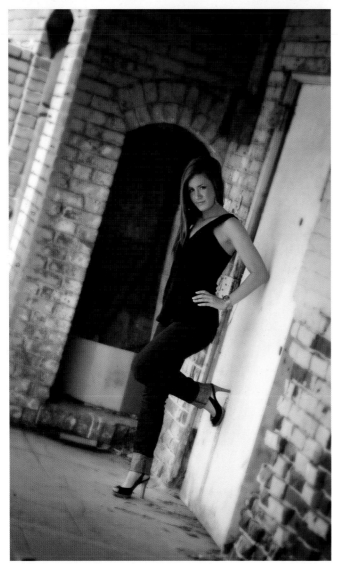

Turning the body to the side slims the look of the entire torso.

their session. Since no problems are readily apparent, the photographer doesn't give it a second thought. A typical imagined problem is something like, "One of my eyes is smaller than the other," "One of my ears is lower than the other," or "My smile seems crooked." As you look for this "freakish abnormality," you have to study the problem for several minutes to figure out what on earth the client is talking about.

Women are more prone to imagined problems than men, for they feel they have to live up to a higher standard. You know the double standard—a chubby guy is "stocky" while a chubby woman is "fat." A mature man has "character" while a mature woman is just "old." Many women feel that they must look like the girl on the cover of a fashion magazine, while most men feel they don't have to look any better than the guy next door (although this is rapidly changing as guys are also becoming more and more image-conscious). This is a primary reason why I have used women for the majority of the illustrations in this book. The second reason is the fact that women generally wear clothing that is more revealing than men's clothing—meaning that any figure flaws they may have are that much more obvious. Guys' clothing, on the other hand, is usually loose and helps to conceal some problems.

The "real" problems are the issues that each and almost every one of us has. We are never as thin as we would like, we think our noses are too large, our ears stick out too much, and our eyes are too big or too small. These problems are easier for most photographers to correct because they are more easily identified as things that need to be disguised in the final portrait.

We may sympathize with real problems more than imagined problems, but all of a client's problems need to be softened if the session is to be profitable.

COMMON PROBLEMS

Neck Area. As you will notice, in many of my portraits the neck area is hidden from view. The neck area, from directly under the chin to the Adam's apple, is the first area to show signs of weight gain and, in older clients, age. In chapter 5, we will discuss the many ways to hide this unsightly area in the final portraits for every type of client.

Men's Concerns. Guys want to look "buff," not scrawny or chubby. Though few will admit it, most guys worry about their nose being larger than they'd like, their

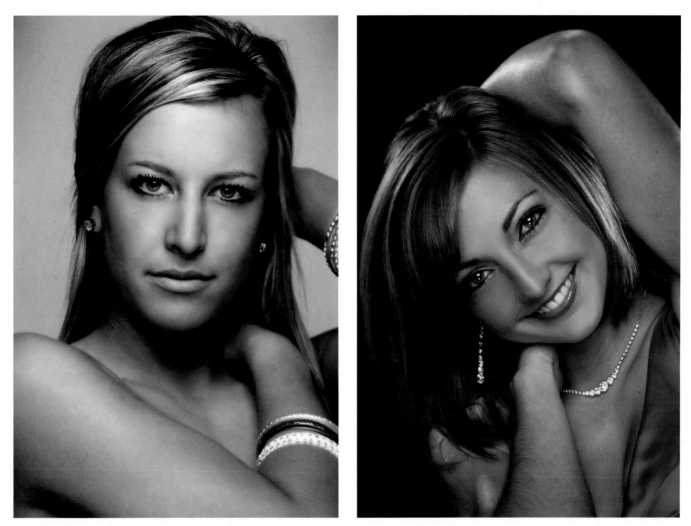

Facial expression can set the mood for the portrait. From serious and moody, to happy full smiles, work with your clients to create the best possible look for each portrait.

ears sticking out a little too far, or both. If the guys are at all heavy, they will also be concerned with the neck area or double chin.

Women's Concerns. Ladies hate just about everything from the hairline down (just kidding—but close!). Women are not prone to large noses, but if a young lady has one you will most definitely want to minimize its appearance. Ears can usually be successfully hidden by long hair (for those who have it). Women also want to have the appearance of high cheekbones, but without looking like they have chubby cheeks or no eyes when they smile.

A woman with any kind of weight problem will worry about the width of her face, the neck area or double chin, large shoulders, the size of her upper arms, and the size of everything else down to the bottoms of her feet.

For the average-sized woman, the face and neck are usually not a problem. Even thin women, though, worry

about the size of their upper arms or dark hair showing on their forearms.

Most ladies with a normal bust want their chest to appear at least as large as it is. As the current feelings of women toward breast-enlargement surgery are generally favorable, it is safe to say that if a woman's bust appears slightly larger than it is in reality, it will probably be appreciated. Many times, a pose will make the bust appear uneven, which is the worst thing you can do.

Women always want their waists to appear as thin as possible. If the subject has a tummy bulge, she doesn't want to see it.

In general, the only part of the uncovered leg to show in portraits is from slightly above the knee to the ankle. Of course the legs should look like they have good muscle tone and not show any signs of cellulite. Even a thin woman will often worry about the appearance of her hips

The longer you practice using corrective techniques, the faster and better you will get at identifying your clients' problems and developing solutions.

and thighs. Unless you are a woman, or are married to one, you may not realize how much women worry about this area of their bodies. It is also generally an area where extra weight is very apparent.

QUICKLY EVALUATING A CLIENT'S PROBLEMS

At one point in my career I would ask a client if there was anything in their appearance they would change. However, the only people who would respond were the near-perfect ones with one very small flaw that they obsessed about. Clients with real problems were either oblivious to them or too embarrassed to mention them. Overweight subjects

and people with age-related appearance issues usually fall into this category, but there are a lot of other concerns—some part of the face or body that falls outside of what society says is the "norm"—that people may also be too self-conscious to discuss. These include things like larger noses, large ears, a large Adam's apple, a too-long or too-short neck, breasts that are too large or too small, a waistline that doesn't taper in from the chest and hips, a waistline that tapers in too much making the hips look huge, too large of a butt, too flat of a butt, thighs and legs that are too large (or too thin, or too long, or too short), feet that are too large or too small, and toes that are not perfect!

Summing up the problems a client has can be accomplished in a matter of seconds. When you sit someone down with the main light turned on, you can immediately start to see what that person's strengths and weaknesses are. You can see how wide the face is, how well the subject's eyes reflect light, and identify flaws like unevenly sized eyes, large noses, or prominent ears that need to be hidden.

As you sum up the problems that need to be addressed, you can start to make decisions about what side of the subject the main light should be placed on, what poses you can use to hide this individual's flaws, which of the client's outfits would give you the most to work with (in terms of disguising the problems the client has), if the person should do full-length images or not, or if they have long enough hair to hide the shoulders and arms so the client may wear sleeveless tops.

The longer you practice using corrective techniques, the faster and better you will get at identifying problems and developing workable solutions. It's just like when you started in photography. You would photograph someone, and when the proofs came back you would find that the subject's feet weren't right, that their hands looked funny, or that their clothing wasn't laying properly. In time, you learned to "scan" the subject quickly from head to toe and identify anything that wasn't right. The same is true for finding and correcting client's problems; with some practice, it just takes a few seconds.

ACCENTUATE THE POSITIVE

To some photographers this may seem overwhelming. After all, how are you supposed to figure out how to make

all that look good? There is good news: I have never met a single person that had all these issues. Fortunately, every human being, even the un-photogenic ones, has redeeming qualities in their appearance.

That is the idea here: minimize or hide the imperfections and focus the viewer's attention on the subject's most appealing attributes. If your client is very overweight but has beautiful eyes, minimize the obvious signs of weight gain and make the viewer focus on those beautiful eyes. If a woman who is being photographed for her husband is overweight but very busty, minimize the areas of weight gain and accent her bust. Maybe the woman taking a portrait for her husband is thin but has weathered skin and an unattractive face but beautiful legs. In that case, soften the lighting on the face and accent those attractive legs.

Like everything you learn, this process will take some time in the beginning, but you will get faster and faster at analyzing what you need to hide or minimize and what you need to focus the viewer's attention on. I ask myself two questions as I look at each client. First, if I were that client, what would I not want to see in my portraits? Second, what attracted this person's significant other to them? (Let's hope it wasn't just their personality—or you could be in for a long session!)

What are your subject's best features? Here, the young lady's intense eyes and long, shiny hair are accentuated. Adding a fan gave her hair good movement.

2. WORKING WITH CLIENTS

As photographers, we worry constantly about improving our lighting, our posing, and even our marketing plans, but often we completely overlook the most important part of our businesses: our clients. If you think, as many pho-

After working with seniors for eighteen years, I pretty much know the areas of the face and body that the average seventeen-year-old man or woman worries about the most.

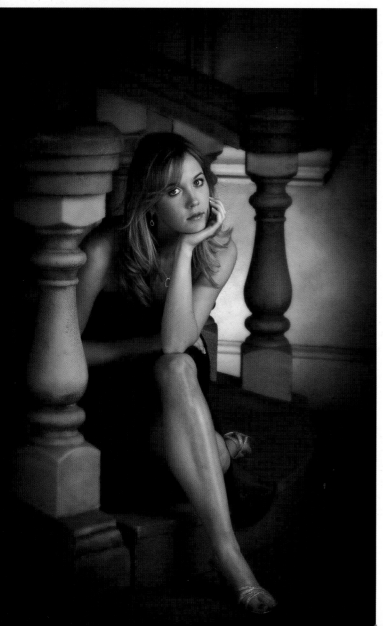

tographers do, that you know more about what your client should have than your client does, your client will prove you wrong every time. After all, you may be the creator of "your art," but the client is the one who must live with your creation and, in the end, is the one who determines whether a portrait is "art" or not.

We are very conscious to deliver to our clients the products they want. We talk with them as much as possible. We ask questions, give them questionnaires, and try to make the exchange of ideas (and any discussion of problem features, real or imagined) as easy as humanly possible. Still, most clients will not come right out and tell you what they consider to be problems with their appearance. They won't write it down on a questionnaire. The majority of the time, the mothers of the seniors are the ones who alert us to issues with their sons' or daughters' appearances—and even this doesn't happen as often as we would like.

To practice corrective lighting and posing in your studio, you have to learn about human nature. Most of us worry about the same things. We are not as different as most people think. After working with seniors for eighteen years, I pretty much know the areas of the face and body that the average seventeen-year-old guy or girl worries about the most.

PREPARING YOUR CLIENTS

The key to a successful session is preparing the client. We are successful because, from the very first phone call, we prepare our clients thoroughly for their session.

For example, our clients know from the outset that they will be viewing their images and ordering them immediately after the session is over—and that this is their only chance to do so. We don't offer "portrait visitation" like

most studios. ("Oh, my husband couldn't come today," says the client, stopping by to "visit" her images. "We'll schedule another appointment to order—today I just wanted to show my mother the portraits.") This isn't a sales process; this is letting your client control your business—and it isn't the client's fault, it's yours. Businesses must have rules that tell clients what to expect. If they don't (or if the "rules" are actually "suggestions" that no one follows), the client can't be blamed for failing to understand their responsibilities in the process.

When restaurants put up a sign that says "No Shirt, No Shoes, No Service," you can be pretty sure they'll ask you to leave if you show up with no shirt, bare and muddy feet, and looking almost homeless. Too many photographers, on the other hand, would see that same client and think, "Well, it's been a slow week. I really need the money." Then say, "Go ahead and come in—we'll make an exception for you this time!" (After the fact, of course, they'd get together with other photographers and complain that their clients just don't listen to the rules.)

Educating your clients will reduce the number of problems you have at your sessions—and increase the quality of your images.

Put everything in writing. Let the client know everything involved in the process. This includes prices (even if given in ranges), what to expect during the ordering and delivery process, what clothes they should select and avoid, how to apply their makeup for the session, etc. Including *everything* will increase their enjoyment of doing business with you and their enjoyment of the final portrait.

Most photographers do themselves and their clients a huge disservice because they run their businesses as though the client has the upper hand. The relationship between the client and the business or service provider should be

Before you create a portrait for a client (a portrait that you actually want the client to purchase), you had better figure out what that client expects his or her portrait to look like.

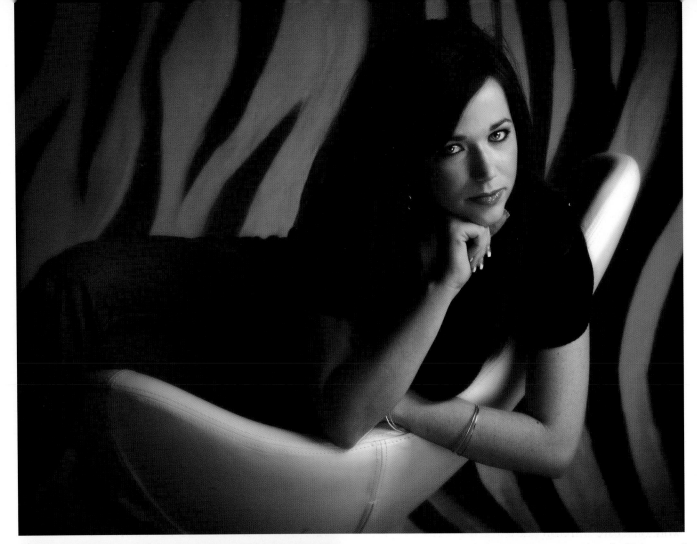

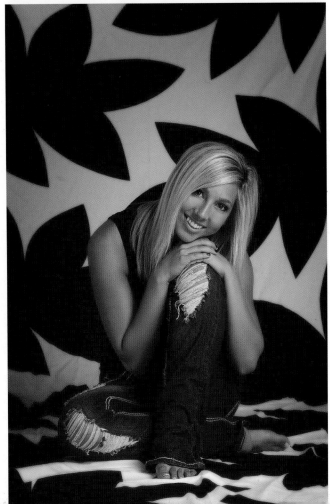

LEFT—*Educating your client is an important part of taking control of your sessions.* **ABOVE**—*If postproduction corrections are needed, making them on a solid-colored outfit will be much easier than if the subject is wearing patterned clothing.*

one of equality, not of a master and servant. You provide a product they want; they have money that you want. They have many choices of other studios; you have many choices of working with other clients. Respect between the client and the business is maximized when they stand on an equal footing. Respect is destroyed when there is master/servant relationship.

If you have a master/servant relationship with your clients, they will want you to work at times when your business is obviously closed. They will order (or not order) at any time they wish and pretty much do whatever they want—because they are the masters. In terms of corrective techniques, this inequality will also make it harder for you to make them look as good as they would like to in their final images—because they will never listen to your rules or suggestions. When, on the other hand, you and your client have an equal respect for each other, they will follow your

suggestions and have better outcomes from their sessions. (They'll also respect your business hours, place their orders at the time you have set, and provide the required deposits/payments if they want to order from the portraits you have created.)

CLOTHING SELECTION

Clothing selection (which we'll cover in detail in chapter 3) is something you must control in order to practice corrective lighting and posing most effectively. The right clothing can make such a difference in the way the client will look in the final image—and getting the client to bring in the correct clothing is your job.

Photographers get so excited about Photoshop that many never take the time to make clothing suggestions that will expedite any necessary corrections. Which correction would you rather make: taking out a large wrinkle in a solid-colored blouse or taking one out in a plaid blouse? Would you rather reduce the size of a woman's thigh in a pair of black slacks (with a black seam) or dark jeans with a lighter stitching on the side of the leg? The corrections to the solid-colored blouse and black slacks will take 50 to 70 percent less time. If I photograph a women with larger arms and need to reduce their size in Photoshop, I'd rather work on a bare arm than one covered in a reflective material like satin, because the light reflecting off the fabric will make the corrections take much longer.

Explain to your clients that time is money. If their failure to follow your guidance results in time-consuming corrections, they'll be responsible for those costs. Give them a realistic cost difference between the two corrections—one in the clothing you suggest and one in the clothing you don't suggest. Once you explain this, you will find that clients listen to your rules/suggestions.

It is also important to define what problems you can fix. Some clients will assume that your studio will take care of all their problems. (When they come in with wrinkled clothing, unwashed hair, and thick glasses [with the glass still in the frame] they will say, "Well, you said you would fix all the problems in my appearance!") We go over what can be corrected in the lighting and posing, what digital retouching can correct, and what retouching will cost them in the event that they don't want to take the time to prepare for their session properly.

In business, almost every problem that arises comes from a lack of communication. In a portrait studio, most problems stem from clients not understanding their responsibilities for the outcome of their session—or the photographer not knowing what the expectations of his or her client were.

MAKING YOUR CLIENTS FEEL COMFORTABLE

As you talk with your client, you must be sensitive to his or her feelings. People are often embarrassed by their flaws,

In a portrait studio, most problems stem from clients not understanding their responsibilities for the outcome of their session, or the photographer not knowing what the expectations of his or her client were. When you're both on the same page, things go much more smoothly.

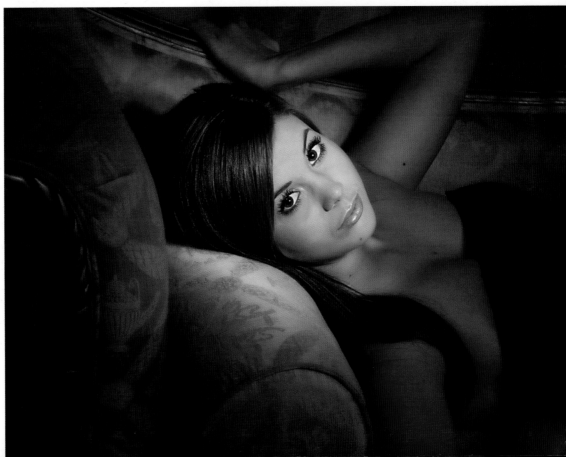

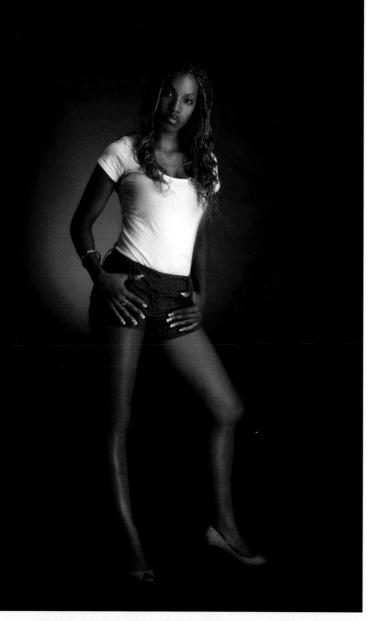

Many women want to do full-length portraits simply because they bought shoes to coordinate with their outfit.

which the client only has to answer "yes" or "no"—and we phrase them to make it clear that lots of other people worry about the particular issue we're discussing.

For example, a typical situation occurs when senior girls bring in sleeveless tops (something we specifically recommend against in our consultation materials). The minute I see them, I explain, "Sleeveless tops are fine." This doesn't make the senior feel like an idiot for not following the guidelines.

Then I continue, "The only problem is that a lot of ladies worry about their upper arms looking large or hair showing on the forearms. Does that bother you?" Either she will smile and say "Yes" or she will say "No." By phrasing your question carefully, you can make it easy for them to voice their concerns without being embarrassed.

The best way to handle a possibly embarrassing situation is to give the client two options, so no answer is needed. We do this with the "barefoot" issue. Rather than ask if a girl hates her feet (many do), we explain: "With a casual photograph like we are doing it looks cute to go barefoot. If you don't mind, you can come out of the dressing room barefoot—but if you'd rather not go barefoot, you can keep your shoes on." When the girl comes out of the dressing room, not a word needs to be said.

The hardest spot to be in occurs when a client wants to do a pose that you know she or he should avoid. For instance, a really heavy girl selects a pose from the sample books of a thin girl in a very striking pose. What do you do? There is only so much that corrective lighting and posing can do. No matter how you pose or light a girl who is very overweight, in a full-length pose she will not appear thin enough to be acceptable to her. In a case like this, you must advise the client to do head-and-shoulders poses.

Situations like this happen more often than most people think. To sympathize with these clients, you must understand why this happens. When I first started in photography, I would think to myself, "Hey, that girl has arms like a tree trunk and she brings in nothing but sleeveless tops—what an idiot!" Back then, I resented these clients because I felt that they made my job harder. What I didn't understand is the way human eyes and brains work to save our egos from having to handle reality when we look in the mirror. You might gain ten or twenty pounds and lose some hair, yet it's not until you see yourself in a picture that you really notice these changes. You think to yourself,

but you can make it easier by educating them from the beginning. Let them know that everybody has things in their appearance that they would change if they could. Explain that if you know what the client's concerns are, you can easily correct many problems in their portraits. In the materials we provide to seniors before the session, we explain that, although we can correct problems in someone's appearance (like weight, a double chin, or a large nose), we cannot correct the problems that arise from not planning their session properly.

There are many ways to get a client to tell you if there is a problem without making them feeling embarrassed or awkward. Before we start the session, we ask questions to

"I look in the mirror every day. Where has this fat, old, hairless guy been hiding?"

Fortunately, it is not so much what you say to clients that is important, it is the way you say it. For every problem and potentially embarrassing situation there is a way to handle it without making yourself look unprofessional or seeing your client turn red.

For example, when I see a heavier girl with a lot of boxes of shoes, I know I am going to have a problem and I need to say something the minute I show her into the dressing room. I first explain, "Many ladies go on a shopping spree to buy a matching pair of shoes for every outfit. Since they bought them, they want them to show in their portraits. The problem is that when you order your wallets for family and friends, the full-length poses make it very hard to really see your face that well." (This gets the girl to accept that not all the poses should be done full-length.)

Then I continue, "Most women worry about looking as thin as possible. The areas that women worry about the most are their hips and thighs. This is why most of the portraits are done from the waist up, not to show this area." Next I ask, "Now, are there any outfits that you want to take full-length, or do you want to do everything from the waist up?" She will usually think for a second and say she wants everything from the waist up. This avoids telling her she can't take full-lengths, or being brutally honest and telling her she shouldn't take them.

Should the girl be really attached to her shoes and not follow what I am trying to tell her, I go to the parent or friend she is with and explain that if we do the portraits full-length, I worry that she won't like them, because women worry so much about looking thin. Once I explain this to the mother, she can tell her daughter not to do full-lengths, or a friend can help enlighten her without causing embarrassment.

REALLY LISTENING

Everyone has a feature or aspect of their appearance that they are self-conscious about. Some of these problems are so slight you might not even see them, but that is irrelevant. The client will see them, and the client is the one paying the bill for the portraits you create.

Often, photographers forget this. I was once at an outdoor location that is used by several other local photographers. As I was waiting for my client to change her clothing, I had nothing better to do than listen to another photographer working with his own client. The subject was a young woman, a few years out of high school. The photographer instructed his client to hop up on a rock that was near the pond. As the woman sat down, her pant leg inched up, revealing her white socks gleaming out of her dark-blue denim pant leg. She asked, "Are my white socks going to show?" The photographer, who was obviously about as compassionate as he was educated in customer

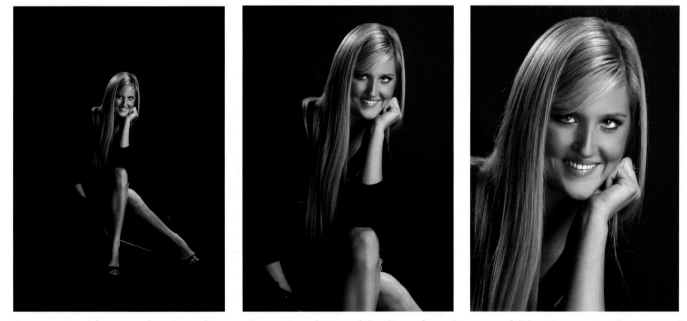

In most cases, it's extremely easy to photograph a variety of views of the client—from close-ups to full-length portraits. This is a good way to ensure that everyone will find something they like when ordering images from the session.

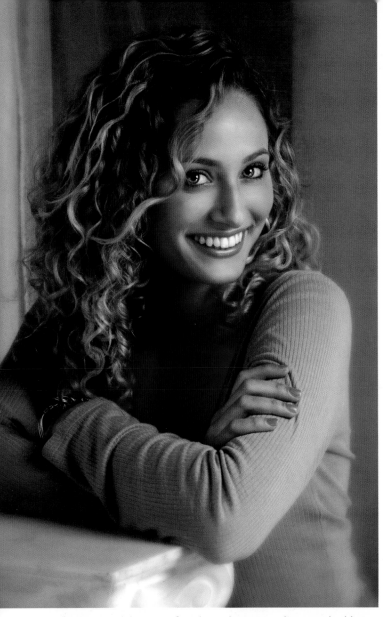

If you want to live very far above the poverty line, you had better take every problem seriously and make sure your client doesn't see areas of concern in his or her final portraits.

service, quickly responded, "Hey, if you didn't want them to show, you shouldn't have worn them!" He then proceeded to take the portrait full-length, showing the white socks.

How hard would it have been to compose the portrait as a close-up or three-quarter-length image, or have the woman take off her shoes and go barefoot? Instead, this photographer refused to try something outside of what he had always done. That was probably his favorite rock, and he took every portrait at "his rock" as a full-length—or he just didn't take it. In our profession, the saying "Ours is not to reason why" certainly applies. Our job is simply to fix it. A client's problems may seem insignificant to you— you may even think they are funny. That's okay, but if you

want to live very far above the poverty line, you had better take these problems seriously and make sure that your client doesn't see them in his or her final portraits.

BE TACTFUL

Photographers don't usually spend a lot of time thinking about how to talk with their clients without offending them. While watching photographers work with clients, I have heard instructions like, "Sit your butt here," "Stick out your chest," "Suck it in just before I take the picture, so your belly doesn't show as much," "Look sexy at the camera," and "Show me a little leg." I am sure the women who were instructed this way didn't feel very comfortable with or confident about their chosen photographers.

Whether you are discussing a client's problems or directing them into poses, there are certain words that are unprofessional to use in reference to your clients' bodies. In place of "butt," choose "bottom" or "seat." Never say "crotch," just tell the client to turn his or her legs in one direction or another so that this area isn't a problem. Instead of "Stick out your chest," say "Arch your back." Replace "Suck in your stomach" with an instruction to "Breathe in just before I take the portrait." To direct a client for a "sexy look," simply have the subject make direct eye contact with the camera, lower her chin, and breathe through her lips so there is slight separation between them.

No matter how clinical you are when you talk about a woman's breasts, if you are of the opposite sex, you will embarrass them. The only time it is necessary to discuss that part of the anatomy is when the pose makes the woman's breasts appear uneven. When this situation comes up, I just explain to the client how to move in order to fix the problem, without telling her exactly what problem we are fixing. Once in a while, we have a young lady show up for a session wearing a top or dress that is too revealing. In this situation, you need to find an alternative. If there is way too much of your client showing, you may explain that this dress is a little "low cut" for the type of portraits she is taking.

3. CLOTHING AND BACKGROUND SELECTION

In order to effectively conceal your clients' flaws, they must be wearing the right clothing and you must select the right background. If their clothes are a poor style or color choice, or fit poorly, you may face insurmountable issues when it comes to applying corrective techniques. With your client in the right clothes, however, you'll be able to achieve much more flattering results.

CLOTHING GUIDELINES

Probably the best advice I can give you in regard to your clients' clothing is to have them bring in everything for you to look at. I am not kidding. We tell our seniors to bring in everything, and they do. The average girl brings in ten to twenty-five outfits; the average guy brings five to ten. By doing this, you always have other choices when a favorite outfit is a bad choice for a particular subject.

Long Sleeves. We stress the importance of bringing in the proper styles of clothing. We suggest long sleeves for all portraits that are to be taken from the waist up. Large arms are much less noticeable in a full-length pose, so short sleeves are less of a problem in these portraits.

Black Clothing. We also suggest that anyone who worries about weight should bring in a variety of darker colors of clothing and several choices that are black. Black clothing is amazing. It will take ten to thirty pounds off of anyone who wears it, provided you use common sense and pair

Pairing light clothes with lighter settings (and dark clothes with darker settings) helps keep the emphasis on the face. It also makes it easier to disguise common figure problems by letting the body blend in with the background.

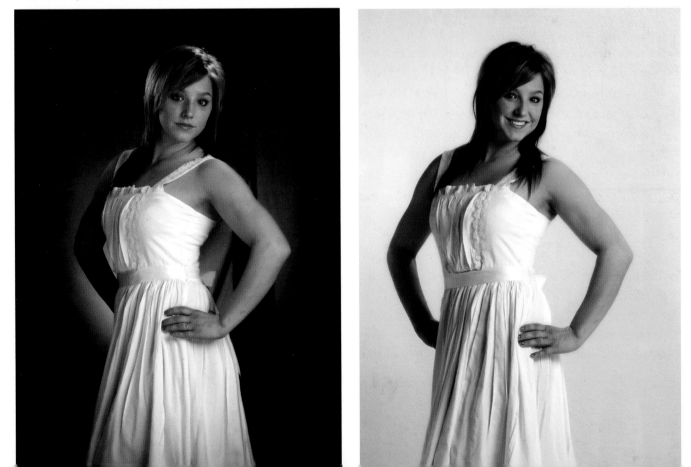

LEFT—*Black is flattering on everyone.* RIGHT—*High heels make the legs look more toned and shapely.*

it with a black or very dark background. If you are photographing a family and Dad has a "beer belly," ask him to wear a black sweater. Unless his stomach is huge, it will appear flat in the final portrait. If Mom has larger hips, put her in a black skirt or dress and she will appear noticeably thinner.

High Heels. Anytime a woman will be in a dress, we ask her to bring in the highest heel she owns to wear with it. If she doesn't have any three-inch heels, she can borrow them from a friend. If the legs are showing, pantyhose should be worn unless the subject has very tan legs with great muscle tone. The nylons will not only make the legs look better by darkening them, but will make them appear firmer and disguise signs of cellulite.

COMMON PROBLEMS

With clothing, the easiest way to know what to do is to know what not to do. If you think in terms of all the problems that clothing can create for your clients and then help them avoid these problems, you will learn how to use your

clients' clothing to make them look their best. Here are some common problems that should be avoided.

Too-Tight or Too-Loose Clothing. We warn clients against wearing jeans or pants that are too tight around the waist. These create a roll where the tight waistband cuts into the stomach. Tight clothing also affects the subject's ability to pose comfortably. I have had some subjects turn beet red because of tight pants as they try to get into a pose. For this reason, we ask all of our clients to bring in a comfortable pair of shorts (or, in the winter, sweatpants), to make it as easy as possible to get into the poses that won't show areas below the waist.

If women have a frequent problem with tight jeans, guys (especially young guys) have the baggies. This cool-looking (so they think) style has the crotch that hangs down to their knees, while at the same time revealing undergarments to the world. Just try to pose a client in a seated position when there are three yards of material stretched out between his legs! Try to have him put his

hands in pants pockets that are hanging so low he can't even reach them.

In general, clothing that is loose-fitting on a person who is thin or athletic will add weight to the person in the portrait, especially if it is loose at the waist or hips. Tight clothing will add weight to those people who are heavier. With tight clothing on a heavy person you can see tummy bulges, cellulite, lines from waistbands, and every other flaw that weight brings to the human body.

Wrong Undergarments. Many women forget to bring in the proper undergarments. They bring light-colored clothing, but only have a black bra and underwear. They bring in a top with no straps or spaghetti straps and they don't have a strapless bra. In this case, they either have to have the straps showing or not wear a bra, which for most women isn't a good idea.

Guys are no better. I can't count the number of times I have had a guy show up with a dark suit and nothing but white socks. Some men (okay, most men) tend to be more sloppy than women, which means that the clothing they bring often looks like it has been stored in a big ball at the bottom of their closet for the last three months. Many show up with clothing that used to fit ten years ago when it was actually in fashion.

COORDINATION AND SEPARATION

Ever since I first started learning photography, I've been told to separate my subject from the background. "Only mall studios or underclass photographers let a person blend into a background!" is what many people will tell you.

To some degree this is true; you won't sell portraits that appear to be two eyes and teeth coming out from a dark background. On the other hand, creating complete separation between the subject and the background is just as wrong—at least when you're trying to correct the flaws that most of our paying clients have.

Instead, you should separate only what you want the viewer to notice, then coordinate everything else—allowing the problem areas blend into the background and disappear from view.

BELOW—Advise your subjects to bring the correct undergarments for each outfit. For example, strapless dresses require strapless bras. RIGHT—When the clothing and background blend tonally, the emphasis is on the subject's face.

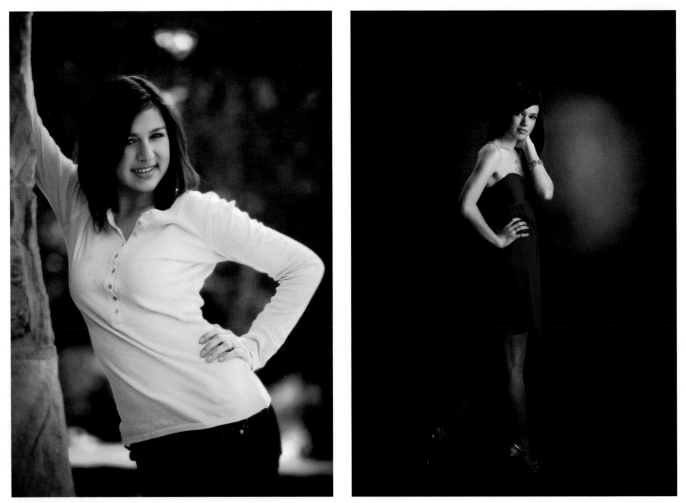

LEFT—*Increasing the contrast between the background and the clothing puts more emphasis on the figure.* **RIGHT**—*Controlling separation lets you keep the viewer's eyes right where you want them.*

Let's consider an example. A young lady comes to you for portraits. She is in perfect shape and wants an image for her husband to show her perfect curves. What do you do? You contrast or separate her entire body to focus attention on every one of those curves she wants her husband to see. If she were in a tight white dress, you would contrast it with a dark background; if she were in black, you would contrast it with white, drawing the viewer's eye right to the dress and the outline of her body.

Your next session also wants a portrait for her husband (it must be close to Valentine's Day!), but this young lady is overweight. While she does have a small waist, her hips and thighs are very large. To create a salable full-length pose for client number two, you will have to separate her very small waist while coordinating the area of the hips and thighs. This would be achieved by having her dress in black (or another darker color), then photographing her against a dark background. You would use a very small back-

ground light at her waist level to separate only the outline of her waist, while allowing the background to fall off to back to black behind her hips and thighs (so the dress and the background blend together). Of course, you would also use separation light to define the hair and probably the shoulders—unless there were any other problems to hide.

The single biggest hurdle in the concept of separation or coordination is the client's clothing. If it's right, amazing corrections are possible. The black sweater or shirt is to the corrective photographer what liposuction is to the plastic surgeon. It's amazing what's possible! You can put an overweight woman (or dear old Dad, who looks like he's nine months along and expecting twins) in a black shirt and pants and create images that will impress them.

TAKING CONTROL

At the heart of this matter, the issue is control. Without control of the session, you cannot control the outcome of

the final portraits, which means you can't control making the sale, which in turn makes it impossible to control not living below the poverty line.

I'll say it again: without control over your session you have no control over your business—and most people leave this profession, one that they dearly love, because their business is out of control. So this is important stuff!

To realize how far outside of the normal business world many photographers are, let's apply the practice of many photographers to another profession. You show up on the morning of your scheduled surgery. They have shaved your head, your wife is crying, and your family and friends have filled the waiting room as the head surgical nurse comes up to you and says, "I bet you're hungry after not eating since last night! No worries—you'll wake up to some great hospital food." (She's a real joker!) You respond, "Oh no, my wife made me a big breakfast this morning. She says it might be my last!" You see your nurse's face become a little tense. She says, "Didn't they tell you not eat before coming in? Those idiots always forget! We are going to have to reschedule your surgery!"

Now, you might be thinking that this is big leap—from a life-and-death surgery to a simple picture—but is it? People take time off work to come to your studio to create an image that, in most cases, will be handed down through the generations. This "simple picture" is what people will go running into a burning home to save. Failing to inform your client properly of what they need to do to prepare for their session is irresponsible—just like the failure to tell the patient not to eat before surgery. This would never happen in medicine, but it happens every day, in every city, in our profession.

To control the clothing your client brings in, simply make a brochure or a few well-designed sheets with images showing what to do (a nice portrait in the proper clothing) and what not to do (a bad choice of clothing and a bad portrait as the result). I guarantee you that if you show your clients a woman with large arms in a sleeveless top and that same woman in a black, long-sleeve blouse or sweater, you won't have to worry about sleeveless tops anymore. Women, when they are shown what to do and are able to see the difference the correct clothing can make in their appearance, will listen to your suggestions.

These photographic illustrations of correct choices and incorrect choices in clothing photos should include: long sleeves *vs.* sleeveless (make sure the lady has very large arms); proper-fitting *vs.* too-tight shirts (showing rolls and bulges); solids *vs.* horizontal stripes; dark clothing *vs.* light clothing; skirts/dresses *vs.* slacks/pants; heels (three-inch or higher) *vs.* flats; and proper-fitting *vs.* too-tight jeans (cutting into waist). I'd also include a series of photos with the client in a black top (coordinating with a darker background and contrasting with a lighter background) and in a white top (coordinating with a white background and contrasting with a black background). You should include every common problem you have seen and had to deal with in your past clients.

This is the first step to controlling your session. You and your clients want the same thing: a beautiful, final portrait that they will happily hand over a big stack of money to own. Once you educate your clients—and quit blaming them—you can start enjoying the process of creating their images.

Without control of the session, you cannot control the outcome of the final portraits—or the sale.

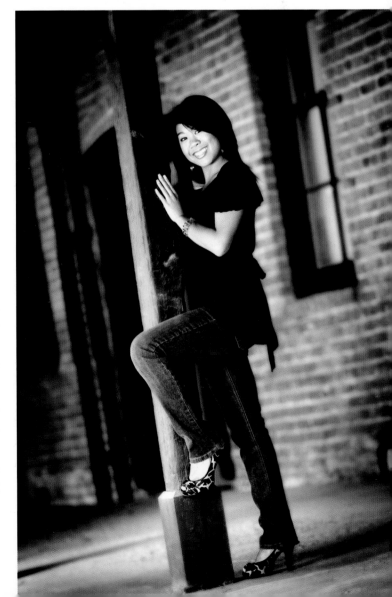

4. CORRECTIVE LIGHTING

KEEP IT SIMPLE

Lighting a portrait is a simple process that photographers have complicated over the years. This has happened for two reasons. First we are gadget freaks. We think, "Why should I use one light when I have three?" Second, most teachers of professional lighting techniques are sponsored by (a nice way of saying their fees are paid by) equipment companies. These companies have all that equipment to sell, so the question becomes, "Why use one light, when we want to sell three and we can charge more for the big one than the little ones?"

This leads many photographers down the path of "crapping up" a simple thing. If I sent most photographers into a white room with one large window, they would be able to take a properly lit image. However, if I gave these same photographers a flash unit with a softbox attached, many of them would look lost. Yet, isn't it the same thing? If you put the softbox where the window was and placed the subject in the same position in relation to it, wouldn't it appear the same?

The second problem of sponsored learning is the "bigger is better" approach to main lights, which is completely

Smaller main light sources give you better control over which areas of your subject are lit and which remain more in shadow.

wrong—at least from the perspective of correcting flaws. These monster sources of main light are the most forgiving to improper placement, but they are the least controllable. It is like the different between a rifle or shotgun, a bow and arrow or a grenade. They all might get the job done, but one is more precise than the other. (Of course, the other is more forgiving if you're a lazy shooter who doesn't like to take the time to aim!)

Huge main light sources illuminate everything on the subject—they ruin the shadowing that we need to conceal our clients' problems. With a four- to six-foot main light source, a subject will be evenly lit from head to toe. It will light her less-than-flat stomach, her large thighs, her "cankles" (ankles that never really slim down, so the calf appears to be connected directly to the foot), and her size twelve extra-wide feet. What a lovely sight.

To have control over your light, the light source must be smaller. You want light only where the client's face and body can handle light being put. Small light sources allow you to place light exactly where you want it (and, therefore, draw the viewer's eyes to the desired areas). If you have a huge light box and really don't want to buy another (or don't have room for a second light box), make or buy a reducer. Simply cut a small hole in the middle of a thick piece of black fabric and you have created a smaller main light source! Some companies like Photo-Flex have reducers available that are custom designed to their light boxes, but the fabric works just as well. (*Note*: Grids/louvers can also be used to narrow the beam of light, but they don't allow you to feather the light [softening it by using the light rays from just the edge of the light box].)

Huge main lights aren't the only way we can overcomplicate our lighting. When I first started in this profession I went to a week-long class and studied with a man who was literally a legend. He showed the class his unique style of lighting and discussed the ratios of lighting he used when photographing. He explained that he used a 3:1 lighting ratio when not diffusing an image and a 4:1 lighting ratio when diffusing. (*Note:* For all you young photographers, this was in the days of film, when fine grain, medium-format film gave us too much detail for the average client's face.)

I came away from this week of learning an enlightened photographer—right up until I started using these lighting ratios in my studio. The models used for the demonstra-

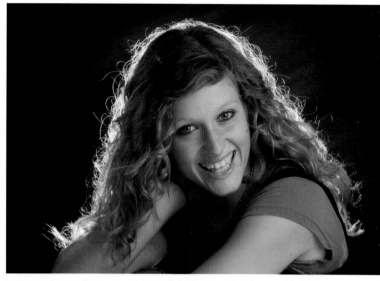

Using reflected fill is one way to simplify your lighting and improve your control.

tions were white with a suntan, but in my studio I worked with many Hispanic and East Indian people that had every shade of skin from olive to chocolate brown. While these lighting ratios worked well for my suntanned clients, the ratio was much too high for someone with darker skin.

Another light went off; "Wouldn't dark skin reflect less light in the shadow areas than light skin? Do you know how many shades of skin there are between suntan white and chocolate brown?" Taking what I had been taught, I would have had to test and come up with a working lighting ratio for every shade of skin and then categories what range of skin tone worked with each lighting ratio. What started off a simple way to understand lighting in a classroom setting turned into a complicated nightmare in the everyday workings of my photography business.

Unfortunately many theories are just like this one—good for the exact context in which they were demonstrated, but not very practical in everyday in business. I needed to find a simpler, more practical way to deal with this issue, and it dawned on me that I didn't need to use flash to fill the shadows. Using flash to fill the shadow, you are always guessing at the amount of fill. With a reflector, the fill is always proportionate to the output of the main light. (You do, however, have to work in a studio area that has subdued lighting, with little or no ambient light from windows or overhead lights.)

Therefore, the first step to un-"crapping up" my lighting was to change from fill flash to filling in the shadows with a reflector. This allows me to fill the shadow on the

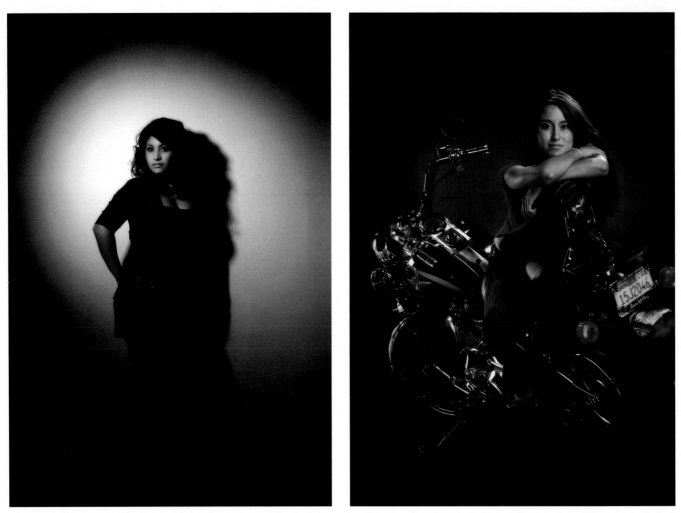

LEFT—*It is shadow that gives a portrait dimension, and it is shadow that lets you disguise your clients' flaws.* **RIGHT**—*Shooting in a dark area ensures that no light is bounced off the walls or items in the room, so I can put light and shadow exactly where I want it and not have it diminished by the surroundings.*

face and leave certain parts of the body unfilled. Reflectors have different surfaces, everything from plain white to highly reflective silver, so you can use the material that gives you the best working distance and look (white will be placed the closest and provide the softest quality of lighting, etc.). The best part of using a reflector to fill the shadow is that what you see is what you get.

SHADOW, NOT LIGHT

Because of our photographic training, we often think that corrective lighting will do the most to hide flaws. Well, it doesn't! In fact, our "training" in how to light a portrait is the biggest problem. When we start to learn about lighting, we learn that light is our "paintbrush." Corrective techniques, however, rely on shadow, not light.

Any student photographer with two lights and a meter can create a decent portrait—just put the main light at a 45-degree angle to the subject and place the other light behind the camera. Set the lights so the main light is two stops brighter than the light behind the camera, stick a diffusion filter on the lens, and there you have it—I have just taught everyone with any knowledge of photography to create a realistic portrait with the appearance of a third dimension. This is the lighting setup mall studios use because it is easy to learn, easy to use and, for most of the buying public, acceptable for a cheap portrait. Unfortunately, this is also the lighting setup that many professional studios use. While clients will accept this type of portrait if they are getting it cheap, they are not going to pay a professional studio's price for something they could get at the mall for much less. Professionals need to deliver more than an "acceptable" portrait. This is where shadow comes in.

It's obvious that not much would exist in an image without light, but it is the darkness that draws the viewer's

eye to the light. It is shadow that gives a portrait dimension, and it is shadow that lets you disguise your clients' flaws—flaws they aren't paying to see (or, perhaps better, flaws they won't pay for if they do see them).

Corrective lighting is about control of light, but even more importantly, it is about control of shadow. In a basic lighting setup like I described earlier, control is impossible. Combine a large main light and a fill light with the white walls of most studios and you have light bouncing around off of everything. The three pitfalls of the average lighting setup are:

1. **Using a main light modifier that is too large and uncontrollable.** Because of our love of light, we reason that bigger is better. In fact, the larger your light source/modifier, the less control you have. If you use umbrellas and want to control your light better, throw them away and buy a small softbox with louvers.

2. **Using fill flash instead of reflector fill.** The fewer lights you can use in your camera room, the more control over the lighting you will have. When you use fill flash, you get fill everywhere and have no control of the shadow formation in specific areas.

3. **Using light-colored camera rooms.** These add to the lack of control in the shadow areas. In corrective lighting, I want light to fall only and precisely where I put it. That can't happen with white or cream-colored walls and floors. These light-colored surfaces themselves become a source of fill light, just like using a white reflector.

You must start thinking in terms of directing the viewer's gaze to the areas where you want it to go (these are the areas you will light) and keeping the viewer's gaze away from the areas you don't want them to see (by leaving those areas in shadow).

At times, you will have to control the light and shadow very carefully, because hiding one problem in shadow will make another problem more noticeable. A good example would be when photographing a young lady with a heavy face. Your first instinct would be to have a portion of her face in shadow to reduce its apparent width. But what if she has a large nose and the shadow on the side of the nose

makes it appear larger? The same is true for the hair, which might be dull and have dark roots showing in blonde hair. To make the hair look shinier, you would light it—but to hide the roots you would need to leave it in shadow. As we will discuss later in this chapter, using smaller lighting sources and pinpoint fill, you can deal with these multiple problems that require two types of lighting.

CAMERA AREA

Although my studio features several camera areas, it's the low-key area where we use corrective lighting. In this area, we've worked to eliminate features that reduce the control you have over your lighting. Thus, the entire area is black—walls, floor, etc. Even the props and furniture are all black, or least very dark. This ensures that no light is bounced off the walls or items in the room, so I can put light and shadow exactly where I want it and not have it diminished by the surroundings.

THE LIGHTS

The Main Light. The main light that we use with corrective lighting is a 24x36-inch softbox with a recessed front panel and louvers. This allows us to put light precisely where it is wanted, without it spilling into areas where it isn't. The size of the box allows us to get a softer light when the box is placed close to the subject, but we can increase the contrast of the light by pulling it back a little.

There are some differences to be aware of when working with smaller light sources that produce light with more contrast. First, you have to watch out for shadows in unwanted places; you can get some harsh shadows on the unlit side of the nose, for example. Second, small light sources can't be feathered like large ones. With large light

CONCEAL THE FLAWS BUT LIGHT FOR THE SUBJECT
Of course, you can't light a subject just to correct flaws. Consider how you'd shoot a portrait of a subject in eyeglasses. This is an excellent example of lighting to correct the flaw (glass glare) rather than to make the client look good. Of the many ways I have seen and tried to eliminate the glare on glasses, I have never seen one that doesn't make the lighting on the subject's face suffer. As a professional, you have to know when to use correction and when to inform your client of his or her responsibilities for the outcome of the session. In this case, empty frames or non-glare lenses are the only way to ensure a pleasing portrait that is taken to make your client look their best.

sources that don't have a recessed front, you can use just the edge of the light to soften the light or cut down on the output. If you try that with a small louvered box, you will have light falloff on the highlight side of the face. The light from this type of box goes precisely where you put it and nowhere else.

The louvers on the main light control the light from side to side. They eliminate light rays from spilling out of the side of the box. To control light from the top and bottom of the box, you must either feather the light or use a gobo to block the light from hitting areas that you want to keep in shadow.

The process of lighting is one that must be tested to be understood. In the beginning, you must test your light an-

For most portraits, the main light will be placed somewhere between the lens axis and 90-degree position.

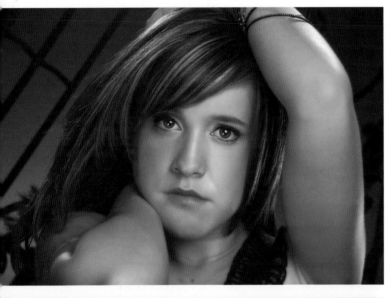

gles and distances to understand the effects these changes have on the effect of the lighting (for more on this, see page 39). This sounds very obvious for some photographers, but many have never taken the time to systematically test their lighting so they know what characteristics each main light will produce at different angles and with varying amounts of fill.

Imagine you are looking through the camera and the subject's nose is pointed right at the lens. If the subject stuck a pencil in his ear (and it could be perfectly straight and the subject didn't mind the pain!) it would be at a 90-degree angle (one fourth of a 360 degree circle). The correct placement of the main light source for the majority of portraiture is somewhere between the camera position and the 90-degree position (where the pencil is pointing out of the subject's ear).

The closer to the camera the main light source is positioned, the less shadowing will appear on the subject's face. For instance, butterfly lighting is created by placing one light above the camera and a reflector or light below the camera. This is the ultimate in portrait lighting without shadowing—or at least shadowing that would hide flaws. At the other extreme, placing the main light at the 90-degree position will create the most shadowing on the face and body, hiding the most flaws.

Where you place the light will be determined by the size and type of light modifier you use, which is why you must test your light. If you use a medium-sized light box, you will be able to work with it closer to the 90-degree position than if you used a smaller light box. This is because the medium light box will produce softer light. Taking this one step further, if you put louvers or a grid on the same small light box, the lighting effect will be even harder, making it necessary to place it closer to the camera position to have shadows that can be filled without a secondary light source. The height of the light is easier to determine: raise your chosen light to a point that is obviously too high, then slowly lower the light until the eyes are properly lit.

When I was first learning lighting, it would take me forever to decide on the correct lighting position. I would have to build up my lighting, start off in a pitch black studio, then place my main light source, then my fill, then my lower reflector, then my hair light, and finally the accent lights to draw the eye to only those parts of the subject I wanted to the viewer to see. (However, while some of my

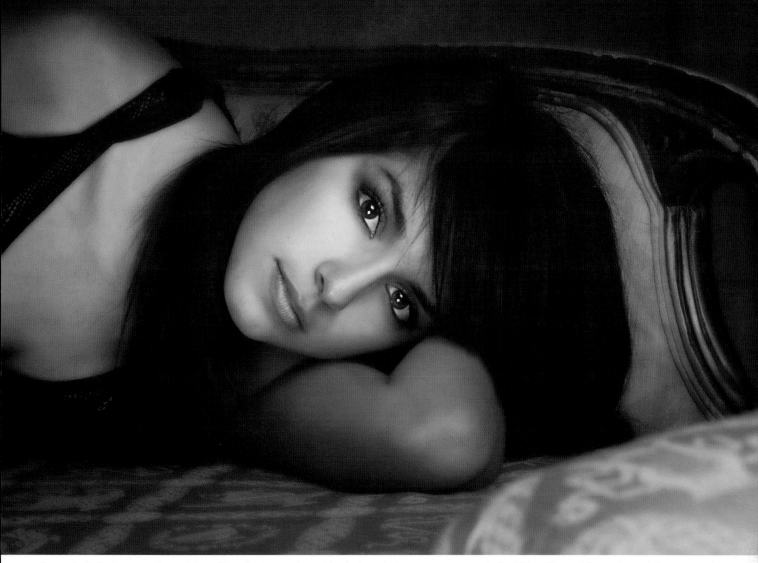

The main light is correctly positioned in relation to the subject when their eyes are correctly lit. This will vary depending on the pose.

clients became impatient in those early days, they never complained once they saw the outcome!)

Unfortunately, the more experience you have with lighting, the harder this process will be for you. Photographers become so used to using the shotgun approach to lighting that we often get lazy. Large light sources are very forgiving of misplacement, and many photographers count on that to get through the day. Corrective lighting uses precise lighting to illuminate only what you want the viewer to see and requires more attention to lighting placement.

The Fill Light. To add fill light only where it is wanted, we use a reflector. For any of you fans of using a flash to fill the shadow, you are about to be offended. I (like all young photographers) was taught that you use a flash to fill the shadow. You put this enormous light source at the back wall of the camera room, and it literally fills your entire camera room to a certain level of light. I was then in-

structed, as most of you were, that to avoid flat lighting you would use a ratio between the main light and fill light of 3:1 without diffusion and 4:1 with diffusion.

I worked with this for quite some time. It wasn't until a young African-American woman came into my studio and talked with me about doing her portraits that I saw a problem. She asked me if I had ever photographed an African-American person before. I thought for a minute and realized that I never had. She explained that she had had her portraits taken several times, at several places, and they just didn't look right. She said they had very heavy shadows. When she said this, I suddenly realized how limiting the use of fill flash was. My first thought was, "Wait a minute, I use a 3:1 or 4:1 ratio, but that is for a light skin tone. What ratio do I use for all the other shades of skin?"

Well, I did the session, but I did it with a reflector for fill, so I could see on her face, with her skin tone and facial

CHOOSE THE RIGHT LIGHT FOR THE JOB

While I do advocate simple lighting strategies, I think that photographers too often try to use one light box to achieve every type of lighting they offer—but they shouldn't.

Imagine you have two clients who both want a full-length portrait. One woman is a personal trainer, has the perfect physique, and wants to show off her curves in a photo to advertise her services. The other is an overweight, out-of-shape housewife. She has been told by her husband she has the world's most beautiful legs; however three children and a diet of fast food have left her midsection somewhat unsightly. What would you choose for your main light source for each woman?

Because both women want a portrait composed from head to toe, many photographers would grab a 4x6-foot light box to evenly illuminate each woman from head to toe. However, the housewife wants to focus on her legs and would rather she or her husband not see (or at least notice) the area from below her breasts to the area where her dress starts showing off her legs. Therefore, a better idea would be to light her portrait as a head-and-shoulders image, using a small main-light source to illuminate only the area from her bust to the top of her head. Then, use accent lights (with barn doors to control the beam of light) in a lower position on both sides of her to accent just her legs. Pair that up with a dark dress and darker background. For separation, use two background lights—one placed high (to separate just her shoulders and head) and one placed low (to separate just her legs and feet).

In a portrait like this, the viewer will focus on just the face and the legs—and never notice the area that she's uncomfortable with. This is the idea of corrective lighting; it is about control and leading the eye only where you want it to go.

structure, how much shadow or fill I wanted. She loved the portraits, and I learned a major lesson. You can know what the ratio of lighting is by metering, but when you use a flash fill you will never know what the "perfect" ratio of light is for each individual's skin tone and facial structure.

In this country we have such a variety of people, with different shades of skin, different facial structures, and (need I point out?) different problems and flaws to hide. The only way to evaluate the right amount of fill is to see it with your own eyes.

If you don't believe that skin tone makes a difference, photograph three people with the exact same light on them and the background. Select one person who is very fair, one with an olive complexion or a great suntan, and one person with a very dark complexion. You will quickly see the difference in the backgrounds. Because of the way the different skin tones are printed, the very fair person will have a very dark background, the olive-skinned or suntanned person will have a background that is normal, and the person with the dark complexion will have a very bright background.

The Separation Light. Accent and/or separation lights become more important with this kind of lighting. Because we use darkness/shadow to our clients' benefit, we must use small, controllable light sources to highlight only the areas you want the viewer to see. As discussed on in the sidebar to the left ("Choose the Right Light for the Job"), we often light a three-quarter- or full-length portrait as a head-and-shoulders portrait (with our main light and reflector for fill), then use accent/separation lights to selectively illuminate the rest of the body. This gives us, as photographers, complete control over the outcome of the final image—and gives our clients a final portrait their egos can handle.

In almost all portraits, we use a small strip light overhead as a hair light. Since this light is aimed back toward the camera, it meters one stop less than the main light and yet provides a soft highlight on the top of the subject's hair and shoulders.

For clients with long hair, we use two lights behind the subject. Each is placed at a 45-degree angle to the subject. These lights are set to meter at the same reading as the main light for blond hair or lighter clothing, or to one stop more than the main light reading for black hair and clothing. These accent lights are also fitted with barndoors to keep the light from hitting any area of the subject we don't want to illuminate.

The idea is that you don't want to see a perfect outline of the body in a problem area. For very heavy people, you don't want to see an outline of the body at all. With the background light low and the subject standing in dark clothes against a dark background, you separate the hips and thighs (the same hips and thighs you know your client will worry about looking large). Raising the background light to waist height will separate the waistline and chest,

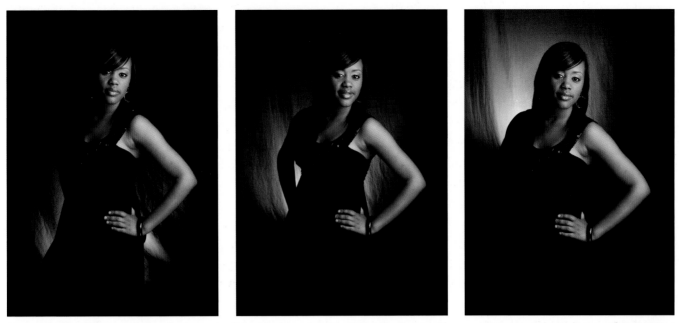

Use separation light to accent only the parts of the client you want to draw attention to. Three variations are shown here, with separation light on the lower body (left), upper body (center), and head and shoulders (right).

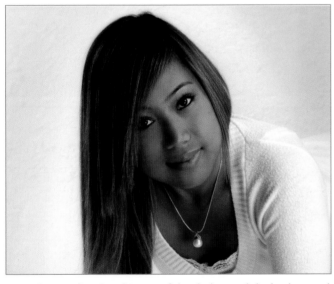

LEFT—By coordinating the tone of the clothes and the background, you can bring the focus of the portrait away from the person's body and to his or her face. RIGHT—When the client's clothes contrast with the background, it calls attention to the shape of the body.

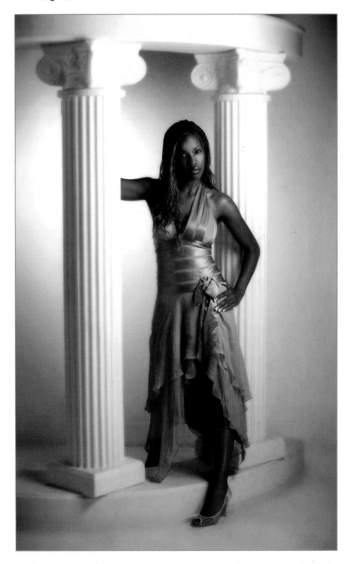

making them more noticeable. Elevate the separation light to the height of the shoulders, and only the head and shoulders will be separated, leaving the body to blend with the background.

The greater the intensity of the background light, the more attention it draws to whatever part of the body it is separating—unless the subject is wearing lighter-colored clothing. Often a client will select a dark background and want to wear lighter-colored clothing with it. In this situ-

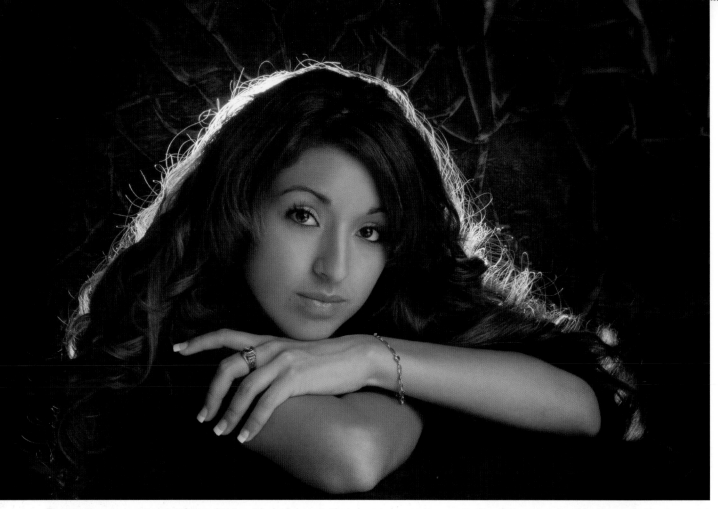

The number-one complaint from clients with dark hair is that, in many previous portraits, they seemed to blend into the background. Adding accent lights angled back toward the camera eliminates this problem by creating a rim of highlights around the hair.

ation, by increasing the background light to match the brighter tone of the outfit, you will actually lessen the attention drawn to this area. By coordinating the tone of the clothes and the background (whether dark on dark or light on light), you can bring the focus of the portrait away from the person's body and to his or her face. If, on the other hand, you create contrast between the clothing and background, you will attract attention to the subject's body.

Whenever weight is an issue and the subject has long hair, we leave the background as dark as possible and put a light directly behind the subject, facing toward the camera, to give the hair an intense rim light all around the edges. This draws the attention directly to the facial area and keeps the viewer's eye away from the shoulders, arms, and upper body.

POSITIONING THE LIGHTS

The angle of the main light is always determined by the orientation of the subject's nose. With the subject's nose pointed directly at the camera, the main light should be at approximately a 45-degree angle to the camera. To add shadow or bring out more facial structure, you may increase the angle of the light, but this is the angle at which most portraits will be taken. The great thing is that the light always stays at approximately a 45-degree angle to where the nose is pointing—even when you go to a profile.

Once the main light is in position, you have to decide how much of the shadow area needs to be filled. With a reflector as fill, what you see is what you get. Start with no fill at all. If the portrait looks great, don't add any fill. Somewhere along the line, you were probably told (like I was) that you have to see some detail in the shadow area. Wrong! If a shadow that goes black is what makes your subject look his best, then that is the perfect lighting to use on that individual client.

Most of the time, however, some fill is necessary to bring the shadows to a printable level. Start with the reflector far away from the subject, then move it progressively closer until you get the effect you want. Whether you use a white or soft-silver reflector will ultimately depend

on what you have on hand. I use a soft-silver one and pull it out farther than I would have to with a white reflector.

With the main light and fill reflector in place, separating the subject from the background becomes the next step. Again, there are no rules. You have one objective, and that is to make your client look as good as possible. Remember, no background or separation from the background means no point of reference behind the subject. No point of reference behind or in front of your subject means no depth in the portrait.

We begin with the hair. For this, a strip light attached to the ceiling gives a soft separation to the hair and shoulders when the light is metered at one stop less than the main light. To finish the separation, we add a light aimed directly toward the hair behind the subject. This creates an intense rim light all the way around the hair. This type of portrait is simple, but vary salable, for it gives any client a version of reality they can live with.

TESTING THE LIGHTING

To test your lighting, start with a fair-skinned person wearing a medium-tone top (for this important, read on). Put a posing stool in its normal spot for your studio area, then eliminate all other light sources. Place your main light at 90-degree angle to the subject at what you consider a comfortable working distance. Adjust the height of the main light as we have already discussed. With the subject's nose pointing at the camera, take a photo. Then move the light one foot closer to the camera position (at the same distance from the subject). Repeat this process at least until you pass the 45 degree angle on your way to the camera position. Each time you place the main light, put a piece of tape on the floor under the light stand—because you will being going through the same sequence several times.

Now repeat the process—only this time, point the subject's nose about two feet to the main light side of the camera (at the same height as the lens). This not only stretches

Once the lighting on your subject is optimized, you can concern yourself with lighting the background.

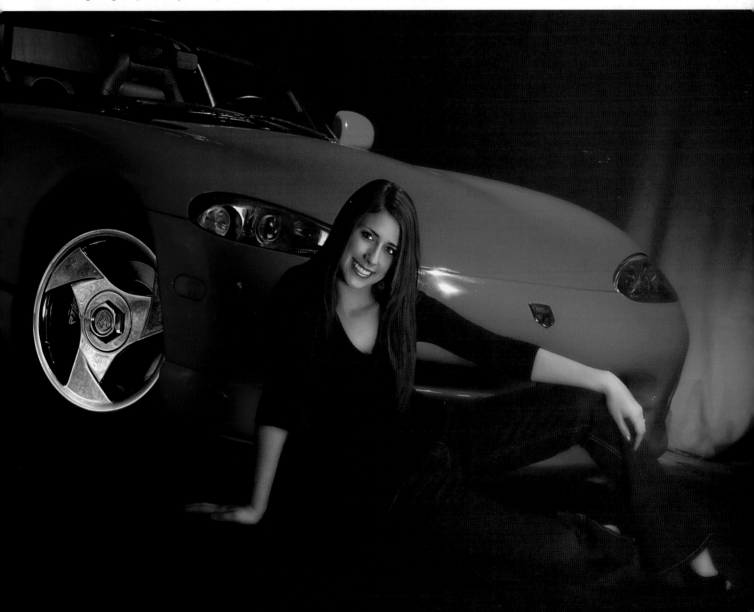

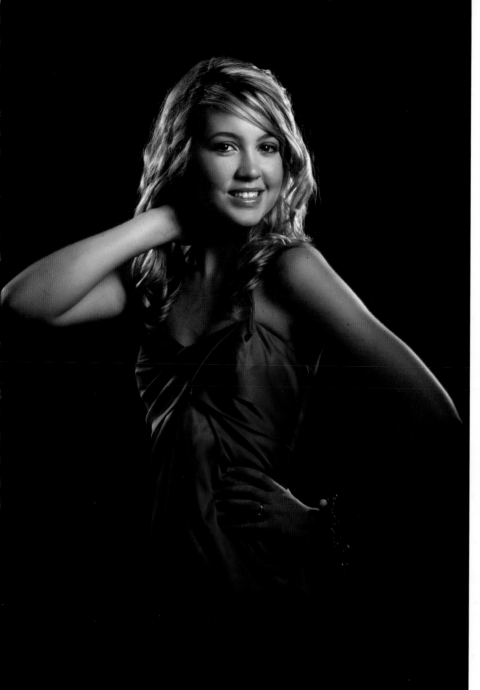

In low-key setups, corrective lighting relies on falloff. You'll light the portrait as a head-and-shoulders image, then allow the rest of the subject's body to fall into shadow.

out the loose skin under the neck but reduces the effect of the shadowing on the side of the face—and, more importantly, the nose. Run through the same series of photos, moving the main light one foot at a time.

For the third series, introduce a reflector for fill. If you use white, start of with the reflector one foot away from the subject; if you use silver, start with it two feet away from the subject—and mark the floor at this position.

With the reflector in place, repeat the first test series with the subject's nose pointing at the camera, moving the main light to each one-foot mark. Then, repeat the series two test with the nose pointed two feet to the main light side of the camera position. At this point, you can guess the next step is to pull your reflector farther from the subject. If it was at one foot, make it two feet; if it was at two feet, make it three feet. Then, repeat both series again.

Once you complete these tests you are exactly one third of the way done! This is because skin tone also affects your lighting ratio. Portrait photographers sometimes question me about the effects of skin tone and clothing on lighting. If these photographers ever shot an event like a prom, where lighting is set the same for the entire event, they would have their answer! A white dress, on a fair-skinned person, will change the print setting significantly—as will a black tux on a dark-skinned person. Lighting ratios must be set lower if you want to ensure that people with darker complexions will not have excessively dark shadowing.

So, you will now repeat these tests using a model with a dark suntan or an olive complexion. Remember to have them wear a medium-tone top. To conclude your testing, the third and final test is with a darker-skinned person— again in medium-tone clothing.

Once you have run this final sequence of test shots, print out the images through the print device you will be using for your clients—with the same changes in contrast and tone as you would for your clients, but without re-touching or enhance anything in the portraits. Our goal is to create beautiful work in the camera—after all, that is what a photographer does.

Study the images. See which ones you like and which you don't—and make notes on the print as to what the problems were. After all this testing, you are ready to photograph those three people you have just run the tests on. However, you will find that, in addition to a different skin tone, each person has a unique facial structure and body type that will need to be addressed in your lighting. The test, however, gives you a foundation on which to base your choices as you address the unique look of each client.

Some photographers might regard this as a paint-by-numbers approach to lighting, but you have to have a foundation. Without a solid understanding of the characteristics of the lights you use, you cannot predict the outcome of the portraits you will take with them.

This is why so many photographers leave every light and stand in the same place—and if they go to a location, they revisit the same spots over and over again. Through trial and error, and a little luck, they have produced salable portraits with that particular lighting or in that particular spot—even if they really don't know the reason why. It works and that's all that matters. Once you understand how to control the direction, quality, and intensity of the light, you can be put into any situation and produce beautiful, salable images.

LIGHTING THE FULL-LENGTH POSE

Since senior portraits became a hot topic in the early 1980s, lecturers, authors, and educators have hailed the offering of full-length portraits as one of the best ways to set your studio apart from the contracted studios. I feel that the full- or three-quarter-length pose has been oversimplified and its importance overstated. Once again, I have never seen one of those photographers/lecturers stroll out with a model who is five-feet tall with a tummy bulge and short legs. Therefore, the first rule of full- or three-quarter-length poses is that if there is any reason not to do them, then don't. (Laziness doesn't qualify as a valid reason not to do a full-length pose, however.) Using corrective lighting, selecting the proper background, and making good clothing choices can do a lot to enhance a person's appearance, but if the subject has significant problems (significant weight issues, large scars from burns, etc.) no amount of enhancements can produce a salable portrait in a full-length pose.

Low-Key Setups. Corrective lighting for a full- or three-quarter-length pose relies heavily on using the main light's falloff to produce a vignette, thereby throwing certain problem areas into complete darkness and not allowing the camera to record them.

The second lighting tool for correction is one we have already discussed: separation. By selecting only the areas of

the body you wish to separate from the background, you determine which areas of the body the viewer's eye will be drawn to.

A 24x36-inch louvered softbox may not be the first main-light choice for the classic full-length portrait, but it is perfect for beautifully lighting the facial area and letting the rest of the subject fall completely into shadow. With this accomplished, you can proceed to add separation to the areas of the subject you feel should be seen in the portrait. This is no different for thinning a waistline than for concealing a balding head. You only separate the subject in an area that the client would want to see.

High-Key Setups. When you move to high key, lighting can do very little. In high-key portraiture, correction relies on the clothing selection, set, and pose. For this type of image, we use large light sources, then employ the other elements of the scene to hide the client's flaws. Often,

something as simple as a good pose and a client's long hair can be enough to make the subject happy with the way she looks.

While very popular, high-key images are best avoided by anyone with a weight problem. With the softer, less contrasty look, faces appear heavier and bodies wider. We have even had many thin clients notice the difference between how wide their faces look on the high-key backgrounds as opposed to the low-key setup.

GRID SPOTS

In high-school senior photography, the use of spotlights has been popular for many years, especially for portraits in black & white. The hard, contrasty lighting produces a very theatrical feeling. Spotlights also have the ability to focus the viewer's eye precisely where you want it to go. When used as a main light, the beam of the spot leads the

In high-key portraiture, correction relies on the clothing selection, set, and pose.

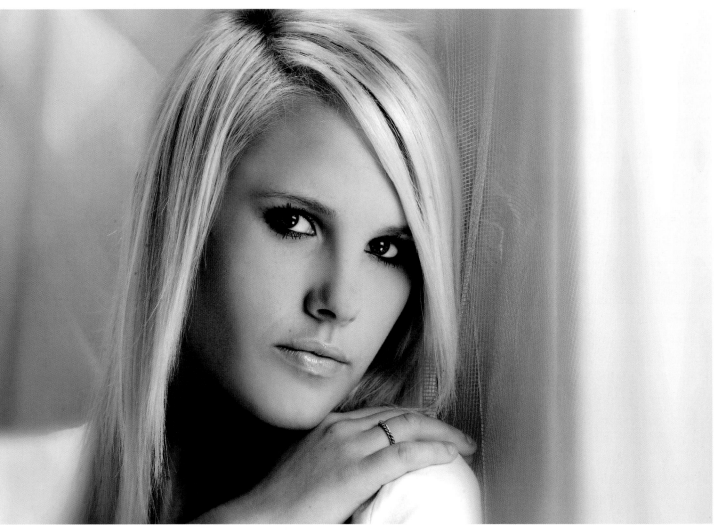

Often, we simply use a single grid spot as the entire lighting for the portrait. A very popular idea for seniors is to set the subject up against a white wall and let the heavy shadow of the subject projected on the wall provide a dramatic background.

eye to the facial area, while letting the rest of the body fall into shadow.

Often, we simply use a single grid spot as the entire lighting for the portrait. A very popular idea for seniors is to set the subject up against a white wall and let the heavy shadow of the subject projected on the wall provide a dramatic background. Watch out for the creation of deep shadows on the face when doing this. While dark shadows look good in the background, heavy shadows on the face can be quite unsightly. The easiest way to handle this is to turn the face more into the spotlight and work with the spot at no more than a 45-degree angle from the camera. Using the spot in this way gives you the greatest contrast and the most options for hiding flaws.

We also use grids as accent lights, working with the main light to draw attention to the face. Simply put the sphere of light on the facial area after your normal lighting is in place. The spot should be set one-half to one stop more than the main light, depending on how noticeable

you want the light from the spot to appear. This little bit of light helps smooth the complexion, but more important is the effect it has on the color of the eyes. If you can see any color around the pupil, this accent light makes it much more vibrant. Anytime I see someone come in who has colored contacts or color around the pupils of their eyes, I do at least one of their poses with this accent light.

DON'T CREATE NEW FLAWS
BY CORRECTING EXISTING ONES

When considering how to light a portrait to correct flaws, you have to remember that by correcting one flaw, you can actually make another flaw more apparent. A good example would be a person with a wide face and a very large nose. You can thin the face by increasing the contrast of the lighting and creating a larger shadow area—but if you are not careful, this will also create more shadows on the side of the nose, drawing more attention to its size. The same thing can happen with a person with bad skin. The more contrasty the light, the more the skin's imperfections will become visible (of course, this can be eliminated after the shoot in retouching).

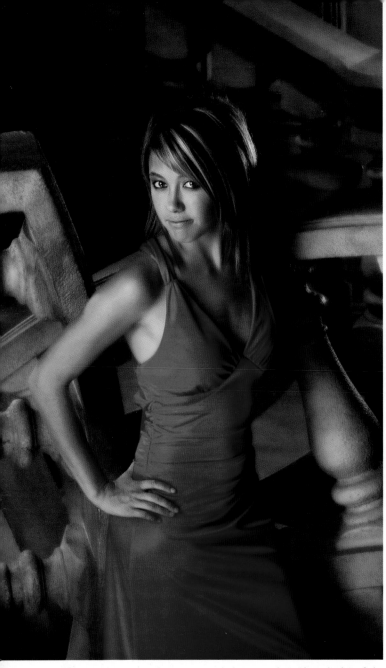

The aperture you choose controls how much (or how little) of the background will be in focus.

No matter how you use grid spots, they allow you to offer your client different styles of lighting and portraiture. A photographer who can only offer his clients one style of lighting and one style of portraiture can only appeal to one type of client with one type of taste.

MAGIC SETTINGS?

A while ago, I received an e-mail from a photographer who asked my favorite question about lighting: "What f-stop was that photograph shot at?" He went on to explain that, in the competitive business we are in, he could understand why I wouldn't want to share such information in my

books. I guess he wanted to know what my "magic setting" was. To be clear, I'm not making fun of him; when I was a young photographer, I thought the same way. I thought that the beauty in a professional portrait came from some magic f-stop or some light attachment that had fairy dust sprinkled on it to make my portraits "magically delicious," too!

In just a minute I will reveal the "magic" f-stop (or as close an answer as there is to that question), but first I will explain a few things.

The f-stop is selected to affect two things in a portrait. The primary creative control the f-stop has is over the depth of field, which determines how soft the foreground and background appear. This will change depending on many factors (meaning, there's no one "magic" setting). Is the background too busy and in need of softening? Or is it very soft and in need of more detail? If the background were busy to the eye and needed to be softened to avoid distracting from the subject, I personally would open up the lens. If the background were already soft, I would stop down the lens to make sure the background didn't turn into a wash of color with no interest.

The second function of the f-stop is to ensure a proper exposure. Inside the studio, or when working with ambient light outdoors, this is a simple process: you set the shutter speed you want to work at and your light meter will tell you the f/stop to start at. I use the phrase "to start at" because you will often find you need to adjust this setting when the first test image is captured and you look at the histogram.

The two final tidbits of information about f-stops are these. First, when you are working with flash outdoors, the f-stop gives you control over the ambient light in relationship to the light from your flash. This allows you to determine how dark or light a background will appear in relationship to the subject. Second, especially as I get older, if I am manually focusing, I will stop down a bit to increase the chances of having the subject in sharp focus.

Now, at long last, we come to the "magic settings." Most of my studio images are shot at f/8 at $\frac{1}{60}$ second—unless I purposely want to achieve a much different look. If I want to soften a background, I might open up to f/4. If I want more depth of field, I might go to f/16. Naturally, in each of these cases, the power output on my lighting would also be adjusted to give me the correct exposure.

(This is another benefit of using reflected fill—as you adjust the power of your main light source, the reflector remains at the same distance.) This works well for me, and I doubt if you could see much difference between studio portraits shot at f/11 and f/5.6.

Outdoors, everything is shot wide open using a 70–200mm f/2.8 zoom lens. I want the background to be soft—and I want the edges to be even softer than the middle of the frame. I select my shutter speed setting based on the light. Since I am typically working with an ISO of 400, this puts the shutter speed around $\frac{1}{500}$ to $\frac{1}{1000}$ second. (And while I'm revealing secrets: I shoot almost everything, in the studio and outdoors, with the 70–200mm f/2.8 lens. I use an extreme wide-angle and fish-eye on oc-

casion for a different look. The camera I use is the Canon 5D—unless, of course, you read this book two years after I have written it, in which case I will be using the next generation of Canon cameras. I use AlienBees lights, which are very affordable and well made. Finally, my favorite modifier for corrective lighting is a 12x15-inch light box with a grid for lighting just the face, even in a full-length pose. There—all the secrets are out!)

Our understanding of light evolves, as does the style of lighting we use. Just remember one thing: the smaller the light source, the more control you have—and the more you must practice using it to get quality results. The larger the light source, the less control you have, and the more of your subject you illuminate.

For soft backgrounds outdoors, I shoot everything wide open using a 70–200mm f/2.8 zoom lens.

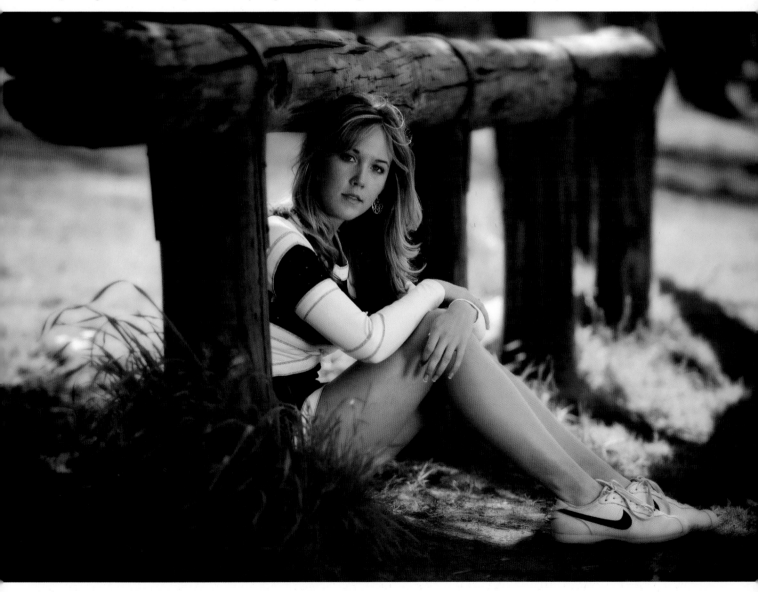

5. CORRECTIVE POSING

Personally, I think posing is the most fascinating part of what we do. If you put a person in front of a window, you can move their arm or their leg—or do something as simple as turn their head—and completely change their appearance. With light as a constant, posing the various parts of the body can be the difference between a happy client and one who walks out of your studio without buying.

The pose can make even the most basic type of portrait come alive. Other than the expression, nothing will sell more than the pose. Posing can also do more to hide clients' flaws than any other technique—and probably as much as all of the others combined. Posing alone can hide almost every flaw that the human body can have. For every person, in every outfit, there is a pose that can make them look great. You just have to find it.

THE PURPOSE OF THE PORTRAIT

Your first consideration in posing is the purpose of the portrait, not just making the client look good. Too often, a photographer creates beautiful images that the client never

A pose like this makes for a striking image—but if this were my daughter, I might get a little creeped-out looking at it (and receive some strange looks if colleagues saw the portrait on my desk).

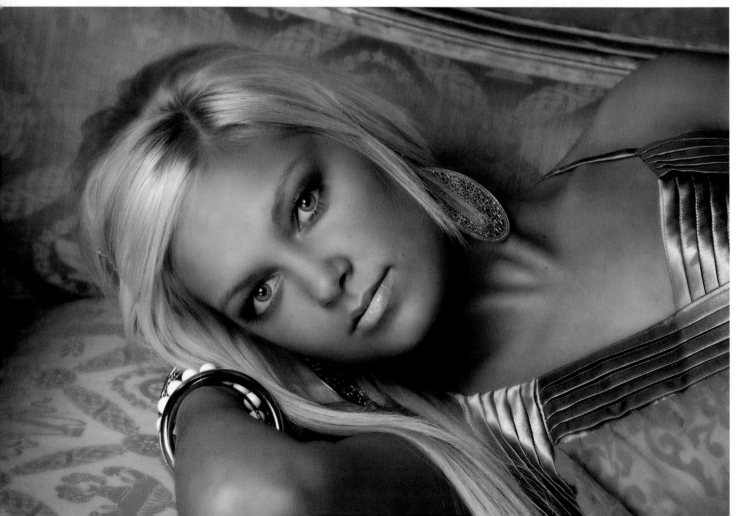

buys—and the photographer never understands why. Usually, it is because the portrait that was created didn't match the client's purpose for having the portrait taken.

I have children, and when I see a photo of them I want to see them the way I see them everyday—relaxed and looking like they are enjoying life. I also have a wife. When I see her, I want to see the beautiful woman that God has given me to share my life. I am a business owner and author, and when I see photos of myself in this light, I want see a traditional portrait taken to fit a specific purpose. If you mix up any of these portraits and give them to the wrong person it doesn't work. I don't think my children want an alluring picture of their mother any more than they want a photo of me looking like a sober judge.

In the same vein, many senior portrait photographers struggle with the fact that educators and books present very sexy, fashion-oriented portraits of seniors. Photographers love these, but they don't sell well to the client—because most people want senior portraits to send out to family and close adult friends. Parents don't want to send out a portrait in which their teen daughter looks "sexy." However you can incorporate a fashion edge in less alluring portraits that will actually sell.

This is the difference between thinking like a photographer and businessperson: a businessperson knows that pretty pictures don't pay the bills, pictures that fulfill the purposes of the client do. Here is an interesting fact: You can take a somewhat crappy portrait that has so-so lighting and isn't posed or composed very well, but if it fulfills the purpose of the client, in all likelihood they will buy that somewhat crappy picture.

Conversely, if your portrait doesn't fulfill the purpose your client had in mind, even if it is an award-winner, they will walk out without buying the portrait that helped put a ribbon around your neck. While I don't advocate taking so-so portraits, I think photographers could live a whole lot better if they would just think of each client's wishes when they create portraits—and make creative decisions based on the client's wants and not their own.

CHOOSE THE RIGHT STYLE

Once you know the reason the portrait is being taken and to whom it will be given, you can design a portrait to fit that need. This is the first step in designing a portrait. The clothing, pose, lighting, expression, and set/location/

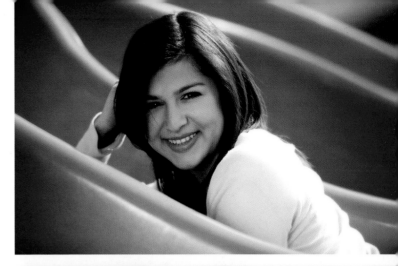

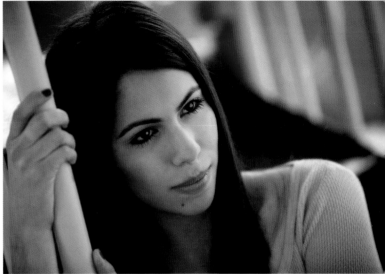

To be salable, portraits must sometimes please two different people. In the case of senior portraits, this means pleasing the senior and their parent.

background should all be selected to produce that style of portrait, for that buyer.

Keep in mind, however, that in some cases you may need to balance the demands and tastes of multiple people. In senior portrait photography, for example, we have two buyers. This means that two different styles of portraits are required. The senior is the first buyer, and she will want to look cool for her friends. The second buyer is the parent, who will want a portrait that makes her little girl look like the young lady she sees when she looks at her daughter. If you don't consider both buyers, and the end use of each set of portraits, you will lose half your business—or never get the senior through the door in the first place.

Once you understand the purpose of the portrait, you need to select a posing style that will be appropriate for the final portrait. Basically there are three posing styles to work with: traditional posing, casual (or "slice of life") posing,

Traditional posing is used for business and yearbook portraits, as well as for photographing people of power or distinction.

A casual pose shows the subject as they might look when relaxing.

A glamorous pose makes the subject look as attractive as possible—the way they would want to look for their significant other.

and glamorous posing. Within a single person's session you may use a variety of posing styles. This is a business decision you must make. But to learn posing you need to be able to distinguish between the various types of posing and know what type of situation each is suited for. (*Note:* Because there's so much to cover in this book, my description of these posing styles must be brief. If you'd like more detail, please check out my book *Posing for Portrait Photography: A Head-to-Toe Guide,* also from Amherst Media.)

Traditional Posing. Traditional posing is used for business and yearbook portraits, as well as for photographing people of power or distinction. This style of posing reflects power, and to some degree wealth, respect, and a classic elegance. Whether these portraits are taken in a head-and-shoulders or full-length style, the posing is largely linear, with only slight changes in the angles of the body. Whether sitting or standing, the spine of the body stays fairly straight and the shoulders stay fairly square. The back is straight and the chest is up (unless photographing a woman with a large bust).

Casual Posing. Casual poses show the person you are photographing as they really are. Watching people as they relax, read a book, watch TV, or have a picnic at a park will

give you some of the best posing ideas you can find. Notice the way people lay, lean or rest their bodies, legs, arms, and even faces. See how people use one part of the body to support another. They will bring up their knees to support their arms and bring up their hands to support their heads. Casual poses are used when the portrait is to be given to a loved one, like a sibling or parent.

Glamorous Posing. Glamorous poses make the person look alluring—the way they wish they looked all the time. Ideas for these poses can be found in sources from fashion magazines to lingerie catalogs. If you want to add to your glamour posing style, look at a Victoria's Secret catalog.

Your clients may have more clothing on, but the structure of the posing will be the same.

The purpose of defining each type of pose, as well as determining the reason the portrait is being taken, is to have a direction for the session. This is the point at which a photographer's own style and experience take over. For example, many of my traditional poses are much more glamorous in their look than what the average photographer would consider traditional. This is because, as human beings, I think we all want to appear attractive.

If you don't have a great deal of time to spend with your client before a session, ask them to tear out images from magazines or catalogs that show what they have in mind for their portraits. This is a great way to get new posing ideas that are handpicked by your target market. (I keep all these tear sheets for my next test session.)

BASIC PRINCIPLES

Less is More. The less you show of a person, the fewer flaws you have to correct. I can create a beautiful and salable portrait of a woman who is a hundred pounds overweight, provided I compose it as a waist-up image. With the right clothing, the correct lighting, and a cool pose to help hide the signs of weight gain, it will be beautiful. If this client wanted me to create a full-length image of her, however, it would be much harder. It could be done, but beyond a certain weight, it is extremely difficult to provide the client with full-length images her ego will accept.

The idea of "less is more" isn't just for minimizing the flaws that the average paying client has. Some of the most requested poses for *all* clients, at least as of this writing, are the extreme close-ups. In fact, head-and-shoulders poses make up 75 percent of the portraits that people *actually purchase*. While photographers have always thought that full-length poses should be included in a session for variety, there are clearly times when they shouldn't be—and from a business standpoint, spending time on portraits that are *less* likely to sell doesn't make sense.

Stand, Don't Sit. When weight is a concern, which it will be for about 75 percent of your clients, standing is often better than sitting. When someone sits, the legs push up the stomach, the stomach pushes up the chest, the chest hides the neck, and before you know it you have a lady with her head sitting on top of two large breasts. When you stand that same person, gravity works in your favor and pulls the weight downward, away from the face.

Camera Angle. When photographing larger people, elevate your camera angle so you are shooting down toward your client. With the client posed normally, simply raising their face up toward the elevated camera stretches and smooths the skin of the neck and face. This is very effective—and it's all the rage right now even for subjects with average builds.

This technique works on portraits from head-and-shoulders to full-length. With the camera in an elevated position (yes, you will need to stand on a ladder), the body

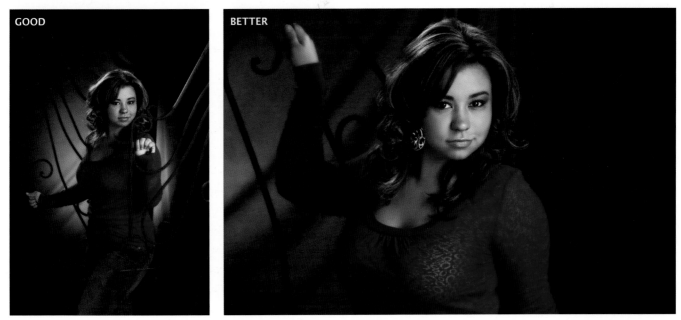

Tighter shots make up 75 percent of what people actually buy—and, for most subjects, they are the most flattering type of images.

can be included in the shot—but its size will be minimized because it is partially obscured by the face and shoulders.

Avoid Mushrooming. When the subject's body touches or rests on a surface, it should only rest on bone. If you have a client sit down, the butt and thighs are going to mushroom out, adding weight and inches to them in their portraits. If, on the other hand, you have the client roll to the side and shift their weight onto one hip (where there is a bone) the hips will look thinner and the bottom will be hidden from view.

The same is true for resting an arm on a column or tree branch. The average client will rest their forearm on the surface, making it mushroom out and appear larger. Instead, have them shift their weight to the elbow and slightly raise their forearm off the posing surface.

If a pose has a client sitting squarely on their bottom, lift their knees up. Bringing one foot or both closer to the camera keeps the pressure points on the two hip bones, lifting the thighs so they do not mushroom out.

Turn the Body Away from the Main Light. No matter what style of posing you are using, start with the body facing away from the main light. This is the thinnest view of the body and creates shadowing in which we can hide flaws. Then, turn the face back toward the main light to properly light it and stretch out the loose skin that most clients have under the chin (for more on this, read on to the next section).

ADAPTING A POSE TO HIDE A FLAW

We have already looked at the typical flaws that both men and women have. Now, you need to adapt your poses to cover, disguise, or cast a shadow on the areas of the body and face that are problems. Many of the more relaxed poses that you will find already hide some of the most annoying problems that your clients have.

Double Chin. The chin—or, in most people, the double chin—and neck area is one of the first areas where weight gain becomes obvious, so it's one of the areas that people are self-conscious about. There are a number of ways to slim or disguise this problem area.

Knowing that a lot of my clients will worry about this area, most of my poses have the client with their body facing one direct and the face turning the other. This stretching, whether sideways or upward (if the camera is elevated), minimizes the appearance of the double chin and tightens up the skin on the neck. This is especially important for your older clients.

For some clients, however, this isn't enough to reduce the visible signs of weight gain in this area. In a case like this, you do what some photographers call the "turkey neck." To do this, have the subject extend their chin directly toward the camera, which stretches out the double chin. Then have them bring down their face to the proper angle. (Raise the camera height and you can increase the effect.) Most of the time, this eliminates the double chin from view. It is especially helpful when photographing a man who is wearing a shirt and tie. Men who have large double chins often also have tight collars, which push up the double chin and make it even more noticeable.

Minimize the appearance of a double chin (top) by having the client stretch their chin forward (bottom) to stretch out the skin.

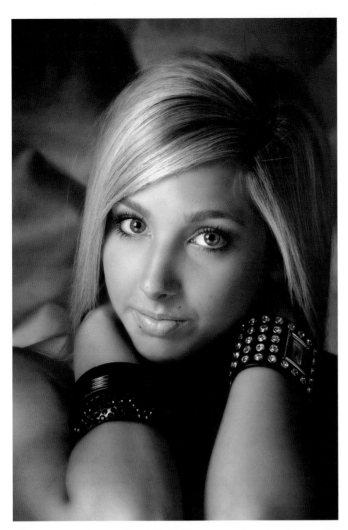

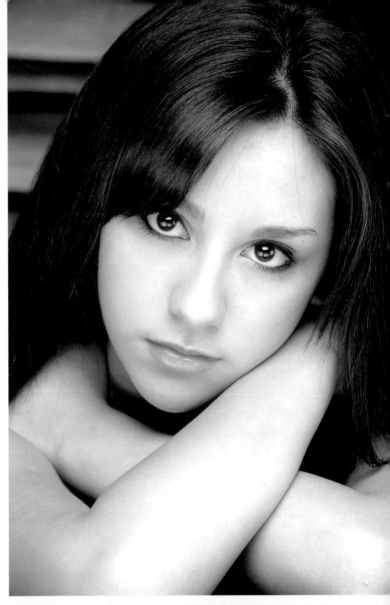

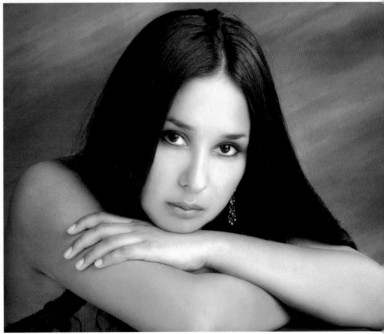

The entire neck area is easily hidden by resting the chin on the hands or arms.

When working with a client who has a very large double chin, you will get to a point where even the turkey-neck technique won't eliminate the problem. When this happens you have to hide the area from view. If you are really lucky, the man or woman is into scarves, but this doesn't happen often. A more reliable method is to rest the chin on the hands, arms, or even the shoulder and align the camera to hide the double chin behind another body part. When bringing the subject's hands to their face, the hands should just barely touch the face; allowing the face to rest on the hands will cause mushrooming and make the face look distorted.

Ears. Corrective posing is also the best way to combat the problem of ears that stick out too far. Ladies who have a problem with their ears usually wear their hair over them. In this case, make sure that the subject's hair isn't tucked behind her ear, as this will make the ears stand out. Larger

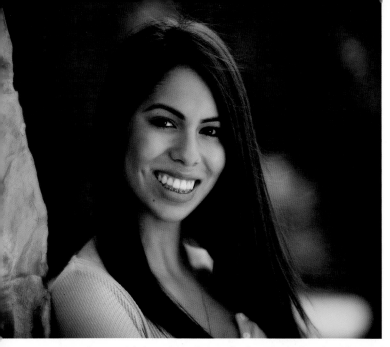

For clients with long hair, bring the hair over the shoulder and around the face to make the ears less visible.

ears can also stick out through the hair, making them appear really large.

Without hair to conceal them, the best way to reduce the appearance of the ears is to turn the face toward the main light until the ear on the main-light side of the face is obscured from view. Then, move the fill reflector farther from the subject to increase the shadow on the visible ear,

or move the main light more to the side to create a shadow over the ear. Reducing the separation between the subject and the background in this area will also make the outline of the ear less visible. Overhead hair lights should be turned off to avoid accentuating the top of the ear.

In a situation where the ears are so large that they can't be hidden in this manner, you have two choices: either let the ears be seen or highlight only the "mask" of the face, letting both sides of the face fall into shadow. This is the type of lighting that Marty Richert made famous years ago.

Noses. The nose is seen in a portrait because of the shadows that are around it. By turning the face more toward the light or bringing the main light more toward the camera, you can reduce the shadow on the side of the nose and thereby reduce the appearance of the size of the nose.

Butterfly lighting, using the main light directly over the camera and a reflector underneath the subject, can also reduce the apparent size of the nose. This type of lighting compacts the nose by completely eliminating the shadows on each side of it. The only shadow that appears on the face is the butterfly-shaped shadow that appears under the nose, hence the name.

Shininess and the strong highlight that runs down the nose on shiny skin also draws attention to the size of the

Turn the face toward the main light to conceal the far ear, then reduce the fill light on the shadow side to obscure the other ear.

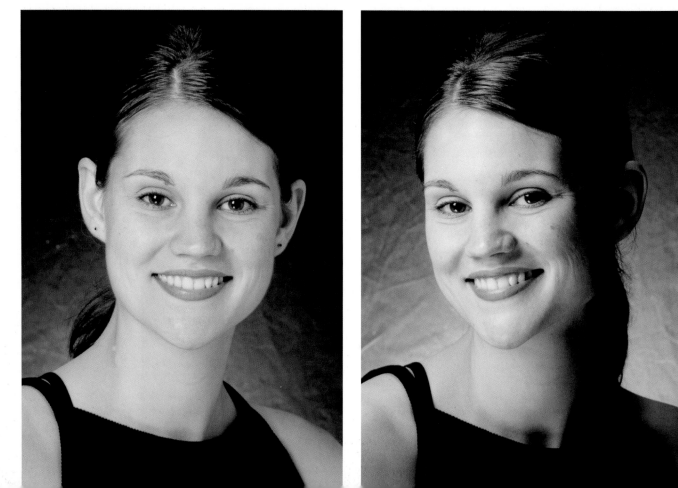

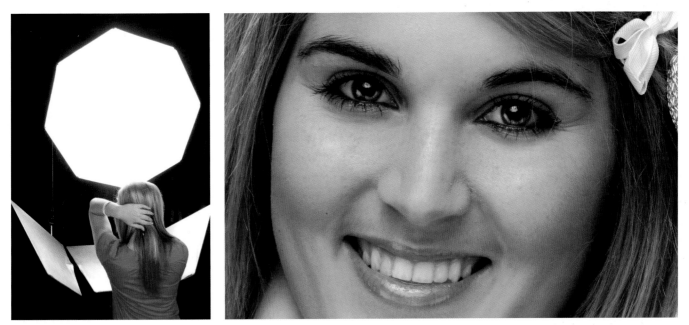

In butterfly lighting, the main light is placed directly over the camera, virtually eliminating the shadows around the nose.

nose. Usually, this is only a problem with guys (or when working outdoors on very warm days). Ladies usually wear a translucent powder that eliminates this shine. By keeping a few shades of this powder handy you can save yourself a great deal of time in retouching.

Eyes. Eyes are by far the most important part of a person's appearance. Making the eyes look alive and beautiful is the single most important part of any portrait. The most frequently made mistake of young photographers is lighting and posing a portrait primarily to bring out the struc-

ture of the face. Instead, the priority should be to ensure that the subject's eyes have beautiful catchlights at the 10 o'clock or 2 o'clock positions and that you can see the color of the eyes. (In dark brown eyes there isn't a great deal of color, but they shouldn't appear black either.) These objectives are accomplished through carefully placing the main light each time you change the pose—especially when using the smaller softboxes recommended for corrective lighting. I have found the easiest way to achieve the perfect illumination is to raise the main light to a point

Properly lighting the eyes is critical to designing a salable portrait.

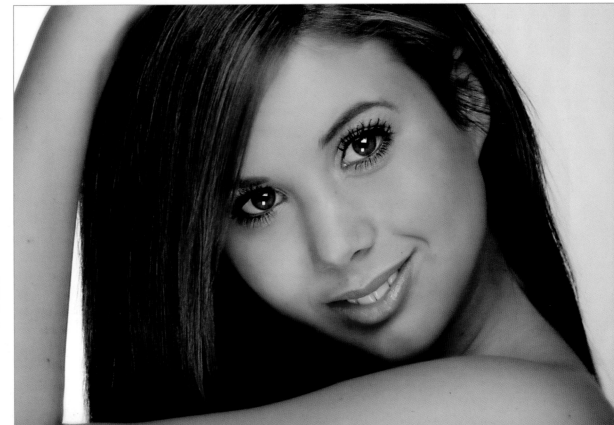

laughing smiles. With children, moody, more serious expressions are salable. In dealing with teens and adults, the best expressions are more subtle ones.

While squinty eyes are cute on a baby, not many adults really want to see themselves with no eyes, huge chubby cheeks, and every tooth in their mouth visible. Large smiles are not only unflattering to adults for these reasons but also because this expression brings out every line and wrinkle on a person's face. Adults are always self-conscious about crow's feet, smile lines, and bags under the eyes—all of which are made much more noticeable by huge smiles. While retouching can lessen these lines on the face, the retouching often reduces the lines too much, resulting in subjects that don't look like themselves.

Expression isn't your client's responsibility. As the photographer, you must develop a connection that allows your subjects to feel comfortable enough with you that they will "mirror" your expression. When you want a relaxed expression, speak to your clients in a relaxed tone of voice, with a relaxed, non-smiling expression. When you want your clients to smile, simply speak to them in more upbeat tones and smile yourself. The client will follow your lead.

With smiling, timing is important. It is easy to get a subject to smile, but once your client smiles, it is up to you to decide when the perfect smile occurs and take the pictures. When most people first start to smile, it is enormous. If you take the shot at this point, you end up with a laughing or almost-laughing smile. Once your client has a smile like this, you must watch and wait. A moment after a person smiles that laughing smile, the expression starts to relax. It isn't that big a change, but it is the difference between a

laughing smile and a smile that is pleasing to an adult client.

Hair. Problems with hair can be obvious (like in the areas where it is supposed to be but isn't) or subtle (like

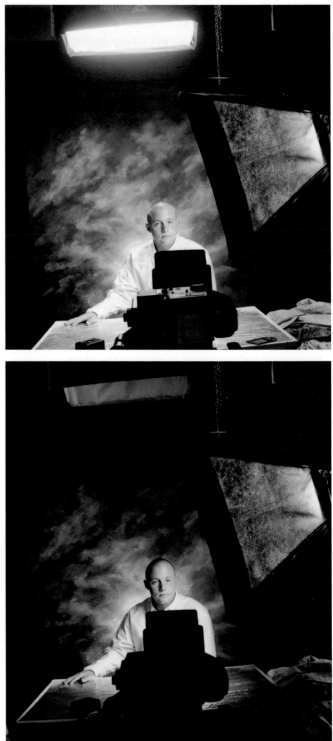

When photographing a subject who is bald by choice, turn off the hair light to prevent the top of his head from glowing. Combine this lighting trick with a lowered camera angle to help disguise the problem for clients who are not bald by choice.

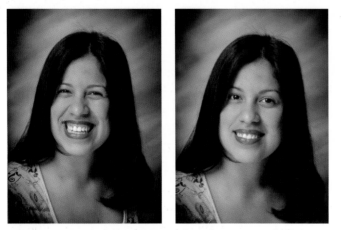

When most people first start to smile, it is enormous (left). A moment after a person smiles that laughing smile, the expression starts to relax (right). This is the expression adults prefer.

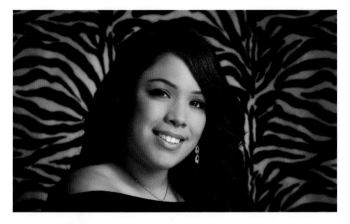

Simply lifting the shoulder that is closer to the camera (as in the two images to the right) improves the look of the portrait.

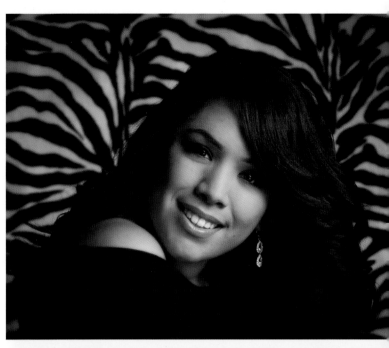

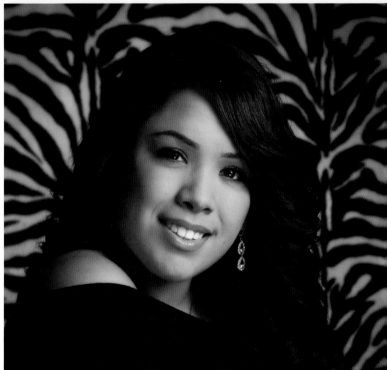

dark roots in blonde hair or a dull appearance instead of a shiny look). I personally don't style the hair for my clients, although I do fix any stray hairs or strands of hair that are out of place.

If a client is bald by choice, meaning they have decided to shave their head, they will not usually be self-conscious about it. To photograph them, simply turn off your hair light and you will be fine.

However, if a person's baldness is out of his control, no matter what he says, he is not altogether too happy about it. When you meet with a man over thirty who is wearing a hat or cap you can be 90-percent certain there is a bald head underneath. To use shadow to reduce the appearance of the balding area, turn off the hair light and lower the camera angle slightly. Then, make sure that the separation light is low enough to just define the shoulders from the background but still allow the top of the head to blend in. At this point, the problem will be much less noticeable.

If a man is really worried about his lack of hair, you can lower the main light and use a gobo in front of the main light source to hold back some of the light coming from the top of the light modifier. They (and you) have to re-member, this isn't an alternative for a hair transplant, though. It doesn't make a person appear to have hair, it just makes the problem less noticeable.

Of course hair isn't always a problem—long hair, for ex-ample, gives us an opportunity to soften or hide larger shoulders and arms or even thin the face.

Shoulders. Shoulders change in appearance with weight gain and age. The shoulders are most often cov-ered—but sooner or later you will encounter a client wear-ing an off-the-shoulders outfit. To make the shoulders look

as attractive as possible, just have the client lift the shoul-der that is closer to the camera—lifting it up to the point of being just under the chin. This makes the shoulder look more slender and adds a dramatic look to the image.

Arms. Most women worry about their upper arms ap-pearing too large or about hair showing on their forearms. Men generally worry about their arms looking too thin or too flabby. The best way to avoid problems with arms is to cover them up with long sleeves. When short sleeves are

worn, your choices are: compose the portrait above the problem area; use lighting falloff or vignettes to make the area darker and less noticeable; or, if the client has long hair, use the hair to soften the problem area.

Hands. Hands look best what they are holding something or resting on something, not just dangling down. The hands can grip or rest on an arm, leg, or shoulder or hold an object like a flower, football, or camera. The hand

Hands look their best when they have something to do. Pose them doing things they do naturally—like resting (on an arm, shoulder, knee, or other surface), with the fingers loosely closed in a fist, with the fingers in hair, with the hands behind head, etc.

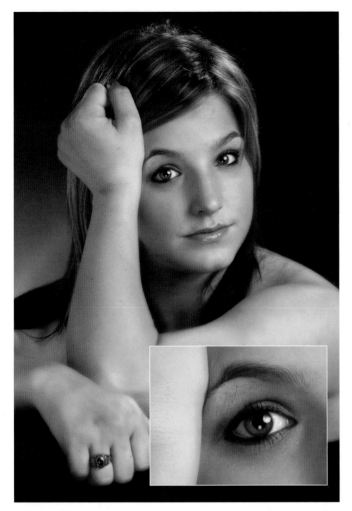

When creating a pose in which the subject appears to rest their face on their hand, do not allow the subject to place any weight on the hand. As seen in the inset photo, this will distort the face. Instead, the hand should just barely touch the face.

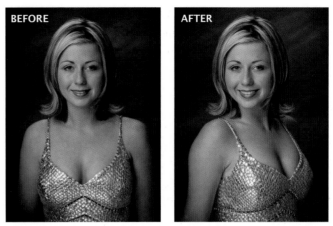

Simply turn the subject away from the main light to increase the shadows that enhance the shape of the bust.

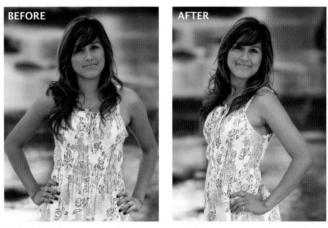

Switching from a straight-on pose (left) to a pose with the body turned (right) helps to slim the waist—and also to enhance the shape of the bust.

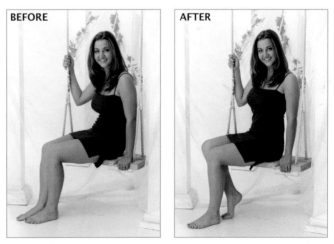

In a seated position, clothing tends to wrinkle (left). To correct the problem, simply have her straighten her back, almost to the point of arching it (right).

can be in a fist, if appropriate. Or the fingers can be put through the hair—or even around the back of the head, with the head resting on the palms.

Bustline. The bustline isn't a problem in most portraits, but you must make sure that it appears even if it will be noticeable in the frame.

When a low-cut top is worn, the size of the bustline is determined by the appearance of cleavage. Cleavage is nothing but a shadow. Increase the shadow by turning the subject toward the shadow side of the frame and you will, in turn, increase the apparent size of the bustline. There are times when a top is too low-cut for the type of portraits a client wants. By turning the client toward the main light, the shadow in the cleavage area is reduced.

Waistline. The waistline is the area that almost everyone feels is never thin enough. In portraits that will be taken full-length, I almost always choose to hide this area from the view of the camera. Maybe one in five clients have a flat enough stomach to show this area in the final por-

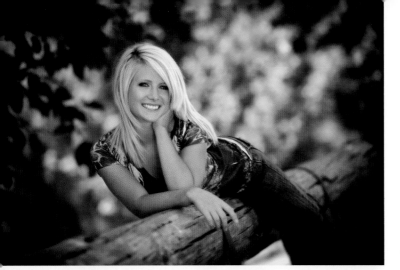

With the subject posed on their stomach, you can create close-up, hips-up, and full-length images.

traits. In the photos throughout this book you will notice that the stomach area is almost always hidden or obscured from view by arms or legs, props, grass, or trees.

The classic rules of posing tell us that to make the waistline appear slimmer, we should turn the client toward the shadow side of the frame. This works well as long as the person has a somewhat flat stomach. But what happens when the client's tummy is so large that when you turn the body you see the outline of the belly? Then, it's time to adjust your separation lights (especially the background light) to allow this area to blend into the background, eliminating the outline of the tummy.

Another way to hide the stomach area is to pose the client in a sitting position, then elevate the leg closest to the camera. This partially obscures the stomach area. Having subjects rest an elbow on their knee (or knees) will completely hide this area. However, sitting positions cause significant waist problems of their own. In a seated position, clothing and skin wrinkle over the waistband of the pants, giving even trim subjects a roll at the waistline. If the person is thin, have her straighten her back, almost to the

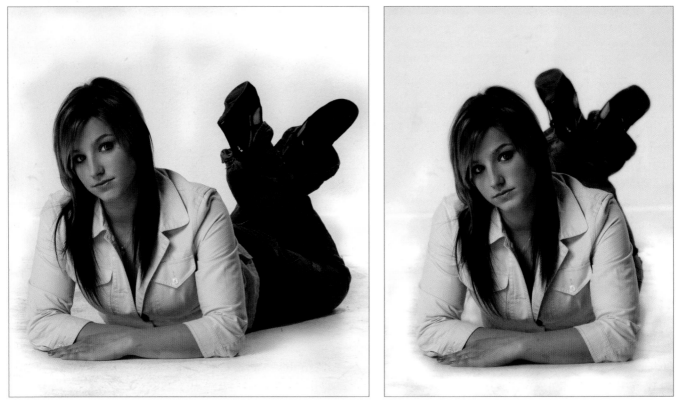

In this pose, rotating around the subject allows you to hide more of the hips and legs behind the subject.

CONDENSING A POSE

The one complaint that parents have about senior portraits taken full length is they can't see the face. Condensing the body (by bringing the feet up into a chair where the subject is seated or photographing them lying down with their feet kicked up behind them) results in a larger facial size than a traditional full-length pose—while still showing a majority of the body. You can also elevate the camera to increase the size of the face while including the entire body in the image.

An elevated camera angle was used to create a full-length portrait but with a larger facial size.

Bringing her feet up allowed me to show more of the subject while maintaining a Mom-pleasing facial size.

point of arching it, to correct the problem—as shown in the images on page 59. If the person is heavier, hide this area as described previously.

Rather than sitting, you can consider having the subject lie down on his or her stomach. This will widen the body slightly (so it's not an ideal option if the hips or thighs are an areas of concern), but it allows you to hide even a very large stomach—and the pose works well for close-up, three-quarter, and full-length compositions.

The Legs and Feet. Thighs and legs need to appear as thin and toned as possible. This isn't a problem for most men, because it's normally only athletic men who ask to take a photograph in clothing that shows their legs or thighs. Women, however, are often told they should wear dresses, tight skirts, and tight pants—even when it would be in their best interest not to.

If there is not a good reason to see the legs in the portrait, don't show them. If someone is heavy, has unattrac-

tive legs, has attractive legs but insists on wearing flat shoes (etc., etc.), don't do a full length pose—or condense the full length pose by bringing the legs up in a chair or having them lie in grass where the legs can barely be seen.

If a subject's legs are going to show in a portrait, you must show both legs. One will be the leg that the weight of the body is put onto, while the other will be the accent leg. You can't do much with the leg supporting the body—if you do, the subject will fall down. The accent leg, then, is the leg that gives style to the image. The accent leg can extend out, cross over, or rest on a higher surface, but it can never, ever do what the support leg is doing. If one legs matches the other, this is not called a pose; this is called standing.

The accent leg should also separate from the support leg. This defines each leg (at least from the knee down) and reduces the appearance of mass you get when the legs are side by side. It also helps slim the thighs.

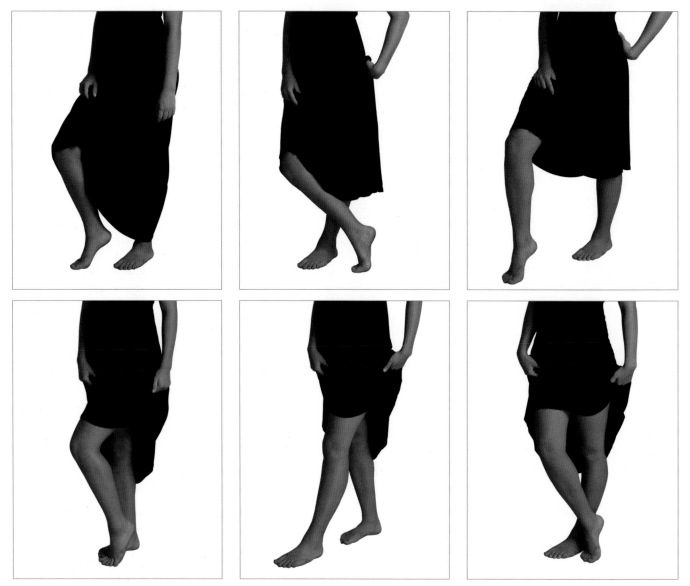

In all of these poses, notice how one leg supports the weight; the other leg is considered the accent leg.

With feet flat on the floor, legs don't look their best (left). Lifting the heel flexes the calf and thigh muscles, making the legs appear longer and firmer (center)—it's the same position you'd see if the subject were wearing high heels (right).

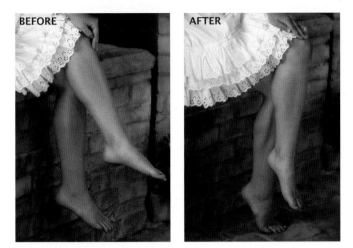

BEFORE AFTER

Ungrounded feet (left) don't look good. Having at least one foot on the floor (right) creates a more appealing look.

Anytime the legs are going to be showing and not covered with pants, have the subject wear the tallest heels she owns. There is a reason why women who want to have the greatest impact when wearing a dress wear very high heels. When the heel is pushed up, it flexes the calf and thigh muscles, making the legs appear longer and firmer. If the woman is going barefoot, have her push up her heels just as high-heeled shoes would do.

Don't forget that you can hide or disguise the outline of the hips and thighs by using elements in the scene to partially obscure the area from view. As with the stomach area, you can also eliminate separation lighting from this area and simply allow the hips and thighs to blend into the background.

Like the hands, the feet look best when they are doing what they do naturally. Feet should be on the ground, or brought up in a chair where the subject is seated.

For full-length seated poses, you also need to consider grounding. Grounding means keeping at least one of the subject's feet touching the ground—especially when the subject is seated (unless both feet are in the chair with the subject). When someone is seated and not touching the ground, they look like a small child in a big world. This is fine if it's the look your client wants, but most of the time it isn't appealing. The legs and feet look odd when they are just dangling.

FINDING NEW IDEAS

To find new poses to offer to your clients, you need only do two things. First, you must open your mind. Put out of your mind everything you have learned about posing. The posing manuals that many of us learned from are outdated by today's standards. When all these rules that we learned were created, the times were different. Women were passive creatures who stayed home and "tended to" their husbands and babies, and men had to look stiff and unemotional. Nowadays, men spend as much time on their hair and getting ready as women do. And if you don't think women have changed, just leave the toilet seat up one time and see what happens—she'll give you "tended to!"

Some photographers are so stuck in what they have always done that they bitterly resist any change. I once took a class on senior portraits. There was another photographer attending this class who was just starting out. Every time the photographer conducting the class wasn't talking, this photographer would ask me all kinds of questions. At lunch, we had some extra time, so, with permission, I went into the camera room and started showing my newfound friend some of the different poses we use with seniors. He

Don't get stuck in a posing rut—look for new posing ideas to make your clients look great.

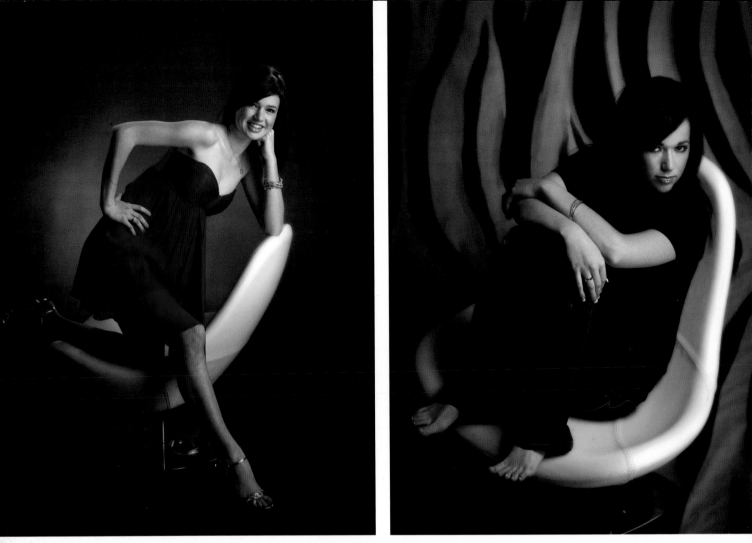

Never take things at face value. Make yourself responsible for adapting a good idea to fit your needs. In these two images, notice how the same chair was used to create two dramatically different looks.

loved it. Everything was going fine until the photographer conducting the program came in. I was doing a yearbook pose that had the subject reclining back, to make the shoulders run diagonally through the frame. The photographer conducting the class remarked that this was a pose more suited to boudoir than seniors. To reply, I simply asked both photographers if the subject looked beautiful in the pose. They both responded affirmatively. I said that was all that mattered.

The moral of the story is that people just want to look great. They want to look natural or glamorous—not like mannequins.

Step one (opening your mind) can be difficult, but step two (finding interesting poses) is easy. Just remember one word—plagiarize! There is no copyright on good ideas. So where do you turn? If you are smart, you start looking at the fashion magazines that are directed toward the market that you work with the most. For our studio, I look at *Sev-*

enteen and *Sassy*, as well as *Cosmopolitan*, *GQ*, and *Mirabella*. Your clients might have older or (in the case of children) younger tastes and styles, but there is a mountain of creative poses each month in these magazines—and they can be yours for the price of a subscription.

If you work with ladies, from high-school seniors to adults, and have problems with posing women for full-length portraits, get a Victoria's Secret catalog. The photographers who work on catalogs like this are masters at making the human form look its best. Naturally, you are not going to be photographing a high school senior in lingerie, but the body can be posed the same way as in the Victoria's Secret catalog—the senior girl will just have more clothing on. For those of you who do glamour photography, your client will be in the same poses, only wearing less clothing.

Never take things at face value. Make yourself responsible for adapting a good idea to fit your needs. The most

unhappy and unsuccessful people in any profession, and in life in general, are the ones who consistently look at new ideas and say that they won't work. The happy and truly successful people in the world look at new ideas and think, "It could work—and I think I can make it even better."

We have taken the idea of gathering poses from magazines one step farther. We encourage our seniors to bring in the poses they see in magazines that impress them the most, and we will duplicate the poses for them. This gives us a constant supply of new poses and—even better—they are poses selected by our target market. This tells us exactly what our specific clients want.

For some photographers, getting rid of old poses and ideas is harder than coming up with new ones. All of us love security. We like to know exactly what to do and not have to shoot from the hip or think on our feet. We are always afraid that when we throw something away we may not have what it takes to fill the void that is left. I pride myself on staying current, so nothing stays in our sample books or on the walls of the studio for more than one year. I repaint at least 30 percent of my backgrounds every year and try not to keep any sets more than three years. I make it my goal to paint at least two new backgrounds, design one new set, and have at least two uninterrupted test sessions each month. Seniors are the most style-conscious type of client, but all photographers need to force themselves to bring new ideas into their studios—and to throw out some of the old ones.

Don't get stuck in a rut. To keep your clients happy, you should always be letting go of old ideas and developing new ones.

TARGETING TEST SESSIONS AND DISPLAYS

If a majority of the money in your pocket is made from weddings, the majority of portraits on display in your business should be weddings and a majority of the test sessions you do should be scheduled with a bride and groom. The same is true for families, children, and seniors. I have visited many studios that make most of their living from weddings yet display mostly portraits of aspiring models in their studio. I know of some photographers who work with mature clients in a variety of situations (families, business portraits, weddings, etc.) and when they do a test session it is always of a young woman in swimwear or lingerie. This is, first of all, a little creepy—and probably why so many photographers get a less-than-sterling reputation. More importantly, it does you and your business no good. You can't learn to work more effectively with one type of client by photographing a different type of test subject.

TEST SESSIONS

An easy way to try out new ideas is by photographing subjects who are not clients. The problem that most photographers have is that they don't plan the test session. They have a person come in to the studio and plan on "winging it." They think to themselves that working off the cuff will raise their creativity. Yeah, right! If you don't plan for your test session, you will almost always end up doing variations on what you already offer—which gets you nowhere. When you schedule a test session with a subject, gather together the clippings clients have given you as well as those you've collected yourself from magazines, books, and other sources. Make yourself a checklist of how many new ideas you want to try and what changes you want to make to each of the ideas you have clippings for. Rarely do ideas spring up fully formed and ready to use in your situation. You have to make alterations to the ideas so they fit your studio and your client's taste.

IN CLOSING

Creative posing can dramatically improve the way your client looks in their images. Posing can hide problems areas that would take forever to correct in Photoshop. All it takes is a few seconds in the camera room and a desire to make your clients look beautiful. Posing is such an important part of the photography you create—but so is camouflaging (learning to hide problem areas with other elements in the scene. This is the topic of the next chapter.

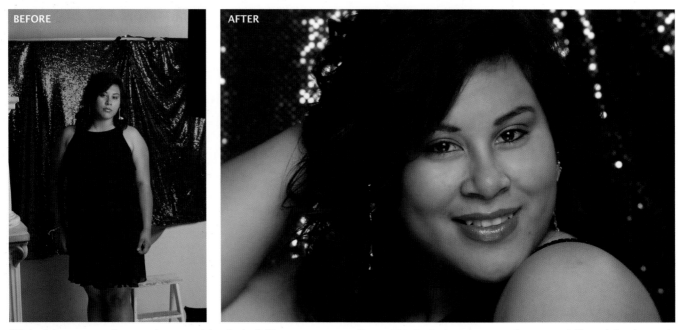

When doing test sessions, seek out models who look like your average clients. This is the best way to refine your skills and develop techniques that you can put into practice at paying sessions.

POSING VARIATIONS

When I was first learning posing, I had such a hard time with it. I would sit someone down and my mind would race, trying to figure out how to make the subject look comfortable and yet stylish. I would go to seminars and look in magazines to get posing ideas, but it seemed that when a paying client's session started the ideas went right out of my head.

I realized, early on, that if I was going to become effective and comfortable with posing, I needed to practice often and in the same situations that I would be needing to use this skill. I needed to practice under the pressure of a session, not as I was fooling around shooting a test session of someone I knew. I also knew that I didn't have ten years to get good at posing my clients—I needed to get as many poses down as I could, and do it as quickly as possible. This led to what I call variations.

Variations are simple changes you can make in a single pose to give it a completely different look. You start out with a basic pose, then come up with a variety of options for the placement of the hands, arms, and/or legs. This takes one posing idea and turns it into five or ten different poses. I make every photographer in my studio (including myself) do this for every session. It provides good practice because it teaches you how to maximize each pose. It also gives your client the most variety from each pose they do.

Using variations keeps each of your poses in your mind, so no matter how much stress you feel, the poses are there. It's just like multiplication tables—once they stick in your mind, you'll never forget them. This is an important factor, since I have ten shooting areas in our main studio and often need to go as quickly as I can from one shooting area to another, working with up to four clients at a time. As you can imagine, this requires some real speed at posing demonstration. I assist each client into the desired pose and refine it—then I'm off to the next client!

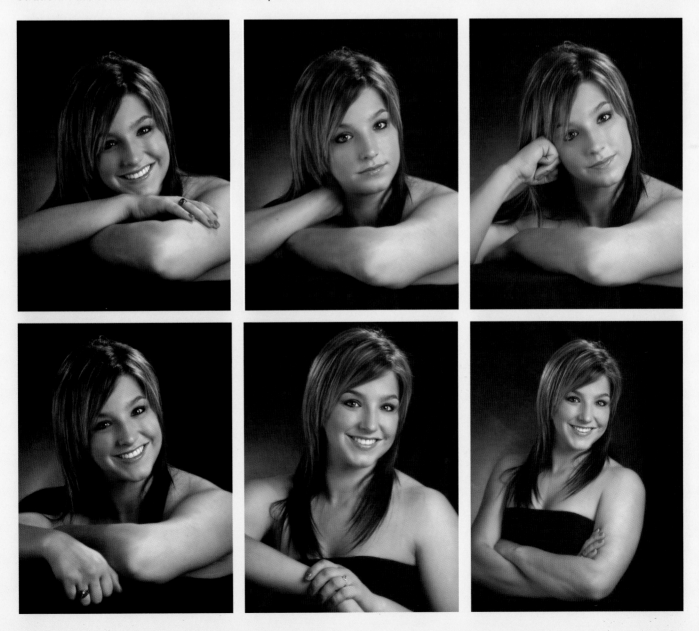

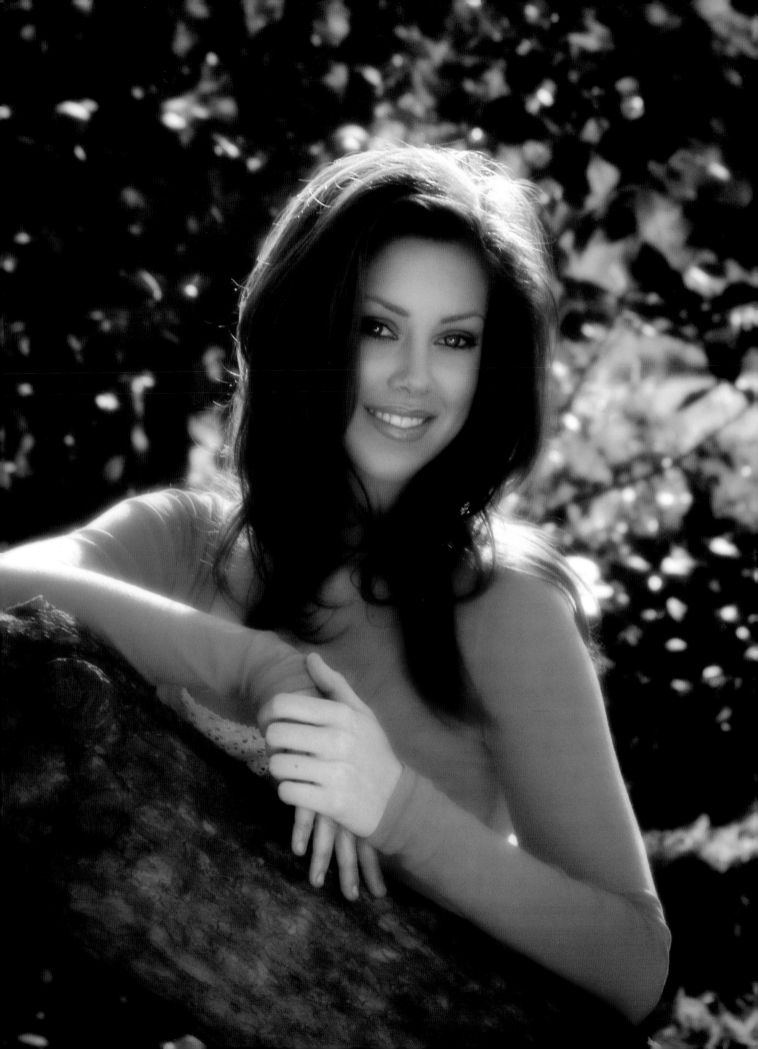

6. CORRECTING FLAWS WITH THE SCENE

The scene or setting can often be one of the most effective tools you have for correcting clients' flaws. As you have seen, letting the body blend into the background can make problem areas like large hips or a balding head much less noticeable. This works well in low-key portraits, but when you start working with high-key settings (or even with a client in light-colored clothing), the problem area is still obvious. But, just as with poses that use the knee, arm, or leg to disguise a problem, elements in the scene can also be used to conceal flaws.

USING THE FOREGROUND

Most scenes give you ways to hide flaws by using the foreground. Although it is often overlooked, making use of the

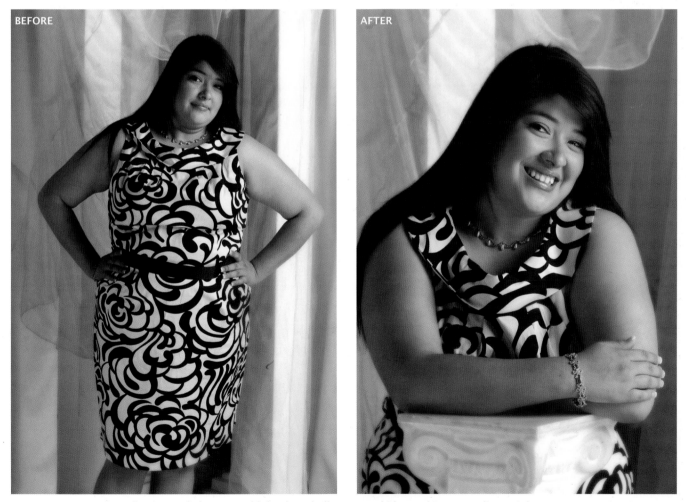

ABOVE AND FACING PAGE—*Foreground elements add depth and allow you to hide anything your client might not want to see.*

"CORRECTIVE" POSES CAN ALSO BECOME POPULAR POSES

If you have corrective poses that everyone (not just those who need correction) requests, you are doing this whole "posing thing" correctly. For example, laying-on-the-tummy poses were designed to hide the stomach. A few years back, however, Kate Hudson had a movie out called *Raising Helen*. In all the ads and displays, she was laying on her stomach with her feet up, legs crossed at the ankles, and a pair of Ugg® boots on. Suddenly, that was the most requested pose—and many girls brought in the shoes and a similar outfit to capture that same look.

foreground not only gives you the ability to hide a client's flaws but, from an artistic standpoint, provides a greater ability to create the illusion of depth in your portraits. By using an element in the foreground, the subject in critical focus, and then a background that recedes farther and farther from the subject, you have a built-in sense of depth.

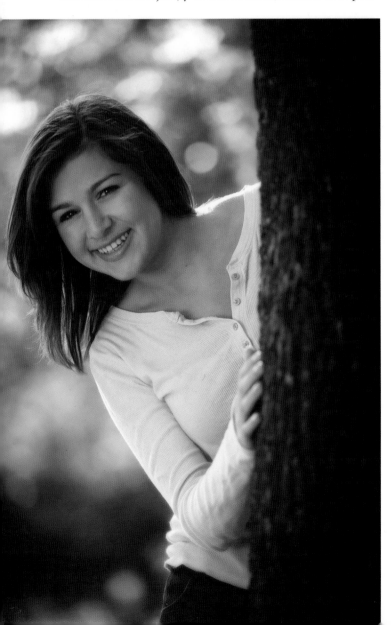

When correcting a client's flaws, it is amazing how even a simple foreground element like a plant or a few columns can soften or hide a large hip, tummy bulge, large upper arm, or hairy forearm. Whether you have something as simple as a client sitting backwards in a chair, or an entire set arranged to hide problem areas, it is a very effective way to give clients a version of reality they can live with.

COORDINATING THE FOREGROUND AND BACKGROUND

Learning how to coordinate the style, look, and color of the foreground elements with the other parts of the scene can be a challenge. A plant or tree is often used in the foreground because it is easy. It goes with just about everything and it doesn't take any time to prepare. Chairs are also a popular and versatile choice for the foreground element. Either one can be effective. (Indoors and out, you can enhance the feeling of depth by using multiple elements in the foreground, or by adding elements in between the subject and the background.)

OUTDOORS

What do you do when you are outside and have a client with a large body size? Well, first, you might find a tree and do the peek-a-boo pose, with the body hidden behind the tree and the face coming out from around the side of the tree. (Although this pose is a classic of corrective posing technique, it is also a popular pose for young ladies who don't have weight issues.) You might also photograph a girl lying in tall grass that obscures the outline of her hips and thighs. You could also simply decide to create something other than a full-length portrait.

Outdoors, many photographers work at the edge of a clearing or have the subject leaning against a tree or column that has nothing else around it. This provides a scene in which the first element is the subject, then the background elements that recede farther and farther away from the subject. While I do this on occasion, I prefer to use a scene that provides elements in the foreground. This could mean using a tree with lower branches or posing the client in the middle of what most photographers consider the background—so there are foreground elements between the subject and the camera.

This is a popular pose for subjects of all shapes and sizes. The tree in the foreground creates a nice sense of depth but also allows you to hide as much of your subject as necessary.

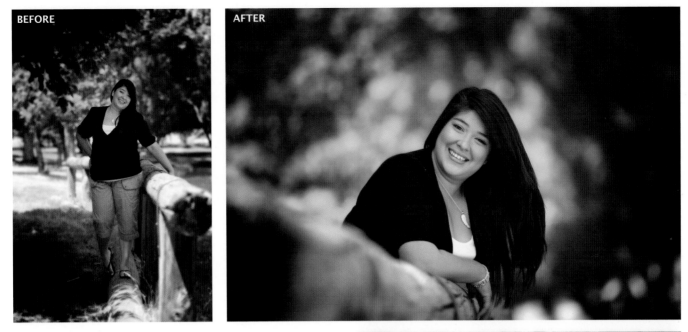

BEFORE

AFTER

*ABOVE—Adding a foreground element can help create an image that is easy on the subject's ego. **RIGHT**—The density of the foreground elements will determine how much of your subject is visible behind them.*

The density of the foreground elements will determine how much of the subject you are going to see. If the foreground is too thick, you will see none of the subject's body. In this situation, you have to ask yourself why you're presenting a reduced head size if it doesn't result in seeing any more of the person. You might be better off just composing the image more tightly (cropping out areas you want to conceal rather than hiding them behind something).

Years ago I was hired to photograph a rodeo queen. She came from a nearby mountain community, so we looked around this area for a place to photograph her. We found an area where the light was great and the field of grass was high—it was perfect . . . or so I thought. The first problem was that it was late spring and we were in an area that was known for having a high rattlesnake population. Not realizing this, we walked through the tall grass without a clue. The second problem was that the grass was so high and so thick that you couldn't even see an outline of her legs from the thighs down. Since I was very young at the time, though, I was very excited about these photos (and not getting bit by a snake), so I had a 30x40-inch print made for the studio. My wife looked at it when I unveiled it to our staff and she said, "It looks like she's missing her legs!" In short, I should have cropped it closer and eliminated the foreground that showed nothing but grass.

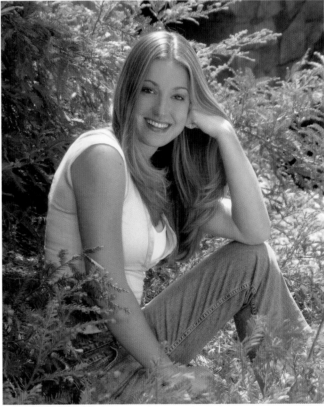

Sometimes we get so caught up in the lighting, the posing, and the beauty of what we are focusing on, we don't notice the unnecessary elements (like all that grass) and forget that someone else has to live with our creation. My wife was right; although I thought the foreground of grass was beautiful, the client would have preferred to see the subject larger in the frame—not ten feet of grass in the foreground.

ABOVE—*Chairs can be turned to create simple foreground elements.* LEFT—*The railing is used as a foreground element.*

IN THE STUDIO

The ability to add foreground elements and use them correctively is one the main reason we use sets, as opposed to just background fabrics, in the studio. Sets also allow us to place elements at different distances from the camera, which creates more depth than is possible with a painted background. I have always said I want at least five points of focus in the average studio portrait. The client is the main point of focus, but even in a head-and-shoulders pose there should be at least four other points of focus at different distances from the camera.

We have found many background and foreground elements at the local home store. For example, I purchased a French door on clearance for $10. We have also purchased ladders, steel grates, tin roofing material, and many other interesting foreground and background items at this type of store. You are only limited by your imagination and your time to shop around. When I first opened my studio, like most new photographers, I had all kinds of time but very little money to purchase sets. Now, with over three thou-

What are these poses hiding through the use of simple obstructions (mostly the subject's own body)? Turn the page to find out.

Posing—especially when combined with the use of obstructions—is one of the most powerful tools photographers possess. Flip to the previous page to see portraits of this mom-to-be. Would you have guessed she was pregnant in any of these images?

is that they sometimes position the set components flat to the camera—and then wonder why their images didn't look like those in the brochure. By angling any set toward the camera, you can create a foreground and bring the background to life by adding focal points at different distances. (*Note:* This idea works with most props, as well. Instead of placing a chair or couch flat to the camera, turning it [bringing one arm closer to the camera than the other] creates depth in the portraits—and a place to hide a seated client's hips, thighs, and not-so-flat tummy!)

Similarly, the average photographer sees an arch at a trade show. He buys it, brings it into his studio, and it remains a single arch for all time. Yet, in addition to being an arch, it is also three individual pieces that can be combined with other set components to create multiple looks. This gives you the most for your money—and it also provides opportunities to improve your photographs and hide your clients' flaws.

Always be on the lookout for items to put in front of clients—items that look natural and coordinate with your sets and outdoor scenes. Even the Viper or Harley (popular props at our studio) can produce a foreground to hide clients' problem areas behind. Just use your imagination!

sand seniors to photograph each year, my writing, and my family, I have much more money than I do time to look for background items, so I tend to purchase them from set manufacturers.

Whether you purchase them or create your own set elements, you need to look for unique ways to use them. Many photographers struggle with this when using the large, expensive sets that some designers sell. One problem

Always be on the lookout for item to put in front of clients—items that look natural and coordinate with your sets and outdoor scenes.

7. OUTDOOR PORTRAITS

As photographers have long known, a session shot on location (or partially on location) will have a higher sales average than a session done in the studio alone. Yet, many photographers avoid the great outdoors like the plague—and for good reason.

LIGHTING

While outdoor sessions can boost profits, working outside gives you little control over your lighting—at least the kind of control needed for corrective lighting. We are all taught that to achieve the best possible portraits outdoors we have to get up at the crack of dawn or stay out until it is almost dark. We have all been told that the ideal lighting exists for a short window after sunrise and your next opportunity starts an hour and a half before sunset. Realistically, this gives you just two short windows of opportunity per day.

To boost our profits by scheduling outdoor shoots, we needed to learn how to work with the natural light as it changed throughout the day. This took some getting used to. Like most photographers, I had used flash for outdoor group portraits at weddings, but the flash all but destroyed the feeling of the soft, warm, outdoor light that exists naturally. Therefore, flash was not an option I preferred.

The better option was to manipulate the existing light with a combination of reflectors and black panels, what Leon Kennamar used to call "subtractive lighting." Essentially, we use the light that exists and modify it to fit the situation. Since we specialize in seniors, the techniques we use are designed for photographing a single person, but the principles will work on a couple or a small group.

Working with midday light, you will find two different lighting situations. The first scene (the ideal one) occurs when you get lucky and find in one location an obstruction

Outdoor scenes offer many good foreground elements.

that blocks the light from directly overhead (under a tree with branches overhead, or on a porch with the roof overhead, for example), and a second obstruction on one side or the other at ground level. This creates a shadow area and a large, directional light source to act as the main light.

In the second type of scene, one or more of the key elements needed to create the ideal scene is missing. In this case, you must identify what is needed to create portrait-quality lighting and use black panels and reflectors to fix the problems. For more on outdoor portrait photography, refer to one of the best books ever written on the subject (if, as the author, I do say so myself), called *Outdoor and Location Portrait Photography*, from Amherst Media.

USE OF SHADOW

When it comes to corrective lighting for outdoor portraits, the use of shadow can soften flaws. Shadow is also the el-

Outdoor portraits should not lack shadows. If you cannot find a natural obstruction that creates direction in the lighting, you can use black panels to place the shadows where you want them.

other of the pupil and positioned in the colored portion of the eye.

If the catchlights are too large, extending from one side of the pupil to the other, or if you see two distinct catchlights, you'll need to modify the source of light or change your subject's position. First, try turning your subject away from the source of natural light (probably the open sky) until the catchlights are in the proper position. If turning the subject doesn't eliminate the second catchlight or reduce the size of the catchlight enough, you can bring in a black panel. Simply place the black panel in front and to the side of the subject to eliminate the second catchlight or reduce the size of the natural main-light source.

ement missing from most photographers' outdoor portraits. Most outdoor portraits I see have a main light source that is too large and wraps light around the entire face. This type of light makes the face look wide and without structure. By placing a black panel on one side of the subject, a shadow is created and the face appears thinner. This also creates a shadow side of the portrait to turn the body toward in order to hide flaws.

EYES AND DIRECTION OF LIGHT

The eyes are the best indicator of light direction and the modifications that need to be made. What you are looking for is one large, well-defined catchlight in the upper half of each eye. This catchlight should be to one side or the

USING THE OUTDOOR SCENE EFFECTIVELY

Working at an outdoor location gives you great opportunities to hide your clients' flaws. Although you have less precise control over the lighting, you have many elements to use in the foreground and background to soften the outline of the subject's body.

Hiding White Socks and Bare Feet. A client comes out and despite everything you have told him, he has a white pair of socks gleaming out from a dark pant leg. The solutions are many. You can look for tall grass to pose him in, so you won't see the white socks. You can angle the shot so that a tree branch or other foliage in the foreground covers the area of the white socks. The same ideas can be used to hide a girl's feet if she wants to go barefoot but either hasn't painted her nails or has painted them a bright color.

A reflector is used to bounce light onto the subject's face.

Arms. The same technique can be used when you have a young lady with large arms who hasn't listened to your instructions and has brought along nothing but sleeveless tops. Look for foliage in the foreground that is at the proper height and comes into the frame at the proper angle to cover a portion of her arms.

Many times a scene is perfect, but there is no foliage or other element in the foreground to soften or hide a problem area. At this point, you'll need to go to a tree and do a little "constructive pruning." Snatch a branch off of a nearby tree and add it into the frame of the portrait where you need it to hide the flaw.

SELECTING A SCENE

To work effectively outdoors, many photographers need to relearn how to locate an appropriate scene. To find the perfect scene, you must first determine the most important quality of a scene for taking portraits. Is it a location with perfect light? Most photographers would think so, but they would be wrong. I can create beautiful lighting, so selecting a scene based only on the quality of light would be a mistake.

What about the quality of shadow? Is there an obstruction above the subject to block the light from overhead, avoiding "raccoon eyes," and an obstruction to one side of the subject to create a shadow area in the portrait? This can thin the face and body, but I can create shadow wherever I want it so, again, to make this a determining factor in scene selection would be a mistake.

What about the appearance of the scene? When you are working in the middle of the day, usable backgrounds or scenes are in short supply, but no matter how perfect the scene is, no matter how perfect the light or shadow, if you have a girl who is overweight and you don't do anything to make her look thinner, all of your work is for nothing, because in all likelihood she will not order.

The first priority when you are looking for a spot to use corrective techniques is to determine what elements are available for hiding your clients' flaws. Once this is determined, you can work at sorting everything else out. If the background is in sunlight, you'll need to add light from a reflector, or mirrored light can be passed through a translucent panel to balance the lighting on the subject with that of the background. If you don't have enough shadow, bring in black panels to create shade.

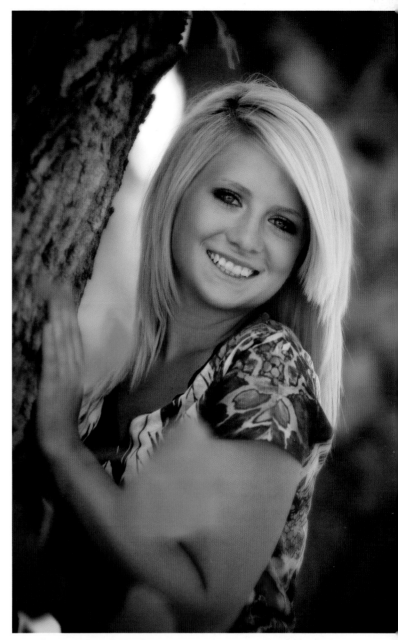

Your first priority when selecting an outdoor scene should be finding areas where you can hide any flaws your subject might have.

8. PUTTING IT ALL TOGETHER

The process I go through to get my clients to look their best is a combination of attention to detail, caring enough to find out what the client wants, and preparing for the session in a logical order.

QUALIFYING THE CLIENT
After seeing one of our many displays, receiving our many mailers, and/or being exposed to our studio on Facebook, a seventeen-year-old lady finally decides to pick up the phone and call the studio.

Our session planning begins immediately after the words "Good morning. Thank you for calling Smith & Co. Studios. This is Michelle. How can I help you?" The person that answers the phone has to educate that prospective client and get an idea of what they want so she knows whether it's something we can deliver. For instance, let's imagine she hears the client say, "We have a vacation home three hours away and I want my photos taken there—but my mom and dad are going through a divorce right now and money is very tight. They said I could only spend $300

Corrective techniques hinge on controlling your session—and that begins with your first phone call from the client.

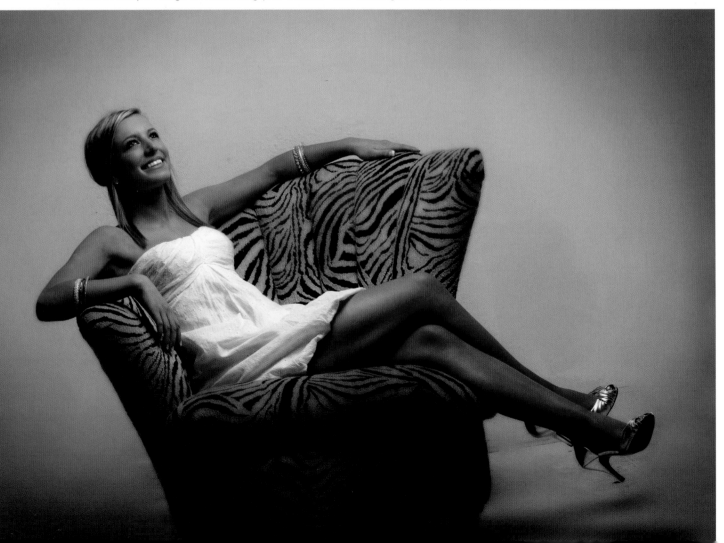

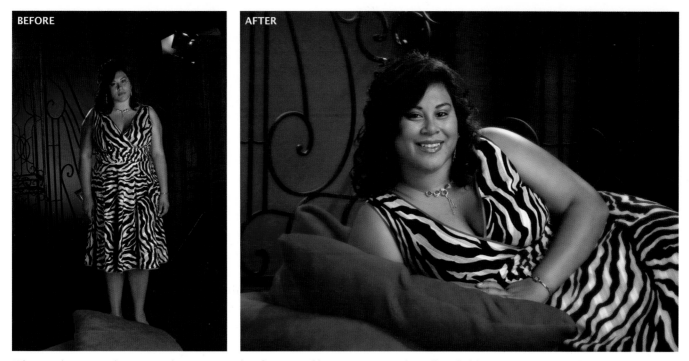

When evaluating a client, I am determining what features of her appearance she will probably not want to see in her portraits.

for everything." This would be someone we could not help; our sitting fee with all that travel would be five or six times more than the client's budget.

DETERMINING THE CLIENT'S NEEDS

After Michelle (our fictitious phone person) qualifies the caller, she starts finding out what the client wants in her session. This lets us know what kind of session she will be buying. Once the senior has decided on a session, she gives Michelle a credit card to purchase that session. By having clients prepay for a session, you can virtually eliminate no-shows. This is important—you don't make money for the studio when you have nothing to do!

Whenever a client has a question about this, we simply say that we devote several hours to each of our clients with many staff members helping them through their session and viewing, so we need to ensure that each session time is scheduled for clients who will be in for their session. We also add that they can cancel up to forty-eight hours before the session and reschedule without additional cost.

EVALUATING THE CLIENT

It seems like the more reason there is for a client *not* do a particular pose, the more she'll want to do it. If your client has very large arms, she'll want to wear a sleeveless top— leaving you to wonder how you are going to hide them.

I work with set movers who prepare the backgrounds and sets for each clothing change of each client. This frees me to meet our young lady as she is looking through the sample books. As I do this, I observe everything about her appearance and think to myself, "If I were her, what areas would I worry about the most? What areas are her strongest?" I look at how symmetrical her face is. I watch as she smiles to see any problems she might have, if her smile might start to be crooked, and at what point in her smile her eyes might start to disappear. I look for obvious signs of weight gain and start thinking of how we will hide those areas in the poses she has selected. I look at her fingers and toes to see if her nails are done (or at least presentable) in case I will have to hide those, as well.

Along with nails, I look to see if her hands or feet show signs of weight gain. Everyone gains weight in different places. There are people who look the proper weight from the waist up but are huge from the waist down. When I was growing up, my mother had a younger friend who had the most beautiful legs but was very large from the waist up. Look at all areas that might show weight and see if there is a reason to not show them.

CHOOSING OUTFITS

Once I have seen the client and her selections, as well as the information that was collected on the phone, I start put-

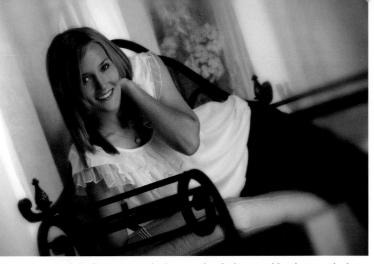

A solid white top works best with a light-toned background—here, one with subtle textures.

ting all the pieces together. I look through her clothing and start selecting clothing to coordinate with the chosen background. I pair dark clothing with dark backgrounds/ sets and light clothing with light backgrounds/sets (unless there is a reason not to—like the client wants to accentuate the outline of her body by contrasting the clothing and background). Solid clothes are always chosen for backgrounds that are busier or where I want to accentuate the face by matching the background and clothing. Plaids, strips, or other busier clothing will be paired with backgrounds that lack texture. I also look to see if any of her clothing will allow her to do full-length portraits, if that is something she has in mind.

BEGINNING THE SESSION

One the set mover has prepared all the backgrounds and sets she will be doing for her first outfit, I start working with the head-and-shoulder poses. I have the client sit down and relax, while I explain that I will take care of everything. This gives the client a chance to relax and get used to being photographed. While tension will not show

GET THE RESULTS—BUT BUILD THE EXCITEMENT, TOO
When I photograph the client, I begin by shooting from a camera stand because I want them looking at me, not the camera; eye contact between two people brings life to the eyes and the expression. For my senior portraits clients, though, the experience is everything—so once I have taken all the shots they will order from, I remove the camera from the stand and start shooting handheld, working at different angles and elevations. From seeing fashion shoots on television, this is what my clients expect—it makes them feel like real models! I shoot about ten images this way.

in a head-and-shoulders pose, the stiffness and rigid appearance will be obvious in a full-length shot.

In the first test shot, I look for anything that I (or my staff) might have missed—as well as any adjustments to exposure or lighting that might be needed. Then, I am ready to start photographing. I never shoot more than is necessary. Many photographers waste so many of their billable hours shooting frame after frame of the same image—images that they then must go in and edit down in the computer. Typically, I take just five non-smiling and five to seven smiling shots of each change of pose or background.

When it's time to move on from head shots to longer views, I explain that I will demonstrate each pose myself so she will see how I want her to be. I will be the first to admit I get some strange looks when I show the clients their full-length poses, but I believe you can't make someone look good in a pose until you can make yourself look good in a pose. I will demonstrate three or four poses that are similar but not the same. (This is the technique of variations discussed on page 67.) This lets the client have a voice in the outcome of her session—as well as seeing that if a 47-year-old man can make a pose look good, she should have no problem.

The most effective way to pose your subject is to literally show them what to do.

Once she selects her pose, I start placing each part of her body as we have already discussed to maximize the corrective techniques and make her look as good as humanly possible. Once her pose, clothing, and hair are perfect, I refine my lighting—then I am ready for the first test. (*Note:* I say "refine" because my assistant will get the lighting close; I then adjust it to that client.)

AFTER THE SESSION

Because we shoot JPEGs, the files take just a few minutes to download. So, after the mother and senior have a cup of coffee or bottle of water, the images are ready to view.

To sell portraits right after the session, you must understand sales. Uneducated clients, meaning those who are not trained in professional photography, can only make one decision at a time. Therefore, we first have clients select their single favorite pose from each idea we have taken. The next decision is the package—based on the size of wall portrait they want. Once the package is selected, then the individual images are brought up and they choose which images they want to fill their package with. Once the images are selected for the package, add-on items are shown and ordered. Then, the money is collected. (*Note:* Studies have been done showing that the first thing a buyer sees sets their expectations. If you want to sell slideshows, videos, or folios, by all means show them to the client first; they will definitely want to buy them. If you want to sell wall portraits, show them portraits first.)

PROCESSING THE ORDER

Once the order is placed and the money is in hand, the images go to the lab. We have our own lab with a chemical printer. At this point, because money has been paid by the client to have enhancements done on their images, we Photoshop to finish our images, refining the final portraits. Photoshop is never used until money is paid for it to be used. Many photographers waste a lot of time downloading raw images, editing, pre-touching, and making a slideshow before a dime has ever been collected. This is the way a hobbyist would approach photography—so excited about all that could be done that they never stop to consider if it should be done.

CONSISTENCY IS KEY

This system works because we inform our clients of the entire process and provided an exceptional product—consistently. Many photographers can take incredible images, but not consistently. When you look in the average client's session at the average studio, you see images that range from outstanding to slightly better than they could get at the mall. The content of the session will also be greatly determined by the appearance of the client. This lack of consistency isn't just about technical skills, it's also about attitude

DON'T OVERSHOOT

I go to senior conventions where speakers talk about shooting as many as six hundred images in an hour-long session, then explain that this is the way they work in their studio. My billable rate in our studio is never less than twice what our attorney charges us (and many times it will be three or four times more)—and you don't make that kind of money per hour editing images! When shooting film, I would take eight shots per idea—because each frame of film cost us (for the film itself, the developing, and the proofing). Digital has reduced these hard costs, but there is still the expense of time, which costs a great deal more than film and processing did back in the day—especially considering most photographers want to edit their own images.

The key to shooting fewer frames is exercising more control. I control my lighting, color temperature, and the exposure—as well as composing each portrait as close as possible to the way it will be cropped in the final image. I have many shooting areas, with different styles of lighting and different main-light sources, but when you look at the images you can't see a discernable difference between the images taken in one area and another. We'll discuss this in greater detail in chapter 9.

When you refine every aspect of the image during the shoot, your images will be ready for the sales session right out of the camera—without need for pre-touching or processing.

and enthusiasm. More often that not, if the photographer is a male and the client is stunning with sexy clothing, the entire session will be great. If she is average looking with plain clothing, she'll get the run-through of the same old things. If we want to maximize our sales at every session, we have to shake off this attitude and start delivering our best work in every image and for every client.

9. DIGITAL FILES

It doesn't make sense to spend your time correctively lighting and posing a client only to create a digital file that, in and of itself, contains flaws that will have to be corrected to make the image salable. These potentially time-consuming problems include some concerns that are largely unique to digital. For example, with film, who cared about the color of light? It was your lab's job to print out any color cast and match all the skin tones. You could also set your exposure by guess (as long as you were overexposing slightly) and you would end up with a usable image—at least most of the time. I am, of course, exaggerating (well, at least somewhat)—but there was a great deal of latitude when using film. Between the forgiving nature of negative film and the good work of a quality lab, you didn't have to worry about much! Digital is a whole different story.

COLOR CONSISTENCY

With digital, the color of light matters—it will change the entire image. Automatic white balance works most of the time, but be prepared for certain colors of clothing and shades of backgrounds to throw off the color across the entire image. In addition, with digital, you (or someone from your studio) have to make all the skin-tones from a session match. This means if you don't get it captured correctly in the first place, all your profit will be eaten up trying to match inconsistent skin tones.

The first person who helped me as I converted my studio from film to digital told me, "When capturing a digital image for a session, consistent color is more important than good color!" These are the truest words ever spoken to me on the subject of digital portrait photography. I can en-

Maintaining consistent colors from shot to shot—especially in the skin tones—is important.

To use Levels to color correct, include a gray or white card in your first shot of any pose where the lighting or lens will change and, in turn, change the color balance. We use a card that is half medium gray and half white. In certain photos, you will find that Photoshop gives a true color with the white card; in others it will be with the gray. These variations are caused by the overall tones and colors of the image.

hance poor color and make it salable, but if I have inconsistent color and exposures, I will kill myself trying to match the skin tones to satisfy the client.

Manual white balance is the digital photographer's best friend. White balance your cameras correctly (read your camera manual for how to do this) and do it every time you change anything with regard to your lighting or lenses. If you work outdoors using natural light, set the white balance every time you change a scene; it will affect the color temperature and the overall look of the photograph.

If you have problems with consistency, use a gray or white card to help you match the skin tones from one scene to another, or one style lighting to another. To do this, white balance your digital camera, then take the first photograph of the client in the pose holding gray card or white card in front of them. With a true gray or white card in that first image, you can quickly color balance the images in Photoshop. Simply load the first image of each scene (the one with the grey or white card in front of the subject) and go to Image>Adjustments>Levels.

At the bottom-right corner of the box, you'll see three eyedroppers: one is black, one is gray, and one is white. If you used a gray card, select the gray eyedropper; if you used a white card, select the white eyedropper. Just click on the card with the correct eyedropper and you will see the color adjust to make the card true gray or true white. You

can then save these setting for all the images in the series (those with the same lighting setup and scene). This will remove any color casts, but it will not typically give you ideal color for the client's skin tone. The idea here is just to make all your images a consistent color from one background or scene to another. Once you have consistent color throughout the session, then you can adjust the color, contrast, and saturation to achieve good skin color.

EXPOSURE

The second friend of the digital photographer is the histogram, a breakdown of your digital image in graph form that shows the tones that make up the captured image. Although most of the time your image won't fill up the entire histogram, for the average scene or setting your exposure needs to be set to fill up at least two-thirds of the histogram for a quality exposure. There are times, in a very low-key or very high-key image, where everything in the image is very dark or very light, that the histogram will show less-than-normal use of the full tonal range, but that is because of the overall lack of dark or light tones in these images.

All professional digital cameras and most digital cameras for hobbyists have an image information button you can push to quickly see the histogram when setting up your shot. Many photographers set up their camera so that a histogram appears alongside the image preview for each expo-

AN EFFICIENT WORKFLOW

Photographers who grew up with film had an established workflow that safeguarded and stored images from their capture to their delivery. Most of that workflow was handled by an outside lab, so as long as you didn't lose the roll of film or misplace the negatives, you were in good shape. With digital, most of the work in the workflow is now yours. How do you store and safeguard your images, ensure correct filing of the proper images, and retrieve them when it is time to work on the final order?

In our main studio, we have eleven shooting areas and seven camera stations. Each camera is connected to a networked computer. When we shoot an image, the camera downloads the portrait to the media card in the camera and then through the cable to the computer. We use the software that came with our camera to create client files and assign file names to each image. For example, on camera one, we have each file read "cam1," then the camera adds a sequential number. So each file reads "cam1-0001," "cam1-0002," and so on. This saves time when we gather all the images from all the shooting areas. We don't have image numbers that are the same, which often happens without a set prefix. This also gives salespeople a way to explain which setup a particular file is ordered from.

Given our volume, we have one person whose sole job is to sit at a computer burning station, which is networked to all the cameras and sales computers. When a session is complete, one of my assistants hands the person at the burning station the client card with all the background selections listed on the back. This way, he instantly knows which computers will have files of the client on them. He gathers all the camera folders and puts them into one client folder, then burns two CDs of the original images and places them in the client card (which is actually an envelope). After the day's last session, he goes to all the cameras and removes the media cards. He then downloads all the images from the cards into a daily backup folder. He burns two copies of this backup and puts them into a file we keep in the studio.

When we photograph outdoors, we go to a separate location rather than using a shooting area in back of the studio. I choose locations that have a natural look, so I am often standing on a hillside, in a river, or on rocky cliffs. This is not ideal terrain for lugging along a computer, so we shoot our images only to the media card in the camera. Once the session is over, I have my assistant download the images onto a laptop so the images are stored in two places until we get back to the studio. Then, two CDs are burned of the files stored on the laptop.

With the CD backups made (whether from a studio or location session), the client envelope moves from the burning station to a salesperson. Once the session is viewed, the client's envelope (with CDs, order invoice, and special retouching requirements) is put into production and waits for processing. We track the orders by date and divide them by services needed. We process all orders with 11x14-inch or smaller prints in the studio and send anything 16x20 inches or larger to our lab. Orders that need to be sent to the lab and/or include artwork for client approval are given first priority.

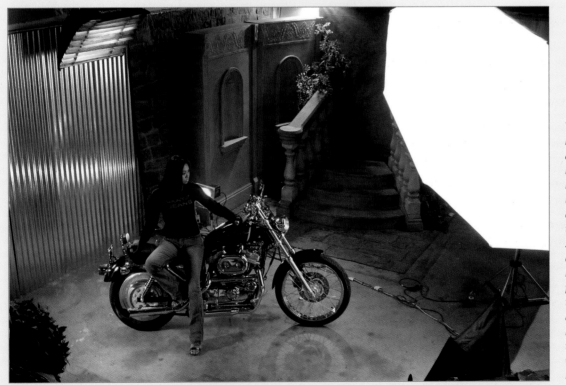

This is one of our largest shooting areas, where the largest props and backgrounds are used. To avoid excessive equipment, the room is designed for the camera, computer, and lighting to work from the center of the room. This avoids major movements and reduces the number of network cables running into the area.

sure. I prefer not to do this, because it reduces the size of the image in the display and, once the exposure is set properly, I don't need to see the histogram; all the images from the same setting will record the same.

As a film guy, when I first started into digital I thought that checking the LCD display gave me all the information I needed about the exposure of my images. Boy, was I wrong! The display is great, but it is so bright that slight variations in exposure can go unnoticed. Additionally, underexposing an image actually makes the skin tones look much richer on the display but doesn't capture the needed information for a quality image. Now, some of you just read that last statement about underexposed images and thought, "But I can fix it!" No you can't—at least not if you want to stay in business, have a life outside of the studio, and make enough money to provide your family with the things they should have.

If you want those things for yourself and your family, you need to get out of the "I can fix anything" mentality. When you start using the histogram, setting the manual white balance often, and using gray or white cards, you will be on the right track—and you'll start reducing your digital imaging costs.

FILE FORMAT

The first decision you must make when you consider workflow is the type of files you are going to capture. I, like most photographers, tend to go overboard when it comes to image quality. So, naturally, when I started shooting digital, I shot in the TIFF mode. The file size was huge and the download time was slow, but it provided the best quality—or so I thought.

One day, the rep from my lab showed me 20x24-inch prints of a pose captured at three different settings—one as a TIFF, one at the largest (least compressed) JPEG setting, and one at the smallest (most compressed) JPEG setting. At the 20x24-inch size, I saw very little difference between the highly compressed JPEG and the TIFF, but there was a slight difference. I saw no difference, however, between the least compressed JPEG and the TIFF.

I told him I wanted to see my own images in the same comparison, so I shot three identical portraits in each of the three file types and sent them to the lab. The results were the same. At that point, I started shooting low-compression JPEGs. This decision was based on the fact

FILE SIZE

Many photographers purchase cameras or backs that provide more information in each file than they really need. If the largest file size can produce a 40x60-inch print, but you only sell 16x20-inch prints, you need to make a change and stop wasting time with files that are larger than what you need. Reduce the size of the file your camera is capturing, or sell the camera/back and buy one that will produce up to a 20x24-inch print size (then put the money you saved in the bank). Cameras are tools, not toys.

that I deal with seniors and, typically, a 20x24-inch is the largest wall portrait they will purchase. If I photographed families and regularly sold 30x40-inch prints, I would still use the TIFF (or RAW) setting.

Many photographers are absolute quality freaks and, as a result, end up wasting time and money. It goes beyond the capture of images—it also involves the storage of images. They believe that files should only be saved as TIFFs or PSDs and with no compression—that way, no quality is lost with opening and closing the same image repeatedly. Of course, repeated saving of compressed files will degrade the images. When a file will need to be opened more than once, for additional retouching or other reasons, we save the in-progress file as a TIFF, then save the final file as a JPEG. For the vast majority of our images, however, we open them up, do all the corrections, then save the final files in the JPEG format. This means our files are only saved twice as JPEGs, once at capture and once for the final order.

The image preview is used for artistic considerations, such as pose, background, and composition; the histogram is the guide for exposure and lighting. Learn to use both to improve the overall quality of your images.

Given the extensive quality testing we have done at our largest normal print size, why would I have my employees waste any time saving their work and burning CDs of every file in the larger TIFF format? If there is no difference in quality at my largest print size, why would I fill up my computer storage space and have my machines run slower? The moral to the story is to use a file format that provides you with an adequate result in the shortest amount of time. Time is money, and profit is king!

I was once at a seminar where the teacher told everyone, "If anyone in the room thinks they are good enough to shoot JPEGs in the studio, you're wrong!" Are we so lazy and so sloppy that even with custom white balance, a large digital preview, a histogram, and highlight alerts (for overexposed areas) we cannot produce a high-quality image in the controllable environment of a studio?

This guy was as old as I am, so he shot film. Like me, I'm sure he even had occasion to shoot slide film in the studio. Shooting digital is exactly like shooting slide film—but back then we had only two instruments available to test the lighting and exposure: a light meter and a Polaroid back (unless, of course, you used a 35mm camera—and then you just had a light meter). We produced amazing images on slide film using these minimal tools, so why wouldn't we be able to produce a high-quality JPEG file in the studio with everything the modern digital camera has to offer? Give me a break!

On that note, however, I should mention that RAW capture does give you options that shooting JPEGs

doesn't—especially when it comes to color balance and exposure latitude. Therefore, I do shoot RAW files when I am photographing outdoors, where changing light and conditions can create problems in JPEG images.

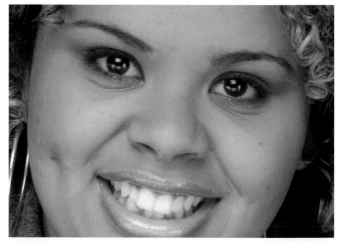

Enlarged view of image saved in TIFF format.

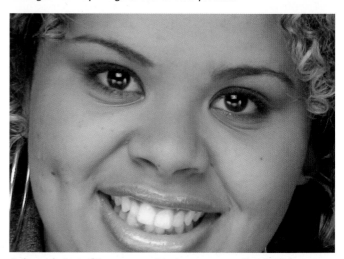

Enlarged view of image saved in low-compression JPEG format.

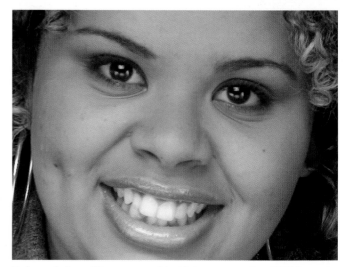

Enlarged view of image saved in high-compression JPEG format.

TIPS FOR SHOOTING JPEGS

When shooting JPEGs, use a custom white balance and check it often. If you use more than one main light in your studio, make sure each light is the same brand and equipped with the same type of flash tube (and the flash tubes are all the same age; color temperature changes with age).

While you are getting used to JPEGs, get in the habit of stringing your lights to ensure they remain at a consistent working distance. This will help you eliminate any variations in exposure. To do this, you tie a string to each light that can change in distance to the subject or background. Before each subject gets to the set, you then use the string to measure the distance of each movable light to the subject position, ensuring you are at your normal working distance and starting exposure. While you will change these positions to adjust for the unique qualities of the subject, getting in this habit gives you a starting point—and a much more consistent file without having to meter each and every time.

10. DIGITAL RETOUCHING: WHO PAYS THE BILL?

Now that you've done everything in your power to pose and light your subject in a way that corrects any areas of concern in their appearance, you can go on to consider how digital imaging can further improve your images. This is still a relatively new step in most photographers' workflow—and it represents a significant new expense.

I should have designed this book to make this chapter 13, since Photoshop and the excitement that some photographers feel about it have driven them to the point of near bankruptcy. Repeat my words: "We are photographers. We make money with a camera. We consume time with a computer."

I don't care about all that Photoshop "can do." Do you want me to blow your mind? I am still using Photoshop CS2. How can this be? It's simple: Photoshop is expensive and my current software does everything I need it to do! So, while other photographers are spending thousands of dollars on the latest version of Photoshop (for each of their computers), I'm putting that money in the bank. That's why I have a beautiful home, investment properties, a Viper, and a Harley. That's why I am 47 and semi-retired; I am businessperson who sells professional photography, not a hobbyist who has to buy every new toy I see.

That being said, I *do* want the images I present to my clients to be as beautiful as possible. The ideas I will share with you in this chapter, however, are based on achieving that goal efficiently. If you put into practice the techniques I have presented throughout this book—if you do your job

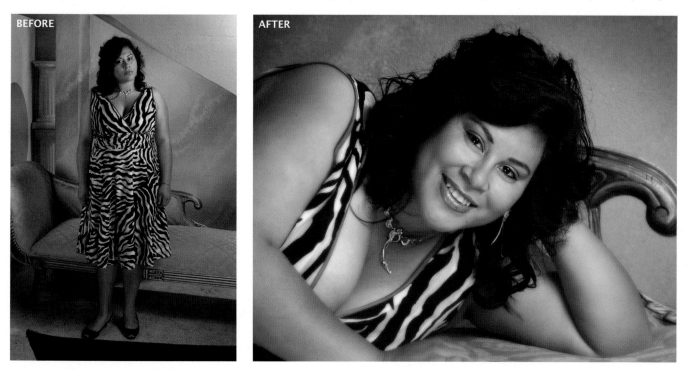

When you learn to light and pose your average clients so they look great, you'll reduce the amount of postproduction time.

in the camera room—you'll be amazed how little time you'll need to spend correcting problems in Photoshop.

THE WORST-CASE SCENARIO

Let me give you an example of a typical Photoshop Guy—we'll call him Joe Smuckenstern. Joe is a nice guy who has long dreamed of becoming a photographer and has recently been released on the public to create "art." Joe is product of the digital age, believing that every problem can be fixed in Photoshop. His session today is a family with eight children. Joe is thinking, "That's a whole lot of eyes right there!" So Joe shoots about five hundred images. After the session is over, he locks himself in his home office to start editing all those images down to a workable number. Yes, his children want his attention. Yes, his wife is threatening to leave him. Yes, all that sitting around means

he can no longer see his feet. But he believes that this is what you must do—mostly because the guy at the workshop said this was the way *he* did things. Yes, the guy at the workshop was also divorced and hated by his children . . . but he must be doing something right—after all, he was giving the workshop!

Finally, long after his wife and children are already asleep, Joe is done editing the images and creating a slideshow presentation from the session. Several days later, the client comes back into Joe's Studio and looks at the images. She likes them; her favorite one has everyone's eyes open (which is a miracle in itself) but Dad has a funny smile—at least to her. Since Joe never learned anything about sales and handling objections, he resorts back to his Photoshop-can-fix anything mind set. He offers to take Dad off of one pose and put it on another. He figures that

When you start creating images that look great straight out of the camera, you can stop spending countless hours in postproduction.

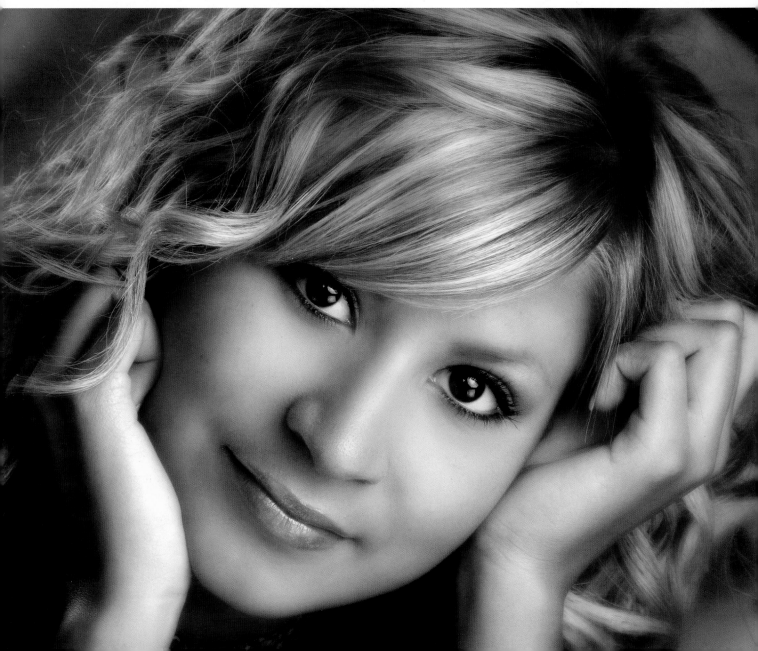

he shot everything on a tripod, so it should be just a matter of placing the bad smile image over the good smile image and erasing Dad's head to reveal the better smile underneath. The client likes this idea and a sale is made.

Back at the computer, Joe is getting the images ready to send to the printer. He starts the head swap but soon realizes that he must have bumped the tripod because the heads don't align. Because it was a windy day, the lighting and background also look different each pose (the wind moved some branches that were blocking the light). The correction is going to take much longer and be much more complex than he thought—and the best part is this: he is not getting paid for his time.

SO WHO PAYS?

Who will pay for the time it takes to retouch or enhance your images? The answer to that question could easily determine whether or not you are in business five years from now. Do you correct everything for the price you charge for an 8x10-inch print? Do you provide only simple retouching for acne, wrinkles, and circles under the eyes for the print price, then offer more extensive retouching that is billed directly to the client? Do you bill all retouching to the client?

Who pays should be determined, in part, based on how you price your work. If you charge $100 to $200 for an 8x10-inch print, you will probably include all the needed retouching and enhancement in the price of the print. At those prices, you would probably have few clients who would be willing pay for additional enhancement. If you price your work in the $40 to $100 range for an 8x10-inch print, you would probably want to include basic clean-up for acne, lines, and circles, then bill out any major enhancement costs to the client. If you price your 8x10-inch prints from $15 to $40, hopefully you don't include much retouching at all—at that price, there's not enough profit to cover the time needed to do retouching (unless, of course, you sell thirty 8x10-inch prints of the same image).

Most studios that offer lower-end pricing have a "pose charge" or "retouching fee" to cover the cost of basic retouching. More extensive retouching is then billed by the hour in fifteen-minute increments. For a fair billing rate, simply call your lab and ask what they charge for digital enhancement. When setting our prices, we determined that our lab charged $60 an hour for digital correction, so we

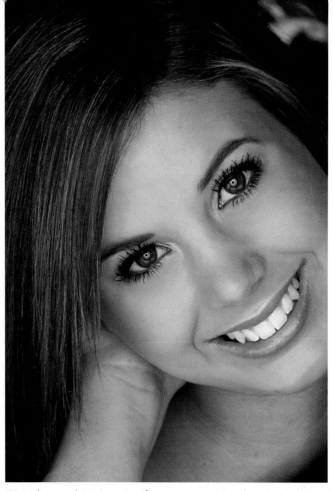

Digital retouching is a significant expense. So who pays it: you or your client?

adopted this rate for our work at the studio. Whether a job takes three minutes or thirteen minutes, the client pays for fifteen minutes. This averages out so that the jobs on which you quote too little time are covered by those that don't require the entire fifteen-minute allotment. Remember, valuable time is spent on enhancement, so you don't want to just cover the cost, you have to make a profit on the service—just like your lab would.

WHAT'S INCLUDED

Of course, the problem that most photographers have isn't setting up a way to offer their retouching services, it is explaining to the client what is included in the service. If you sell your 8x10-inch prints for $100 and vaguely tell the client that the images are completely enhanced, what do you do when the client looks at the final image and tells you they appear too fat in the photograph and you need to fix it? How many rolls and chins can you stretch and cover for $100 and still make a decent profit?

I have people come into the studio every day who think we can fix anything with the click of a mouse. They don't

NEVER SKIP RETOUCHING

The one thing that is even more damaging to your business than charging too little for retouching is letting any image go out of your studio without retouching. Every image that leaves your studio is a representation of your work and forms your reputation in the community. If you release work that has blemishes and doesn't represent the best that you can do for your client, you are shooting yourself in the foot.

understand that although almost any correction can be done, many corrections simply take too long to be cost effective. Communication is the key here. You have to inform your client, in writing, about what you do include and what you don't include in your print price. If you charge a retouching fee, you have to outline very carefully what types of retouching procedures this covers and give examples of work that isn't included.

In our studio, we work with high-school seniors. Seniors have traditionally been offered a lower price per 8x10-inch print due to the fact that they purchase a package. I am not the person who came up with the idea, I just have to live with it and find a way to make the best profit I can. Because of this, we include a "pose-change charge" or "image fee." This covers basic cleanup of the face—eliminating acne, softening lines and wrinkles, and removing the darkness under the eyes. The fee is the same whether the person has one zit, no zits, or a face as red as a beet from acne scars—and the client does not have the option to eliminate the fee if they don't want retouching.

Anytime you impose a pose-change charge, as is common in most senior-portrait studios, you will have frugal parents who don't want to pay it. You will get comments like, "She looks good enough!" or "They don't need retouching on that pose!" or "These are just for her friends!" To avoid this confrontation, we call this charge an image

IMPROVE OR ELIMINATE?

Many clients expect difficult corrections to be flawless. This can get you into trouble. When a complex correction is requested, sit down with the client and explain what can be done and ask them what they expect from the correction. Removing braces, eliminating eyeglass glare over the center of the eye, smoothing wrinkles on clothing with patterns—all of these things can be done, but they can take a significant amount of time to make perfect. You have to clearly define whether the client wants to improve the problem or eliminate it, and then make sure the client has approved paying for the time it will take to accomplish that.

fee and explain that it covers the color correction, testing, and retouching of each image. This is a legitimate statement, because often the color correction and testing do take longer than the actual retouching—and with senior packages, unlike normal portraiture, the first print isn't priced significantly higher in order to cover these costs.

COMMUNICATION

In my experience, most problems that arise between a business owner and a client are nothing more than a lack of communication. I believe in over-communication with my clients. When they call to make their appointment, they are sent a brochure and consultation CD, which explains what to bring in and how to plan for their session. It also discusses what retouching is, what is retouched, and what isn't. It gives examples of bad choices, like wearing glasses that have glass in them, and informs them of how much the retouching for this type of mistake can cost. Suggestions are also given for avoiding common problems like wrinkled clothing, messy hair, white socks with dark pants, ugly toenail polish, etc.

The whole idea here is to make the client aware of what their responsibilities are. If you don't inform your clients as to what to do and not to do, you deserve to be sitting in front of your computer every night retouching problems that could easily have been avoided.

Because this is such an important issue, we display posters in each sales area showing what normal retouching

We are careful to discuss normal retouching, which is covered in the image fee, as well as extra corrections that might need to be made if the client plans poorly (and what these will cost).

Taking the time to adequately educate your clients is a key factor in creating salable images.

covers and additional corrections that can be done and billed to the client. To fill in the time after the session and before the image presentation, we also have a video set up. This explains the image-selection process, emphasizing that it will be easy and fun. It also explains retouching, noting that the images they are about to see are not yet retouched, describing what normal retouching is, what image fees are, and showing the available special effects options, like vignettes and black & white. It ends by explaining that a trained assistant will guide the client through all these options.

In taking all of these steps to inform our clients, we have greatly reduced the conflicts that can arise from retouching. Most of the time clients will ask, "How much will it be to whiten her teeth?" or "How much will it be to remove that hair?"

Digital correction is no different than any other service you offer in your studio. You have to establish prices that make it profitable, explain to the client how much you charge, and then monitor the actual time you take doing it to avoid reducing your profit.

SALES TECHNIQUES

By the time our clients see their first image they have been well educated. This is why our clients spend as much as they do—and why, when a pose needs correction, they don't argue about who's paying for it.

If digital retouching is requested, we show examples of similar corrections made for other clients (to give the client a realistic expectation). A complete explanation of the process is given and a total time and fee for the correction is written on the slip before the client signs it. If the correction is complex, we set up a time for the client to come in and view a test print to ensure they are happy with the correction before we print out the order and complete the correction on all the poses they have ordered.

I can't stress enough the importance of educating your client about the portrait-buying process. I talk with so

While this may be your thirty-thousandth session, often it is your client's first, so teach them how to have a successful experience with your studio.

many photographers who do nothing but complain about their "ridiculous clients." Yet, when I ask what they did to educate their client about whatever issue created the problem, there is always a long pause or a completely dismissive comment. While this may be your thirty-thousandth session, often it is your client's first, so teach them how to have a successful experience with your studio.

THE LONG AND SHORT OF IT

Because I think like a businessperson, I do everything I can to use Photoshop as little as possible. Some photographers question my philosophy about Photoshop and selling after the sale—but as I was writing this section I went onto my Facebook account (the one I have for photographers, not clients). It was about 8:45PM here in California, but three photographers were posting that they had just finished editing down the images from the day's sessions—and these

photographers were all from time zones one to two hours later than mine!

It made me think about thought how crazy this was. I had finished my last session at 4:00PM (almost five hours earlier) and walked out of my studio without a care in the world. My staff finished the last order at 6:00PM. Both my staff and I were totally off work—free to enjoy our families and lives—and the money from the day's sessions was ready to go into the bank the following morning. These night-owls, on the other hand, were using the too-popular approach of over-shooting, editing down, creating a slide presentation, viewing a week later (if the client shows up), trying to sell prints (to client who has just seen a moving slideshow and now wants to buy that presentation), finally selling those prints, and then promising to fix everything in Photoshop. It's no wonder so many photographers are completely stressed out!

There is no single right way to run a business, but there is a single way to evaluate your success: look at how much of your time it took to create a certain amount of profit. (And, yes, you must count the time you work at home. That is the most expensive time of all—because family therapy and divorce attorneys don't come cheap!) There are photographers who operate highly profitable businesses with average orders of $400. Hour for hour, these businesses out-earn studios with much higher per-session averages because they don't invest countless hours of time making that $400 sale. This is why you'll often hear photographers talking about session averages—it makes them look successful! They don't like to talk about their hourly averages, because that makes them look unsuccessful—and not very smart.

It's a simply process: you account for every second you spend on clients' sessions and everything you have to do before and after the session. You total your time then you divide the total sale by the total hours. Doing this will quickly put the use of Photoshop into perspective. Photoshop is a great tool that should only be used when it is absolutely necessary—and never by you, the photographer, on a client's images. That's a job you can hire someone to do. Always remember the golden rule: We are photographers. We make money with a camera. We consume time—and lower our billable sales per hour—on a computer.

11. NORMAL RETOUCHING

What is "normal" retouching? That has to be determined by you, the photographer, and the expectations of your clients. The first step in retouching an image has nothing to do with Photoshop. As the photographer, it is up to you to determine the look you are going for and then map out the method you want your computer people to use to achieve that look.

RETOUCHING STYLE

Just as photographers have a photographic style, people who work in Photoshop have a style of working with an image. That style is based on what looks good to them and the way they learned to do the task at hand. If you have four people working on your images, your images will have four distinct looks in regard to the retouching and corrections that are done. In my studio, I do very little of the computer work on the images from my sessions, but I control the process used for all the retouching and corrections. This ensures a uniform look from one session or order to another.

This was a hard lesson to learn, because there are egos involved. When our computer staff first grew to include several new people, I spent a day with each of them demonstrating how I retouched and corrected the most common problems in a senior's image. They all nodded and smiled through the training and said they were impressed with the way our photographs looked. I thought all was well—until the orders started coming out of the lab.

One computer person used the Healing Brush instead of the Clone tool and ended up with dots all over the senior's skin. Another blended the overall skin tone very well but was unobservant when it came to cleaning up all the blemishes. You could easily see that the retouching (and

THE "GOOD STUFF"

I know some photographers are waiting to get to what they consider the "good stuff"—the head swaps, the breaking off of a subject's arm to change its angle, etc. That's what we love to learn about: the extremes of corrective techniques. Although photographers love to talk about it and love to see it being demonstrated, that is not what you are going to spend 99.9 percent of your computer hours doing. What is going to make your studio work move smoothly is learning how to do basic corrections efficiently. I have been using digital for quite some time and I have never been asked to change the angle of a subject's arm or move a head from one family photograph to another. That is because I learned everything that we have discussed to this point and I do it well and consistently.

color correction) had been done by different people because there was no continuity.

We started training all over again, except this time I showed my new employees the fruits of their labor and explained why it was unacceptable. I then retouched an image the way I wanted it done, printed it out, and held it up next to theirs. The images not only looked like they had been retouched by different people, they looked like they came from different studios with different photographers!

There were two retouchers who knew much more about computers than I did—one of them was older and one was younger. The younger of the two saw the difference in quality, realized the validity of what I was saying, and currently runs my studio's lab. The older gentleman explained why he preferred his way of working in Photo-

At the conclusion of retouching, subjects should look great—but they should also still look like themselves.

the eyes eliminated and the darkness on each side of the bridge of the nose lessened. I feel the eyes must "pop," so I want both the main and secondary catchlights enhanced to draw the eyes of the viewer to the eyes in the portrait. I like a more glamorous look in my images, which is reflected in my style of retouching.

It is my job to outline for each computer person the specific steps, tools, and settings I use to obtain the look that I am going for. If they don't produce that look, it is not their fault—it's mine.

DON'T GO TOO FAR

The idea here is that we want to replace what the negative retoucher used to do on film and improve it where we can—but without crossing the line between reality and fiction. I have gone to programs where the instructor has advised enhancing the skin color to look as though a perfect makeup application was done, enhancing the color of the eyes, even making the bust appear larger on almost every woman. This is crossing the line between reality that a client can live with and creating a whole new person.

This idea of changing too much is not a new one. Years ago, when boudoir photography was popular for the first time, every mall had a Glamour Shots—a studio devoted to making each woman look as different as possible from the way they looked every day. They used very heavy, dramatic makeup and a tricky little hair comb that would bring all of the woman's hair from the back to the front, making in essence a hair wreath around her face. They would then spray and tease the hair wreath as much as possible (because back in the day "big hair" was thought to be sexy).

Back then, the mother of the one our seniors had very large wall portrait done at one of these places for her husband's birthday. When he opened the framed portrait, he got a huge smile on his face and he said, "This is absolutely beautiful—it looks nothing like you!" Ouch!

This is exactly what happens when you cross the line between enhancing an image and creating a new person by over-enhancing an image. Our subtle flaws make us human—and that's what your subject's loved ones expect to see in a portrait.

OUR PROCESS

The following is a detailed description of the procedures we use to achieve the look I want. You may use different

shop and that, in all his experience, his was the best way to retouch an image. After he finished, I explained that I only know how to do three things on a computer: make money, find the fastest way to accomplish what needs to be done, and achieve the look I want my photographs to have. Beyond that, I don't care how it works or what else it can do. Needless to say, he is no longer employed by our studios.

The method of retouching you will use is the most important process to establish, because it is done on each and every image ordered. If you can't master this, you will constantly send out work that has no distinct style or look. This sounds very complex, but it isn't. Simply make notes on each step you take and the tools you use to get an image ready to send to the printer. This gives your employees a step-by-step guide to follow to ensure consistency.

The look I want for my seniors is smooth skin with no blemishes, blotchiness, or shine. I want the darkness under

tools, different settings, and have different methods to obtain your studio's standardized retouching—and that's fine as long as you have a standardized retouching process for your studio.

Retouching the Subject. After the image is opened, we color correct the image, because adjustments to the contrast, saturation, and color will change the appearance of the skin.

Once color correction is done, we look at the print size that is being ordered from the pose being retouched. The final size will dictate how much retouching is done. If only wallets are ordered from a full-length pose, very little retouching will be necessary. If, however, the client has ordered a 20x24-inch print of a head-and-shoulders shot, the image will require more extensive retouching to achieve the same look.

We instruct our computer people to retouch the image about two to three times larger on the screen than the largest print size that will be made from the file. If you are retouching for wallets, the image on the screen should be a 4x5- to 5x7-inch size. If you are retouching for an 8x10-inch print, the image should be 11x14 to 16x20 inches on the screen. Of course, these dimensions are just approximate. The point is to keep your computer people from

over-retouching, which wastes time and money. If you don't see this as a problem, go in and watch people retouching. Whether the final output size is a wallet or 30x40-inch print, they will have the image magnified to see just the eye and part of the nose on the monitor. This wastes a huge amount of time. Retouching by size keeps your orders moving as quickly as possible.

When retouching, I have my staff remove all blemishes, soften lines and wrinkles, soften circles under the eyes, and reduce shadows around and under the nose and under the lip. While dark shadows work well to conceal the width of the face, they are too noticeable on the side of a larger nose. Note that I say we "soften" not "remove" lines, wrinkles, and circles; we want our clients to look like people, not like they have vinyl skin.

When retouching, we start off with the Clone Stamp tool set at 23-percent opacity. Why 23 percent? I like it better than 22 or 24, to be honest—but as long as it's in this area, it really doesn't matter (now, 33 percent would matter). We start at the top of the face and work down. Typically, we start off with the skin between and slightly above the eyebrows. It is a middle-tone skin color and is good for lightening the darker areas and darkening the shiny areas.

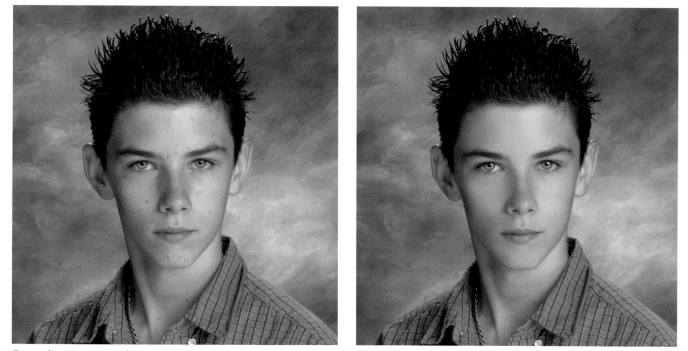

Every client image needs to receive standard retouching using the same tools and steps to the same level of correction. We start off using the Clone Stamp tool to blend the skin. Once the problem areas are softened, we correct any shadows areas that are too heavy or off color. The final step is to enhance the catchlights with the Dodge tool. We count the number of clicks on the first eye and then duplicate them on the second eye to avoid a noticeable difference between the catchlights.

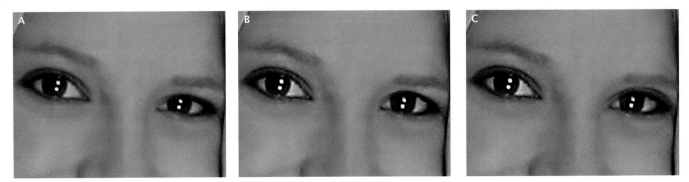

Most of the time, you can make uneven eyes (A) look the same size by matching the catchlights in the eyes. Even though the opening of each eye will still be a different size, if the catchlights look identical, the problem will be less visible. If this doesn't work, the next option is to use the Liquify filter to enlarge the smaller eye. As you do this, you may notice that it distorts the upper or lower lid of the eye (B). If this happens, use an area from the uncorrected eye to replace what has been distorted (C).

Rather than trying to remove individual blemishes, I like using a large, soft-edged brush to blend large areas of skin. We select the Clone Stamp, press Opt/Alt, and click to sample the area to be cloned. While holding down the left mouse button, I start making sweeping motions across the skin. For general smoothing, one sweep is enough. For problem areas that have shine or bad texture, multiple passes are needed to blend away the problem.

I look at retouching as a way to correct flaws both in the client but also in the photographic process. There are differences between shooting digital and film. Despite all the benefits that digital offers, it also has shortcomings. Digital doesn't work well with oily skin that reflects light. Shadow areas also tend to pick up colors other than the skin tone, getting darker and darker as the shadow recedes to near black. Even when the subject has a beautiful skin tone, the shadows will often have a greenish appearance, and normal shine on the skin will often glow. These are problems that need to be corrected. A simple swipe from the Clone Stamp tool and the greenish cast is lessened by adding in skin color. Because we use a lower opacity, the shadow isn't drastically lightened.

There are other shadow areas and areas of the skin that can appear too dark and need to be corrected, as well.

WHICH TOOL TO USE?

There are many ways to accomplish the same task. Some photographers like the Healing Brush, some work with the Patch tool. I have tried them and I found they worked well but didn't give me the look I wanted. I found the Healing Brush often created a spotty appearance (although if I had one enormous zit to retouch quickly, that would be my tool of choice). The Patch tool is great for retouching skin, but I find it slower for me (and my computer people) to work with. Time is money, so I use the Clone Stamp tool.

These are the shadows on each side of the bridge of the nose and under the bottom lip (with a subject with full lips). You may also need to adjust the skin color all around the mouth and chin. Since the main light is closer to the top of the face than the bottom, the skin in this area often appears slightly darker and needs to be lightened to match the rest of the face.

Once I've retouched the entire face with a large brush, I go back to any areas that need a different size brush and more or less opacity. When the skin is smooth, the blemishes eliminated, and the shadows corrected, I move on to the eyes.

To enhance the eyes, I use the Dodge tool (at a low opacity) to lighten the whites, then remove excessive red veins in the eyes using the Clone Stamp tool.

Next, we move on to the catchlights. I use the Dodge tool, setting it to 50 percent and Highlights in the options bar at the top of the screen. I select a soft-edged brush that is approximately the size of the main catchlights. I position the brush over the first catchlight and count the number of clicks needed to make the catchlight as bright as I want it. I then go to the other eye and repeat the same number of clicks over the second main catchlight. This way they appear to have the same brightness.

You can use the same process when a client has one eye that appears to be smaller than the other. Typically, the reason the eye seems smaller is that you see more of the main catchlight in the larger eye; in the smaller eye, some of the catchlight is usually hidden by the top eyelid. If you enlarge the catchlight in the smaller eye to match the size and brightness of the catchlight in the larger eye, both eyes seem to be the same size.

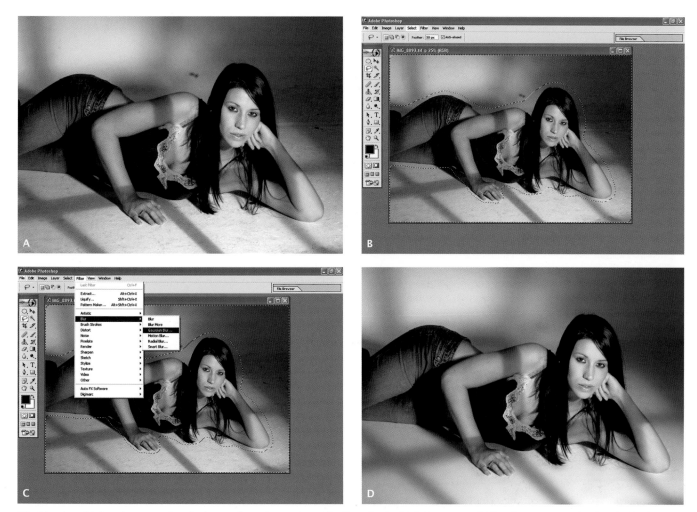

Working in a high-volume studio, the issue of marks on the white floor in the high-key areas (A) has been an ongoing battle. In the summer, which is our busiest time, we paint the white floor every two days—but the marks soon return because of the amount of traffic. To hide these marks, we select the area (B) and use the Gaussian Blur filter (C). This produces a clean background (D).

This is the extent of retouching that comes with our normal retouching fee. Any other retouching is billed to the client and falls into the "extensive" retouching category, which is offered to the client with a quote sheet.

At this point retouching is basically done—and so is the money that has been paid by the client to cover the time it takes to enhance the images. The last step is to check for any little problems I might have missed when shooting. The retoucher will look for bra straps peeking out or any wrinkles in the clothing that can easily be removed. (*Note:* Some mothers are wrinkle freaks. If any extreme wrinkle removal is requested, the client will pay for the time.) The retoucher will also check for things like spaces in a young lady's bangs or a strand of hair that is completely out of the place (99.9 percent of the time I fix it before I take any photos, but every once in a while something slips by!). A few seconds with the Clone Stamp tool can fill in missing

hair or remove a strand of hair that was overlooked. One final check the staff also does is for bulges that can be easily reduced (using the Liquify tool) to improve the client's appearance. Again this must be a correction that can be done in a few seconds; if it requires more time than that, they won't do it.

Retouching the Background. After the subject is completely retouched, I look at the entire image to see if there are any flaws in the background/floor. We are a high-volume studio, so our white floors and sets get marks on them throughout the day—including those from having the Harley rolled over them! This is not something I want my clients to see, so we have set up a simple action to blur and slightly lighten the floor to hide any marks or spots. Sets can also get chipped, or there can be a small cup or piece of trash off in the distance of an outdoor background. I catch most of this, but I am not perfect so the retouchers

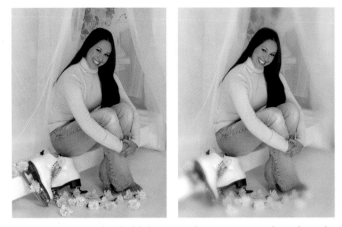

Vignettes are used to hold the viewer's attention on the subject by reducing or eliminating lines that lead out of the frame. With film, you would use a vignetter on the camera; with digital, you just add a vignette before the image goes to the printer. I normally use the Marquee tool to select an oval area, then feather the selection to 200 pixels for a blended look. I inverse the selection, then use the Brightness/Contrast command to darken/lighten it. I often blur the area as well, as seen in the final image (right).

check each pose and use the Clone Stamp tool to remove/ repair anything that should not have been there.

Vignetting. Once the retouching is complete, the final step is to add a vignette to the image if it is requested. A vignette simply makes the image darker, lighter, or blurrier around the edges. Many painters use this darkening of the edges around the point of focus as a way to hold the viewer's attention where it should be. There are no rules to follow when it comes to vignettes. Some photographers use them around the entire image, some just at the bottom of the frame. I have examples of the vignettes we offer in the sales areas, and I have the salespeople suggest the appropriate vignette for the image (or the client can choose not to have a vignette—the choice is theirs).

The process of preparing the image for the vignette is the same whether you darken, lighten, or blur the selected area. For a complete vignette, select the Elliptical Marquee tool, set the feather amount to 200 pixels, then click and drag over the focal point of your image to select an oval area of the height and width you feel is appropriate. At this point, right mouse click and choose Select Inverse, which will select everything outside of the subject area. At this point, you are ready to create your vignette. If the portrait is low key (darker background), go to Image>Adjustments>Brightness/Contrast. Reduce the brightness to create the desired effect. If the image is high key (light background), follow the exact same steps but lighten the se-

lected area until you get the desired effect. I seldom use a white vignette. I prefer to blur the selected areas of high-key portraits. This adds a dreamy look, rather than just turning edges white, and can be done using the Gaussian Blur filter.

For a vignette on the bottom of the image only, the process is similar; you just use a different tool. Select the Lasso tool and draw a U-shaped selection around the feet and off to the sides of the image, then continue the selection along the outer edges of the bottom and sides of the image. Once the selected area is where you what it, simply use the above methods to darken, lighten, or blur the area for the desired result.

Converting to Black & White. We have one more step in finishing the average order. Many clients like the look of black & white, so we need to convert color digital files to black & white images. This is a really simple thing that photographers have tried, with all their might, to complicate. I have seen actions that involve fifteen steps! Again time is money, so if you have a favorite method for converting images to black & white and it is saved as an action, that's great. We produce many beautiful black & white images with a two-step process. We desaturate the image (Image>Adjustments>Desaturate), which takes the color out of the image, while leaving the image in RGB mode. At this point the photograph will appear flat and lack contrast. We simply boost the contrast by 10 points (Image>Adjustments>Brightness/Contrast) and we have a beautiful black & white image. If you want to add a warm tone, add red and yellow to the black & white image, but again, put it into an action and make it standardized so everyone's color is the same. For more on actions, see chapter 14.

When creating black & white images, using an action ensures consistent results.

Spot coloring is a popular look for senior portraits.

Spot Coloring. Another common request for seniors is spot coloring—leaving selected areas of color in an otherwise black & white image. For some, the color area is their eyes; for others, it is the accent color in a cheerleading uniform or letterman jacket.

To create this effect, we duplicate the background layer, and then turn the top layer black & white. Next, we go to the background layer to lighten it and increase its saturation. Returning to the top (black & white) layer, we erase the areas where we want the underlying color to show through.

Once these areas are erased, you can return to the background layer and tweak the color/saturation to achieve the desired look. Some people want natural colors while others want a heavily saturated look.

That's it! Now the vast majority of your clients' orders are ready to go to the printer. You have profited because you have been paid for your time spent correcting the images, and your clients are happy because they look great. Next, we will start discussing ways to correct problems created by the client (which they will pay for), as well as the photographer (which you will pay for).

12. OTHER COMMON CORRECTIONS

All that we have discussed leading up to this point has dealt with getting the average original image out of the camera and preparing it for the printer. You have done your job in the camera room, the client has done their job preparing for the session—life is good. Now, we will start to discuss the most common corrections that are needed when things don't work out as they should. Sadly, the most common corrections for the average photographer don't have anything to do with the client but are caused by the photographer himself.

POOR FOCUS

I started into photography when everyone used Hasselblads, Mamiyas, or Bronicas. Everyone had bright screens that aided their focus, until their eyes went bad and they had to rely on corrective optics for the finder. The first autofocus cameras were like a godsend! Finally, we could relax and not have to focus back and forth until the image was crystal clear. I have been using autofocus cameras for the

If an image is slightly lacking in sharpness (left), digital sharpening filters can improve the situation (right).

last seven years and I love it—except when they don't focus on the area I want in focus.

More often than many young portrait photographers think, even a quality autofocus camera will actually focus on a point other than where it originally focused. We all get a little lazy or distracted from time to time and end up concentrating on the session while letting the camera worry about focus. This leads to a serious situation when the client's favorite image is the one in which the autofocus decided to focus on the branch beside Dad's head instead of his face.

You have to realize that no matter how good a sharpening tool you use, there are many photographs that are simply too out of focus to be fixed. The second thing to remember is you must fix any focus problems or eliminate the out-of-focus pose before the client sees it. If you let a client see a soft image and then try to fix it, it will never be clear enough; they will always be looking for signs of the shot being out of focus.

Basic sharpening of an image is a two-step process. First, you need to bring detail to the area that should be in focus. Next, you need to eliminate sharp detail from the mistaken point of focus in the background or foreground.

Let me explain. Most photographers confronted with a problem of unwanted softness go to their favorite sharpening tool: Unsharp Mask (Filter>Sharpen>Unsharp Mask). They adjust the amount of sharpening to be able to see detail in the subject. The problem is, this also proportionately increases detail in the areas that were already in focus. So even though the client does now have some detail in their eyes and clothing, the rock, tree, or painted background still has a great deal more detail because it has been sharpened, too. Therefore, your eyes still see the subject as soft.

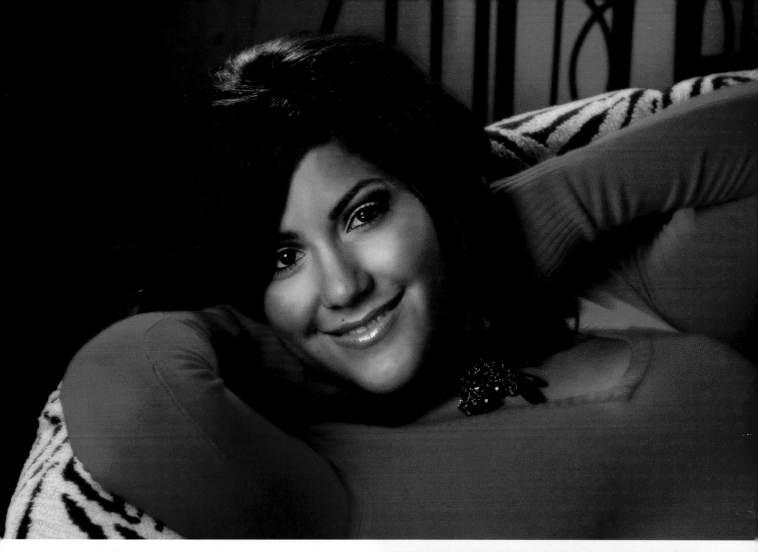

In portraits, the critical areas of focus are the eyes and lips.

The easiest way to approach this problem is to select the in-focus area with your Lasso tool, then blur it with the Gaussian Blur filter (Filter>Blur>Gaussian Blur) to a point that it appears more out of focus than your subject. Also, look for any other elements in the photograph that have more detail than the subject and soften them, too. Once the subject is the sharpest point in the image, use your favorite sharpening tool to increase the detail on the subject. For extremely soft images, you may want to select just the subject to sharpen. In either case, you must create adequate detail on the subject without giving the image an unappealing oversharpened look. If you can't accomplish this, trash the image before the client sees it.

The eyes are the windows to the soul; if they appear to have detail, the rest of the portrait will, too. Therefore, the final step is to enlarge the image on screen to view just the eyes. Start by defining the catchlights as we discussed previously. You will then define the distinct lines of and

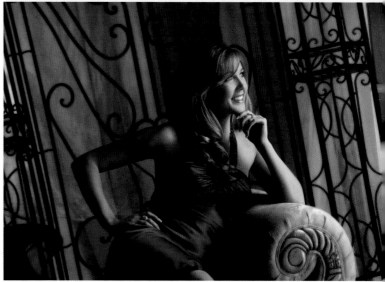

around the eye. How you work will depend on the size of the image—whether it's a head-and-shoulders shot, full-length, etc. If the photo is a close-up, you can define the line around the color portion of the eye as well as the eyelashes. In a full-length photo, defining the catchlights is

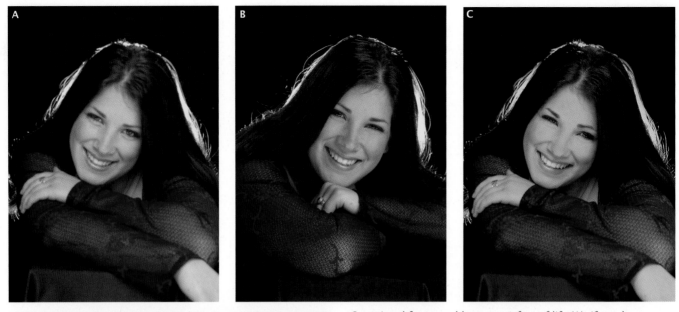

Occasional focus problems are a fact of life (A). If you have a second image that is almost the same but sharper (B), you can place the soft image on a new layer over the sharp one. Then you can erase the eyes, hair, and eyebrow area of the soft image (as seen in the screen shot to the left) to reveal the more detailed versions of these areas in the underlying image (C).

about all you can do without making the photograph appear unnatural.

If you have a second image that is almost the same but sharper, you can, as a last resort, place the soft image on a new layer over the sharp one. Then you can erase the eyes, hair, and eyebrow area of the soft image to reveal the more detailed versions of these areas in the underlying image.

This only works well, of course, if you used a tripod or camera stand to create the portraits; if you handheld your camera, the images won't line up perfectly. In an area of the studio where we handhold the cameras, we recently had an autofocus lens that would indicate it was focused when it actually wasn't (it was close, but not perfect). Luckily, the lens died within a day of when the problem began. Another lucky break was that most of the orders for the images shot with this lens happened to be for small prints where the problem wasn't apparent. There was, however, one order

from a client who wanted an 11x14-inch print. Since all of the images from this camera were soft, we found a similar pose taken with a different camera in another camera area. We duplicated the sharp eyes, hair, and eyebrows and blended them onto the soft image. The final portrait made the client happy and saved the embarrassment of having to reshoot the image (which would have been difficult, because the senior had since cut her hair).

If none of these steps make the image appear focused, the image is not salvageable. You can spend the next few hours of your life trying to breathe life back into the image, but is it really worth it? The answer will be found in how many other poses were taken and if it is possible to reshoot the image.

POOR COMPOSITION

Another common photographer-caused problem comes from composing an image through a viewfinder that isn't formatted to the final composition of the images we must print out. If you shoot your digital images with a 35mm-style camera, the final output size should be 8x12 inches, not 8x10 inches. If you think this problem will be remedied anytime soon, ask a photographer who shoots weddings with a Hasselblad how the 5x5-inch frame market is

The end of the wall on both sides is a distraction (A). To extend the background, simply use the Marquee tool to select a strip of the existing background that is wider and taller than the area that needs to be extended (B). Copy this area onto a new image canvas (C), then drag the strip of the background back to the original image to fill in the area. For this particular photo, we then repeated the process on the left side to match the shade of white as it varied from one side to the other (D).

nowadays. (Hasselblad and some other medium-format cameras use a $2\frac{1}{4}$-inch square negative, thereby producing 5x5- not 4x5-inch proofs.)

When composing an image in a viewfinder that isn't formatted to the final composition size, we have two problems to consider. First, if we leave too much extra room on the top and bottom of the image to compensate for this difference, we waste our image quality by using only a portion of the file. If we leave too little space to compensate for this problem, we end up cropping off the tops of our clients' heads or their feet. No matter how careful you are,

at some point you will end up composing a photograph closer than you should. When this happens, your choices are to chop off some part of the client's body at the top and bottom of the frame, or to extend the background at the sides of the image to fit the print size.

This is one time not to use the Clone Stamp tool. This tool duplicates the pattern of the background too well, revealing the fact that the background has been duplicated. The easiest way to fix this problem is to open the original

Making sure that every aspect of the portrait looks just right is critical to producing salable images. This includes making smart decisions when planning and shooting the session, as well as when retouching the images.

then move one underlying layer to the left and one to the right, filling in the blank space with the background. You may need to do some cleanup with the Clone Stamp tool, but it is better than cutting off body parts.

POOR EXPOSURE

The next correction is one that all digital photographers hate to make. When you picked up your first digital camera the big warning you probably received was this: "Whatever

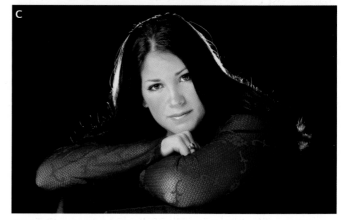

Overexposed images (A) can be corrected using the Multiply layer mode (B) to produce a better exposure (C).

image and duplicate the background layer (Layer>Duplicate Layer) giving yourself a copy to work on. Then, crop your image to the size you want it (set the height and width in the options bar). As you first click and drag with the Crop tool over your image, you will only be able to go to the sides of the photograph. At this point, release the mouse button and boxes will appear at the corners of the crop box. Click and drag on these to extend the cropping indicator past the sides of the image, composing the portrait with enough room at the top and bottom of the image. Then, hit Return to crop the image.

At this point, empty space will appear on each side of your image. In the options, delete your settings from the width, height, and resolution fields so nothing appears in those boxes. Then, crop the white borders off your image. This gives you an image that is the correct final height but narrower than the standard size. Now, create a new file that is the final size and resolution you intend your photograph to be (File>New). Copy the cropped image into your new blank canvas on three separate layers. Center the top layer,

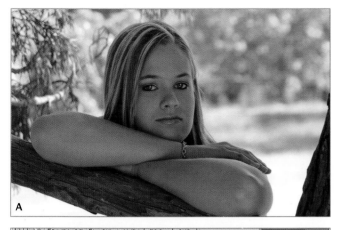

A

B

C

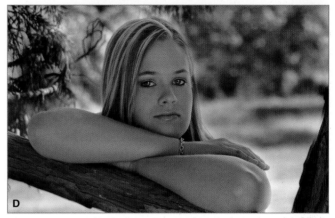

D

I work at outdoor locations throughout the day. This means that backgrounds can have hot spots or areas that, when the subject is placed in shade, will be in direct sun and appear much too bright for the exposure set for the subject (A). To ensure this isn't a problem, I photograph the subject. Then, when the subject leaves, I take one more shot using the exact same composition, but without the subject and with the exposure set for the brightness of the background (B). I do this for each background that I worry will be too light because of direct sun. Then, in Photoshop, I place the portrait on a layer over the background-only image and erase the light background area from the top image to reveal the darker foliage underneath (C). When this is completed, the result is an image in which the exposure on both the subject and the background is correct (D).

you do, don't overexpose your images!" Sooner or later, though, you'll be faced with images that are overexposed and that you can't reshoot . . . and you'll be just about ready to lay an egg! I will be the first to tell you, this correction isn't a flawless one—it isn't going to make the image look as good as it would have if you had exposed it properly—but with a little work, it may save your bacon.

This correction multiplies layers to build back the detail that was lost due to overexposure. There is a limit to the amount of overexposure this will fix, but it can help. The first step is to use the Clone Stamp tool to reduce, as much as possible, any glowing highlights. The success of this will be determined by the amount of overexposure. Once the glow is minimized, create a duplicate layer on top of the original. Open the layers palette and set the mode of the overlying layer to Multiply. Next, duplicate another layer on top of the image. You will notice it appears darker. If it is too dark, reduce the layer's opacity. If the image still appears overexposed, duplicate another layer.

As the layers build, you will notice the contrast increasing in the portrait. Once you are done adding layers, you can fix this by going to Image>Adjustments>Brightness/Contrast. Once the contrast is adjusted, flatten the image and use the Clone Stamp tool to conceal any highlights that are still blown out.

BACKGROUND PROBLEMS

Another good example of the use of layers is found when taking outdoor photographs. At my studio, we set up an entire day of outdoor appointments for a single location, so we have to deal with lighting as it changes throughout the day. Wedding photographers find themselves in the same

WHERE TO DRAW THE LINE

You have to learn not to eliminate every little problem you see on your client (the one exception is acne). Instead, you want to soften the appearance of these problem areas.

Photoshop has made it easy to alter a client's appearance to the point that the person doesn't look like himself anymore. A mother of one of my seniors once had a glamour portrait taken at one of the mall photo studios. She bought a large wall portrait for her husband, who opened the gift, looked at her and said, "This is absolutely beautiful—it looks nothing like you!" After several nights on the sofa, he probably wished he could rephrase his comment, but there was a great deal of truth in what he said. The lady in the portrait was beautiful, but she didn't look like his wife, who is also beautiful.

This is especially true if you work with older clients. How young do you want to make grandmother look? If Grandma is your client and she is looking for a new beau, she probably wants to look as young as possible in her portrait. If, on the other hand, the portrait is commissioned by a family member, they probably want Grandma to look her age. This would mean removing large liver spots and slightly softening the wrinkles and other visible signs of aging. Do more than that, and the lady in the portrait no longer looks like Grandma.

situation. How many times do you go to an outdoor location to create a portrait, place the subject in shade, and find that at least some of the background is in bright sun? With the shaded subject correctly exposed, the areas of the background that are in direct sun are blown out. To combat this, after the last shot of the subject, I have the client step out of the scene and I take a shot of the background, metering for the sunlit areas. I do this with each pose. When a pose with a blown-out area is ordered, I simply open the image without the subject (the one metered for the sunlight) then place the ordered image (with the blown-out background) on a layer above it. Using the Eraser tool, I remove the blown-out areas, revealing the properly exposed image data on the underlying layer.

We back up our school-dance and prom backgrounds in the same way. Once the background is set up and tested, we photograph the first image of the background only. If a gel falls off the light or a background light stops working and our photographer doesn't catch it, we digitally replace the problem area of the background with the first image without a couple.

WHITENING THE TEETH

Now, we move on to the most frequently used digital corrections to address problems with the client. Most corrections will obviously be done to the head and face, because this area is in each and every portrait you take.

Probably the most common enhancement we are asked for is for the teeth to be whitened—everyone wants to have that "perfect smile." White teeth should appear white if your images are properly color balanced; however, some people's teeth are not white in the portrait because they are not white in person. This simple correction is billed to the client. The average quote is for fifteen minutes. The correction usually takes less than five minutes, but we have the extra time if needed.

To whiten the teeth, we use the Sponge tool, which removes color. We use it at a lower opacity to avoid making the teeth look unnatural—because no one's teeth are com-

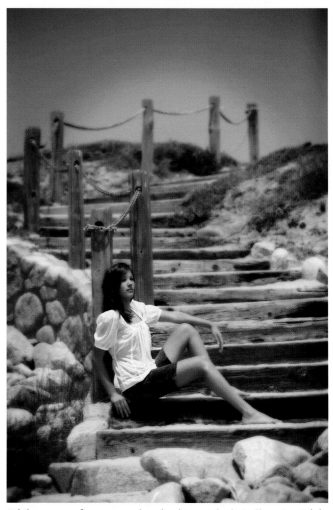

While you can fix your outdoor backgrounds digitally using Adobe Photoshop, remember that working in a carefully selected location that doesn't require you to do so will save both time and money.

Probably the most requested correction in portrait photography is to whiten the subject's teeth.

with small boxes on all four sides as well as at the four corners. To elongate the image, just put the cursor on the center box at the top of the photograph and drag it slowly upward. A little move goes a long way. Once you are done stretching Aunt Betty, click on the image and select Apply or Cancel, depending on whether or not you like the results. You should only try this if the client is standing with their body and arms positioned vertically in the frame. If the arms or legs run horizontally, stretching the image will just increase their size!

THE NOSE

As noted on pages 52–53, the nose is defined by the shadows on the sides of it and the highlight that runs down the center. To reduce the apparent size of the nose, reduce the shadows. The best time to do this is by posing and lighting the client carefully when taking the image. If you need to retouch the image after the fact, use the Clone Stamp tool, set to a low opacity, and clone lighter skin from the cheek onto each side of the nose. As the shadows diminish, so will the apparent depth of the nose—but don't overdo it! You can also make the nose less noticeable by reducing the brightness of the highlight that runs the length of it, as well as the highlight that usually appears at the end of the nose.

While shadows are our friends when hiding flaws, they can also create problems on the face. The shadow on the side of the nose often needs to be softened to avoid drawing attention to the size of the nose. A shadow that is too prominent can also make the eye socket appear deeper on the shadow side of the face than on the highlight side. To correct any shadow, use the Clone Stamp tool (set to a low opacity) to blend in a natural skin color while lightening the shadow. And remember, it is always better to undercorrect than overcorrect.

pletely devoid of color. Once the teeth are whiter, they typically need to be lightened. To do this, we simply select the teeth and brighten them slightly. Any visible plaque is then removed with the Clone Stamp at a lower opacity and, again, reduced but not eliminated. You can use the same technique to lighten the dark areas that appear between the teeth.

The basic rule here is to undercorrect rather than overcorrect. Teeth are an area of the face that is best left alone, so the less you can do with them the better. It is very easy to make teeth look unnatural. When corrected, the teeth should have a bit of color and appear slightly brighter—not noticeably bright or pure white.

SLIMMING THE SUBJECT

Some photographers skew their portraits, elongating them to make their clients appear thinner. Here again you risk changing the appearance of the subject to correct a problem. If you want to try this, open an image and go to Edit>Free Transform. A line will appear around the photo,

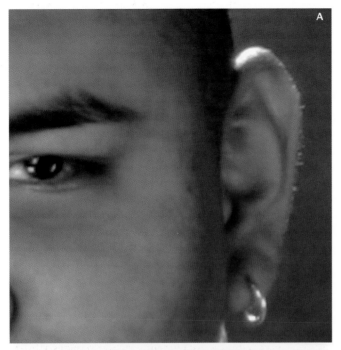

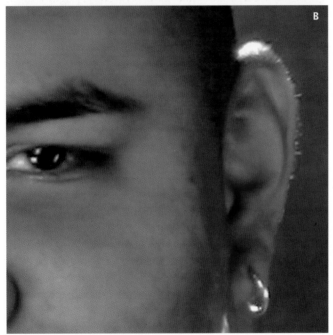

If you have to deal with correcting the ears after the shoot (A), the Liquify filter will help. With some subtle work, a better look is achieved (B).

THE EARS

The ears are usually best handled while shooting (see pages 51–52). If you have to deal with correcting the ears after the shoot, the Liquify filter will help. To begin, select the subject's entire head, then go to Filter>Liquify. A full-screen dialog box will appear with a preview of the selected area. Using a large brush, nudge the outer line of the ears inward toward the head, reducing their size.

Even a thin person can have a less-than-flat stomach. To correct this, use the Liquify filter. Select the area of the bulge, liquify it, and then use a brush to nudge it so that it disappears.

TUMMY BULGE

The Liquify filter is also the best way to handle a less-than-flat-stomach when the subject is in a profile position. Select the stomach area (the tummy bulge) and, with the brush, push the line of the stomach back toward the body. Make sure that as the correction is done, lines don't get distorted. This is a very helpful tool for those clients whose outline could use some correction. I have used this on everything from wide waistlines to thick hips. Just make sure the line of the body part you are working on stays a line without unnatural hills and valleys (you will see what I mean when you use the tool).

OPENING EYES

Opening eyes is something every photographer should learn how to do—it can often save a sale.

We have never had to use this particular correction with our senior photography, because there is always another pose to select from, but we have had to use it in our prom and school-dance photography. We always take two shots of each couple at a dance, but there have been occasions where two, three, four or even five shots have been taken of a couple and either the girl or the guy (whoever is the blinker) has their eyes closed in all but one—and, of course, that's usually the one shot in which their date blinked. (On top of that, he or she will also turn out to be the son or daughter of the superintendent or principal of your largest school.) Of course we would swap heads for them—but wait! She likes her smile better in one of the poses where

You have two poses, one with the eyes open and a large smile with braces (A), the second with the eyes closed and a better expression on the mouth (B). Assuming the images are otherwise identical, you can place the image with the eyes closed on a layer over the image with the eyes open. Then, select the Eraser tool and erase the closed eyes from the top layer, revealing the open eyes (C). You have just made a customer happy in less than a minute!

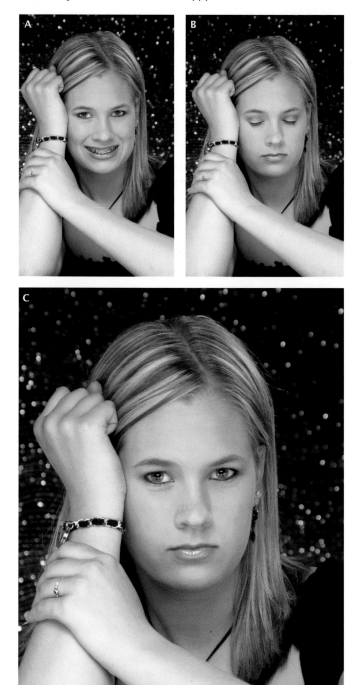

EYEGLASSES

There's a lot you can do in Photoshop—but much of it won't be necessary if you plan the session properly and do your job in the camera room. For example, we don't photograph people with eyeglasses if I can see a reflection in them. Many of today's glasses are non-glare; with a little change in lighting, most of the time it's fine. However, if I can see a reflection in the lenses, my clients know they will either have to take off their glasses or agree to pay for a very costly correction. We explain this in all of the pre-session information our clients receive and strongly suggest that if they want to wear glasses in their portrait, they should get empty frames from their optometrist.

her eyes are closed, so she wants both of her eyes and his swapped.

To quickly switch the eyes in this kind of situation, we use the layer technique that was described on pages 105–6. We start with the image with the girl's eyes open, then place the image with the correct smile on a layer over it. Select the Eraser tool and set the brush size slightly smaller than the size of the closed eyes on the good-smile layer. Erase the closed eyes, revealing the open eyes in the image underneath. Once it looks perfect, flatten the image (Layer>Flatten) and repeat the process with the image that has her date's eyes open. This works well, provided the images are composed exactly alike.

STRAY HAIRS

Another commonly requested correction is the removal of stray hairs. Even though we always look for this problem while photographing, some hair styles just naturally have hairs going in directions they shouldn't. The process of retouching a stray hair isn't difficult. I use the Clone Stamp tool, but this time with a high opacity and a hard-edged brush. This is because I want to completely cover the problem hairs with the background and do so without affecting any of the other hairs.

There are two problems that photographers often run into with this type of correction. First of all, they don't remove the stray hair or strand at a point where it looks natural. To avoid creating a chopped-off look, you must follow each stray hair back to a point where another hair or hair strand crosses it. This leads to the second problem, which is quoting enough time for the correction to be

Stray hairs, especially when lit from behind, are a nasty correction to make (left). The technique is easy enough; use the Clone Stamp tool to clone the background over each strand of hair. The problem is knowing when to stop. You must follow each hair back to a point where it intersects with another hair (B). If you take out every last stray hair, it looks unnatural.

done properly. We can give most quotes without even examining the image. With hair, however, what may look like a five-minute job often takes twenty minutes or more. This is especially true when the hair is highlighted from behind and the strands are glowing.

BRACES

In years past, we would have a few clients each year ask us to remove braces from their son or daughter. We recently stopped offering to do this because of the intensive work required to produce natural-looking results. Instead of correcting this in postproduction, our staff works with our clients to make appointments after the braces are off. If that is not possible, we work with the seniors to avoid huge smiles in close-up poses.

FINAL THOUGHTS

This completes our look at the most commonly requested corrections that clients are usually willing to pay for. You will notice we didn't talk much about head-swapping or putting a third eye in the middle of a client's forehead, because the market for both procedures is fairly limited.

Although Photoshop has given the average photographer the ability to quickly retouch many problems that used to be too expensive to correct using film, it doesn't mean that the digital photographer must do his or her own corrections—or at least not all of them. It's just not cost effective to do so.

I know many photographers who provide the basic retouching for all their work and have their lab provide all major corrections, things that will be billed to the client. This is also a good approach for the photographer who lacks experience with Photoshop. You might do the simple corrections yourself and have your lab handle the more difficult enhancements until you gain the needed experience to do all of your own retouching (or build your business to the point where you can hire a staff member to do it).

We live in a time where everything can (and if you are an American, should) be fixed by a pill, a plastic surgeon, or Photoshop—that's just the way it is! Once clients hear that you are digital photographer, they think you can fix anything! "I don't need to put on makeup," they think, "be-cause the photographer will put it on for me!" What a wonderful, joyous time we live in!

Yes, I'm being a little bit sarcastic, but there is still a great deal of truth in this. People in general, and our clients specifically, do want to look perfect, but they don't want to

As seen here, corrective lighting and posing can make a huge difference, but at some point people still have to accept the way that they actually look.

Both men and women have problems in the under-chin area (A). Using the Liquify filter, the lower part of the face (the chin and jowl area) can be reshaped (B). After some additional blending with the Clone tool, the result is natural looking and more flattering (C).

get out of bed to shower and shave (so hitting the gym is pretty much out of the question). No one thinks anyone notices as they grow through the dress sizes and develop a neck like a linebacker. Then they have their portrait taken by you, you lucky dog. You strain through the session, using every trick in "the book" (actually, in my book!) to make this client happy with the way she appears. Then the moment of truth arrives—she looks at the proofs and shrieks, "Who is that wildebeest in my portraits? You claim to be a professional photographer and you create photographs that look like this? I've taken better photographs at home with my point-and-shoot!"

So now what do you do? At this point, you have already explained about normal retouching, what it does and does not fix, as well as digital correction and the fact it is billed to the client, right? If you have, you can ask what it is the client doesn't like about the portraits. Once the client has calmed down, she will tell you the problem areas she worries about the most. It is your job to graciously explain the cause of these problems, then educate the client about what can be done to correct them.

WEIGHT ISSUES

Some of the most-requested corrections stem from clients being overweight. These problems can be imagined by the near-perfect female who feels her hips look too thick, or they may be very real concerns from a very overweight person who just wants to look better.

You will find the first signs of weight gain on a man at his waistline and the area under the chin. Women's extra weight also shows up in these areas, but the most common problem areas are the hips, thighs, and upper arms (if they are visible). Women also have issues with the appearance

of rolls, which are often caused by their undergarments or the waistband of their pants.

Unlike typical corrections of the facial area, retouching the body requires more time and the use of multiple tools and techniques to fix a single problem. For example, if a woman with weight issues wants the rolls caused by her bra and waistband taken out and she wore a blouse with a strong pattern, that's going to be a difficult task. Not only must you remove the shadow area (where the clothing folds in) to smooth the appearance of the roll, but you must also keep the pattern of the clothing from becoming distorted.

A common weight-related correction is to make a double chin less noticeable. You'll recall we covered techniques for minimizing this concern with lighting and posing (see pages 50–51). If you need to address this issue at the retouching stage, the first step is to soften the line that separates the "natural" chin from the "double" chin. Without this fold, the double chin is less noticeable. The next step will depend on the shape of the double chin. If the double-chin area is small, you can often quickly fix the little bit of saggy skin by using the Liquify filter and selecting a tool to push the skin up. The success of this will depend on the area around the saggy skin. If it is just more skin, chances are no one will notice the distortion; if, on the other hand, the client has on a high-collared shirt or blouse, this procedure may not be possible.

If this is the case, you will need to clone over the saggy skin while maintaining a natural look. This typically requires smoothing out the hills and valleys. If you think of retouching this way, it makes it easier to know what needs to be cloned. Weight problems, as well as age, create hills and valleys in the skin/body. Hills are usually only noticed

because of the valley or the shadow created in the valley. If you soften or eliminate the shadow in the valley, often you never notice the hill. You will find that not all double chins are fixable—at least not in an amount of time that can reasonably be billed to a client.

AGE-RELATED CONCERNS

In older clients, extra skin under the chin is related to the widening of the face on either side of the chin that occurs as we age. To remove the double chin without thinning the face in the jowl area would make the client look completely unnatural.

Wrinkles are part of a mature person, so they need to be softened, not eliminated. Often, the subject's eyes will need enhancement to whiten the whites and bring back the sparkle the eyes once had. The skin on the neck also needs to be smoothed, softening the cords that often become visible with age. When dealing with mature clients, we also brighten and whiten their teeth (unless they have dentures, which obviously don't age).

In a portrait of a mature person, all of these areas needed to be addressed in order for the correction to make sense visually. This would be considered standard retouching when working with mature clients.

MULTIPLE ISSUES

As noted above, you must often deal with multiple issues in order to have the corrected portrait look natural. For example, if the client has a weight issue, how can you correct some of the problem areas without addressing all of them? Let's say you have a heavy girl in a sleeveless top and she asks that you make her arms smaller. If you just make

The retouching for a person over forty needs to address the signs of aging that occur in all of us (left). If we just eliminate wrinkles, it looks unnatural. Look at each area that is affected with age. The skin needs to have the lines softened, not eliminated. The eyes typically need to have the whites retouched and the catchlights enhanced. Our faces tend to widen as we age, and this needs to be addressed. We automatically whiten the teeth and soften the neck area. Only when you address all these areas do you come up with a complete correction that looks natural (right).

Many photographers get very stressed trying to achieve perfection when they have already achieved greatness. No matter how beautiful the image, they always say, "Well, I wish I had done this or that differently."

her arms smaller without addressing her larger hips and waistline, it will just re-focus her attention from one of her problem areas to another. Therefore, when you give her the estimate, you should quote enough time to address all of the weight issues instead of just the one that bothers her the most.

A problem with correcting weight issues is that a particular correction will work with a client in one pose and not in another. You can stretch a person as discussed on page 107, but this only works if the client is in a standing pose. You can work with the Liquify filter—but only if the part of the body you need to correct has a background without distinct lines or patterns directly behind the area you need to correct.

Look through the photographs in this book to see how we corrected the weight issues for these clients. Not every tool will work with every pose, so you just have to get

imaginative and figure out the fastest way to make any given correction.

GUIDING YOUR CLIENTS

Clients need to be guided through their decisions when it comes to retouching. How much is really needed? Is a correction really worth the cost of doing it, or is the client better off selecting another pose, or even just living with the pose without the correction?

Everyone needs to understand that there is a difference between "great" and "perfect." Almost every meal I have is edible; seldom, however, is a meal perfect. Although I eat out often and have been fortunate enough to eat at some truly exceptional restaurants, I have had only one perfect meal. We showed up early and were seated at great table right away. We had the best waiter we have ever had, the food was perfect, and my wife wore a beautiful dress

(which completed the experience). Although that was the only perfect meal I have had, I have enjoyed many great meals. I've been happy with my experience and recommended those restaurants to others.

Many photographers get very stressed trying to achieve perfection when they have already achieved greatness. No matter how beautiful the image, they wish they had done this or that differently. They won the print competition, but it wasn't good enough. When you create a beautiful image for your client and know that perfection can be achieved without an incredible expense, then suggest it. If great is as good as it can get, be honest; tell the client that the image is beautiful and it doesn't need correction.

Clients also need to be advised about all the options that Photoshop has given us. With film, I shot low-key images with a black vignette and high-key images with a clear crinkle vignette—unless of course I didn't want to use a vignette. The choice was mine and the client accepted what I created. With digital, we don't shoot with any vignettes, because they are so easy to add in Photoshop. The client can put any type of vignette on any image—and that's a choice that most clients can't make without some help. You have to explain their options and make suggestion as to what they should do.

I am a firm believer in the client calling the shots and being given as many options as possible. We have always allowed clients to select the backgrounds and poses they want done in their session. With girls, the mothers typically help with the selection. For years, I wondered what was wrong with our clients—the mother would pick out a full-length pose from the sample books, we would photograph it exactly like the sample portrait, and yet when the mother looked at it she didn't like it because it was "too far away."

I began to understand the situation better one day when I was up in the front of the studio and was asked to talk with an assertive mother suffering from this problem. The mother told me her daughter was too far away and she couldn't see her face. I explained that her daughter was photographed in the same way as the sample portrait she selected. The mother insisted the sample portrait was closer. I pulled it out of the book to compare the two photographs and they were identical. Yet, even with both prints in front of her she said her daughter looked smaller.

As I was talking with her, I realized something I never thought of before. When a mother looks at someone else's child, she sees the beauty in the pose, the set, and the lighting; when a mother looks at her own child, she wants to see her child. At this point, I realized that while clients need to make their own decisions, they also need guidance to make the right choices. We now make it a point to photograph each full-length idea in a close-up as well.

As we expand what is possible with digital and the number of options we offer our clients grows, so does the amount of guidance our clients need to make the decision that is best for them. No matter how detailed your advice to clients, however, you should also be sure to put everything in writing. If you are doing digital corrections, put in writing what the client can expect from it, state what the cost is, and then have them sign it. This eliminates any potential conflict between you and your clients.

More is possible with digital, so our clients need more guidance to make the decision that is best for them.

14. WORKING QUICKLY IN PHOTOSHOP

Time is money. Whether you are paying staff to work on your images or giving up your own free time or billable hours, every minute you are on the computer is a minute that costs you profit. With that in mind, I have some suggestions for getting the most out of your time and money.

REMOVE THE GAMES

The first suggestion is especially important if you have your staff work on your images. Remove all games from each computer in your studio and never have Internet access on the stations where you will be working on your images. I can't count the number of times I have walked in on staff members playing solitaire. Games should be outlawed on computers produced for business use. Not only does the Internet waste time, no matter how good your virus scan is you risk down time and lost work.

ISOLATION

Isolation is another important factor in profiting from digital correction. Most people can't work together without talking. Working on digital files requires concentration. Employees needs to have breaks and time away from digital

Achieving top quality results and efficiency in imaging requires undisturbed concentration.

Whether you are paying staff to work on your images or giving up your own free time or billable hours, every minute you are on the computer is a minute that costs you profit.

production, but make it as difficult as possible for your employees to talk freely. Use large partitions or black curtains around each desk—whatever it takes to keep each person at their station and focused on the job at hand.

In the studio, we believe in training our employees well. I show each person how much time is wasted when you stop what you are doing to talk with a coworker. The biggest problem is that, unlike talking on the phone to a spouse or boyfriend, when one employee is talking to another I have two people on the clock doing nothing!

To that end, we often look for quiet people to fill our production positions. The worst person to put into a production situation is a salesperson. At one point, I thought (frugal person that I am) we could fill in the time of some our salespeople by having them help with the retouching on the orders they had taken. Most of them were already familiar with Photoshop and quickly understood the process. The one problem I didn't foresee was that, because we hire salespeople who are friendly and love people, they talk and talk and talk. We actually got less work out of

five people than we did the original three! Each time I went into the lab, the gossip session abruptly ended and everyone scrambled back to their computers.

KEYBOARD SHORTCUTS
Another important timesaver is learning Photoshop's many keyboard shortcuts—combinations of keys that will accomplish any function or command. This saves a huge amount of time for the people involved in your production work.

ACTIONS AND BATCH PROCESSING
Actions and batch processing are great labor-saving devices for photographers doing digital correction. An action is a recorded digital process containing everything you want done to achieve a particular type of adjustment. Once you've recorded the steps for one image, you can use the action to replay them at will, applying the identical steps to any other image needing the same adjustments.

To create an action, open an image. Then, open the actions palette (Window> Actions). Click on the drop-down

When creating sepia-toned images, using an action ensures that the color will look just the way the client expects—and will match perfectly from image to image.

The creation of high-contrast black & white portraits can also be automated with an action.

menu at the upper-right corner of the palette and select New Action. Name the action as you like, then hit Record. Every change you make to the image will be recorded until you hit the Stop button (located at the bottom of the actions palette).

Actions not only increase the speed at which you accomplish your work but also ensure consistency. For example, we use an action to convert our color images to black & white. This action is installed in each sales computer. When viewing images with a client, all the salesperson has to do is hit the play button and the color image is quickly converted. Consistency is achieved, because the same action is used in all the computers in the lab—so what the client sees is exactly what they get.

A batch process (File>Automate>Batch) lets you apply any given action to an entire folder of files. Batch processing works well when you have a large number of files that all need similar corrections. This can save you a lot of time.

Let me give you an example. To prepare our images for printing, we open all the images that a client has ordered from and retouch each pose. Then we start recording a new action, as described above. The first thing we do is select Levels and make any needed adjustments, then we add saturation, sharpen the image slightly, and save the image into a file we create called "Current Order." Once we save the image, we crop it to 4x5 inches and then re-save the cropped image into a subfolder called "Proofs." Then we select Edit>Step Backward, which takes us back to the un-cropped image. Now, we crop the image to 8x10 inches and save the image into a second subfolder titled "8x10." We then select Edit>Step Backward again, then crop the original image to 5x7 inches and save into a third subfolder called "5x7." We then select Edit>Step Backward a final time, taking us back to the original image. We then stop the recording of the action.

At this point, we have created an action that can be used to color correct each image from the session and provide a 4x5-inch file for the folio, a 5x7-inch file for either 5x7-inch prints or wallets, and an 8x10-inch file to package the 8x10- and 4x5-inch prints. It then leaves the original image open for any larger prints needed from this file. It can be reused for each and every order placed from the session.

While this sounds good, many photographers are thinking, "Wait a minute! I like to adjust my color for each pose specifically, not have a general correction. And what about cropping? Not every image is going to be cropped the same!" That's why actions have a stop feature. On the left side of each command in the actions palette is a box you can highlight to make the action.

We also have an action made to place eight opened 4x5-inch files place onto a 10x16-inch sheet, flatten it, turn it in the correct direction to go through the printer, then save it in the "Print" subfile of the "Current Order" file (where everything goes before it goes to the printer).

Most of our special-effects portraits are also created using actions. When we use layers to create an effect, we have an action prepare the layers, add textures or effects, stop so we can erase the area we want to show through, then restart and flatten the completed image.

Using actions requires some forethought. Many photographers create a specific action that is used for only one order, then the delete that action only to create another identical action for the next order, because they want the action to save the image into a specific client's folder rather than a generic folder. This wastes time. We use generic folders for our actions, then transfer the images to a client folder or burn the work to CD so we don't waste time constantly creating actions.

Actions will save time and money, so sit down and think of ways to automate your work with actions—and remember to keep actions generic so they will work with all your images.

Working more efficiently in Photoshop will allow you to save time and money—while still delivering flawless images.

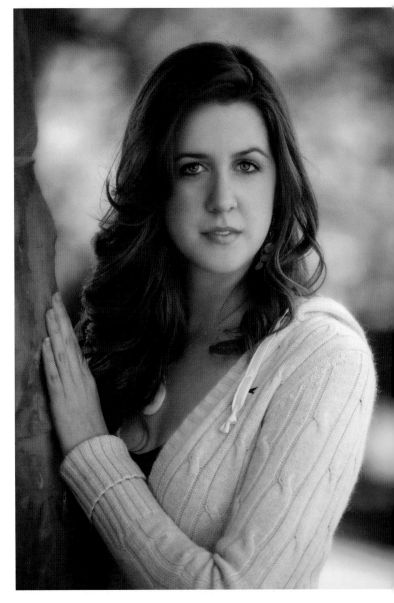

CONCLUSION

What photography student couldn't take a beautiful portrait of a beautiful person? Reality is exactly what the camera is designed to record. Unfortunately, many photographers base their estimation of their own level of expertise on their best photographs of their most beautiful clients. The problem is, these aren't the images that will sustain your business and your livelihood. To be a successful professional and enjoy a profit from every session (not just the sessions of beautiful people), you need to evaluate your least photogenic clients and see how you made them look. Do you give them a version of reality that they can live with, or is your mind working desperately to save your ego, by telling yourself, "What do you expect, she or he was too overweight, too short, too homely, etc.?"

When I was a young professional and trying to define the direction of my business, I really tried to make each client look his or her best. Quite frankly, in those days I couldn't afford to lose any clients. On one occasion, I had photographed a young senior girl who was probably sixty to eighty pounds overweight. I used a very contrasty light to have a very dark shadow, thinning the face. I used poses that hid her very large double chin from the perspective of the camera. I picked out her clothing, all of which was very dark, and used her long hair to soften the size of her shoulders and arms. At that point in time in the studio, I was both the photographer and the person who delivered the proofs to the client. When this girl and her mother came in to the studio and started to look at her proofs, the mother started to cry. The mother said, "I have always told my daughter that, despite her weight, she is a beautiful young lady and these portraits show the beautiful young lady she is." The mother gave me a hug and thanked me. This is a session I will never forget, because for the first time I un-

ABOVE AND FACING PAGE—*Comparing the "unposed" image above with the ones on the facing page makes it obvious what a huge impact posing alone can have on the subject's appearance. When this is paired with careful lighting and postproduction refinement, the resulting portraits are images that average people will be proud to show their friends and family.*

derstood how much a professional portrait means to our clients.

Digital technology has given today's professional photographer many new options and opportunities for achieving this goal—but it's also become an expensive crutch for

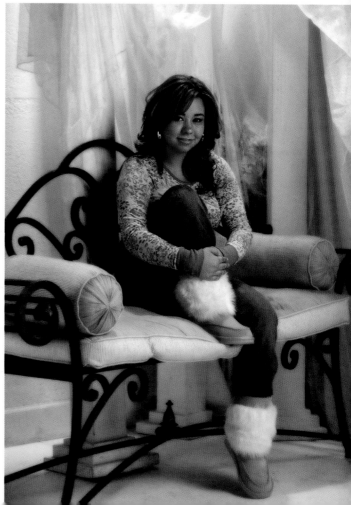

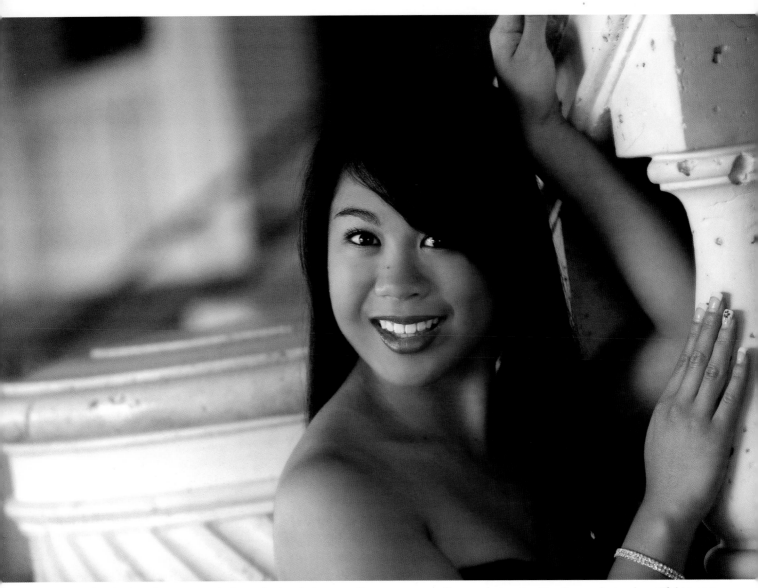

Digital technology has given today's professional photographer many new options and opportunities for producing beautiful images—but it's also become an expensive crutch for those who don't want to master their craft.

those who don't want to master their craft. Photoshop has provided us with a way to improve the basic retouching that all finished portraits should have, as well as cleaning up white floors, marks on sets, and other imperfections that occur in a busy studio—things your clients shouldn't have to suffer with. I am a firm believer in offering a client the very best product that is possible, but if you find that you are taking your great images and making them perfect without an increase in prices, you are on a slippery slope.

So, if I could leave you with one message, it would be to care about and have compassion for your clients—all your clients. Try to put yourself in their shoes and feel the way they are going to feel as they look at the work you create. Put the same effort into a session with a person who

has obvious flaws as you do into a session with the perfect people you invite to come in for test sessions. Measure your growth on how good you can make each client look, not on your best photographs of your most beautiful clients. Use digital to help you achieve this goal, but do so wisely, making sure you'll still be in business the next time your very satisfied clients are in need of your services.

I always like to hear from the photographers who read my books, if you have any questions or comments please e-mail me at jeff@jeffsmithphoto.com.

INDEX

JEFF SMITH'S GUIDE TO
HEAD AND SHOULDERS PORTRAIT PHOTOGRAPHY

Jeff Smith shows you how to make head and shoulders portraits a more creative and lucrative part of your business—whether in the studio or on location. $34.95 list, 8.5x11, 128p, 200 color images, index, order no. 1886.

JEFF SMITH'S SENIOR PORTRAIT PHOTOGRAPHY HANDBOOK

Improve your images and profitability through better design, market analysis, and business practices. This book charts a clear path to success, ensuring you're maximizing every sale you make. $34.95 list, 8.5x11, 128p, 170 color images, index, order no. 1896.

JEFF SMITH'S POSING TECHNIQUES FOR LOCATION PORTRAIT PHOTOGRAPHY

Use architectural and natural elements to support the pose, maximize the flow of the session, and create refined, artful poses for individual subjects and groups—indoors or out. $34.95 list, 8.5x11, 128p, 150 color photos, index, order no. 1851.

JEFF SMITH'S LIGHTING FOR OUTDOOR AND LOCATION PORTRAIT PHOTOGRAPHY

Learn how to use light throughout the day—indoors and out—and make location portraits a highly profitable venture for your studio. $34.95 list, 8.5x11, 128p, 170 color images, index, order no. 1841.

THE PHOTOGRAPHER'S GUIDE TO
MAKING MONEY
150 IDEAS FOR CUTTING COSTS AND BOOSTING PROFITS

Karen Dórame

Learn how to reduce overhead, improve marketing, and increase your studio's overall profitability. $34.95 list, 8.5x11, 128p, 200 color images, index, order no. 1887.

ON-CAMERA FLASH
TECHNIQUES FOR DIGITAL WEDDING AND PORTRAIT PHOTOGRAPHY

Neil van Niekerk

Discover how you can use on-camera flash to create soft, flawless lighting that flatters your subjects—and doesn't slow you down on location shoots. $34.95 list, 8.5x11, 128p, 190 color images, index, order no. 1888.

LIGHTING TECHNIQUES
FOR PHOTOGRAPHING MODEL PORTFOLIOS

Billy Pegram

Learn how to light images that will get you—and your model—noticed. Pegram provides start-to-finish analysis of real-life sessions, showing you how to make the right decisions each step of the way. $34.95 list, 8.5x11, 128p, 150 color images, index, order no. 1889.

PROFESSIONAL PORTRAIT POSING
TECHNIQUES AND IMAGES FROM MASTER PHOTOGRAPHERS

Michelle Perkins

Learn how master photographers pose subjects to create unforgettable images. $34.95 list, 8.5x11, 128p, 175 color images, index, order no. 2002.

COMMERCIAL PHOTOGRAPHY HANDBOOK
BUSINESS TECHNIQUES FOR PROFESSIONAL DIGITAL PHOTOGRAPHERS

Kirk Tuck

Learn how to identify, market to, and satisfy your target markets—and make important financial decisions to maximize profits. $34.95 list, 8.5x11, 128p, 110 color images, index, order no. 1890.

CREATIVE WEDDING ALBUM DESIGN WITH ADOBE® PHOTOSHOP®

Mark Chen

Master the skills you need to design wedding albums that will elevate your studio above the competition. $34.95 list, 8.5x11, 128p, 225 color images, index, order no. 1891.

CHRISTOPHER GREY'S STUDIO LIGHTING TECHNIQUES FOR PHOTOGRAPHY

Grey takes the intimidation out of studio lighting with techniques that can be emulated and refined to suit your style. With these strategies—and some practice—you'll approach your sessions with confidence! $34.95 list, 8.5x11, 128p, 320 color images, index, order no. 1892.

MASTER LIGHTING GUIDE
FOR PORTRAIT PHOTOGRAPHERS

Christopher Grey

Efficiently light executive and model portraits, high and low key images, and more. Master traditional lighting styles and use creative modifications that will maximize your results. $29.95 list, 8.5x11, 128p, 300 color photos, index, order no. 1778.

SOFTBOX LIGHTING TECHNIQUES
FOR PROFESSIONAL PHOTOGRAPHERS

Stephen A. Dantzig

Learn to use one of photography's most popular lighting devices to produce soft and flawless effects for portraits, product shots, and more. $34.95 list, 8.5x11, 128p, 260 color images, index, order no. 1839.

SIMPLE LIGHTING TECHNIQUES
FOR PORTRAIT PHOTOGRAPHERS

Bill Hurter

Make complicated lighting setups a thing of the past. In this book, you'll learn how to streamline your lighting for more efficient shoots and more natural-looking portraits. $34.95 list, 8.5x11, 128p, 175 color images, index, order no. 1864.

THE BEGINNER'S GUIDE TO PHOTOGRAPHING NUDES

Peter Bilous

Peter Bilous puts you on the path to success in this fundamental art form, covering every aspect of finding models, planning and executing a successful session, and getting your images out into the world. $34.95 list, 8.5x11, 128p, 200 color/b&w images, index, order no. 1893.

DOUG BOX'S
GUIDE TO POSING
FOR PORTRAIT PHOTOGRAPHERS

Based on Doug Box's popular workshops for professionals, this intensive book allows you to quickly master the skills needed to pose men, women, children, and groups. $34.95 list, 8.5x11, 128p, 200 color images, index, order no. 1878.

DIGITAL PHOTOGRAPHY BOOT CAMP, 2nd Ed.

Kevin Kubota

This book based on Kevin Kubota's workshop series is fully updated with techniques for Photoshop and Lightroom. A down-and-dirty, step-by-step course for professionals! $34.95 list, 8.5x11, 128p, 220 color images, index, order no. 1873.

PORTRAIT LIGHTING FOR DIGITAL PHOTOGRAPHERS

Stephen Dantzig

Dantzig covers the basics and beyond, showing you the hows and whys of portrait lighting and providing demonstrations to make learning easy. Advanced techniques are also included, allowing you to enhance your work. $34.95 list, 8.5x11, 128p, 230 color images, index, order no. 1894.

JERRY D'S EXTREME MAKEOVER TECHNIQUES FOR DIGITAL GLAMOUR PHOTOGRAPHY

Bill Hurter

Rangefinder editor Bill Hurter teams up with acclaimed photographer Jerry D, revealing the secrets of creating glamour images that bring out the very best in every woman. $34.95 list, 8.5x11, 128p, 270 color images, index, order no. 1897.

PROFESSIONAL WEDDING PHOTOGRAPHY

Lou Jacobs Jr.

Jacobs explores techniques from over a dozen top professional wedding photographers in this revealing book, taking you behind the scenes and into the minds of the masters. $34.95 list, 8.5x11, 128p, 175 color images, index, order no. 2004.

THE ART OF CHILDREN'S PORTRAIT PHOTOGRAPHY

Tamara Lackey

Learn how to create images that are focused on emotion, relationships, and storytelling. Lackey shows you how to engage children, conduct fun and efficient sessions, and deliver images that parents will cherish. $34.95 list, 8.5x11, 128p, 240 color images, index, order no. 1870.

50 LIGHTING SETUPS FOR PORTRAIT PHOTOGRAPHERS

Steven H. Begleiter

Filled with unique portraits and lighting diagrams, plus the "recipe" for creating each one, this book is an indispensible resource you'll rely on for a wide range of portrait situations and subjects. $34.95 list, 8.5x11, 128p, 150 color images and diagrams, index, order no. 1872.

500 POSES FOR PHOTOGRAPHING WOMEN

Michelle Perkins

A vast assortment of inspiring images, from head-and-shoulders to full-length portraits, and classic to contemporary styles—perfect for when you need a little shot of inspiration to create a new pose. $34.95 list, 8.5x11, 128p, 500 color images, order no. 1879.

PROFESSIONAL COMMERCIAL PHOTOGRAPHY

Lou Jacobs Jr.

Insights from ten top commercial photographers make reading this book like taking ten master classes—without having to leave the comfort of your living room! $34.95 list, 8.5x11, 128p, 160 color images, index, order no. 2006.

PROFESSIONAL DIGITAL TECHNIQUES FOR
PHOTOGRAPHING BAR AND BAT MITZVAHS

Stan Turkel

Learn the important photographs to get and the symbolism of each phase of the ceremony and celebration. $34.95 list, 8.5x11, 128p, 140 color images, index, order no. 1898.

SCULPTING WITH LIGHT

Allison Earnest

Learn how to design the lighting effect that will best flatter your subject. Studio and location lighting setups are covered in detail with an assortment of helpful variations provided for each shot. $34.95 list, 8.5x11, 128p, 175 color images, diagrams, index, order no. 1867.

MOTHER AND CHILD PORTRAITS

Norman Phillips

Learn how to create the right environment for the shoot and carefully select props, backgrounds, and lighting to make your subjects look great—and allow them to interact naturally, revealing the character of their relationship. $34.95 list, 8.5x11, 128p, 225 color images, index, order no. 1899.

500 POSES FOR PHOTOGRAPHING BRIDES

Michelle Perkins

Filled with images by some of the world's most accomplished wedding photographers, this book provides inspiration to spice up your posing or refine your techniques. $34.95 list, 8.5x11, 128p, 500 color images, index, order no. 1909.

THE BEST OF WEDDING PHOTOJOURNALISM, 2nd Ed.

Bill Hurter

From the pre-wedding preparations to the ceremony and reception, you'll see how professionals identify the fleeting moments that will make truly memorable images and capture them in an instant. $34.95 list, 8.5x11, 128p, 150 color images, index, order no. 1910.

ADVANCED WEDDING PHOTOJOURNALISM

Tracy Dorr

Tracy Dorr charts a path to a new creative mindset, showing you how to get better tuned in to a wedding's events and participants so you're poised to capture outstanding, emotional images. $34.95 list, 8.5x11, 128p, 200 color images, index, order no. 1915.

AVAILABLE LIGHT
PHOTOGRAPHIC TECHNIQUES FOR USING EXISTING LIGHT SOURCES

Don Marr

Don Marr shows you how to find great light, modify not-so-great light, and harness the beauty of some unusual light sources in this step-by-step book. $34.95 list, 8.5x11, 128p, 135 color images, index, order no. 1885.